The Salvador Dali Museum Collection

A Bulfinch Press Book Little, Brown and Company Boston • New York • London

The Salvador Dali Museum Collection

Foreword by A. Reynolds Morse

L I

Introduction by Robert S. Lubar

First Paperback Edition
Fifth Printing, 1999

Library of Congress Cataloging-in-Publication Data

Dali, Salvador, 1904–1989
 Dali: The Salvador Dali Museum Collection/foreword by A.
Reynolds Morse; introduction by Robert S. Lubar. — 1st ed.
 p. cm.
 "A Bulfinch Press book."
 ISBN 0-8212-1810-7 (hc)
 ISBN 0-8212-2086-1 (pb)
 1. Dali, Salvador, 1904–1989 — Catalogs. 2. Morse, Al-
bert Reynolds, 1914– — Art collections — Catalogs.
3. Art — Private collections — Ohio — Cleveland —
Catalogs. 4. Salvador Dali Museum — Catalogs.
I. Salvador Dali Museum. II. Title.
N7113.D3A4 1991
759.6 — dc20 90-49499

Bulfinch Press is an imprint and trademark of Little, Brown
and Company (Inc.)

PRINTED IN ITALY

Edited by Lindley Boegehold
Copyedited by David Coen
Designed by Wondriska Associates
Production coordinated by Amanda Wicks Freymann
Set in Aldus™ (trademark of Linotype Co.)
by Eastern Typesetting Company, Hartford, Connecticut
Printed and bound by Arti Grafiche Amilcare Pizzi, S.p.A., Milan

Contents

Foreword

A. Reynolds Morse

The impact of Salvador Dali's art on America dates back to the inclusion of some of his early works in the 1928 Carnegie International in Pittsburgh. A notable example was *The Basket of Bread* of 1926. This panel was eventually purchased by the well-known collector-critic James Thrall Soby, one of the first Americans to perceive that the most exciting and influential modern art was appearing in Europe and in the Surrealist movement in particular. He recognized the importance of de Chirico, Tchelitchew, Berman, and certain other twentieth-century painters long before most Americans, except, of course, the expatriates in Paris, had ever heard of them, though Dali had held several shows in the 1930s at the Julien Levy Gallery in New York and later at the Hatfield Gallery in Los Angeles, California.

To avoid the cold New York winters, the Dalis divided their years in exile between the Del Monte Lodge in Pebble Beach, California, and the St. Regis Hotel in New York. The present Morse Collection, as it now exists in the Salvador Dali Museum in St. Petersburg, Florida, was born in the spring of 1943 with the purchase of *Daddy Longlegs of the Evening — Hope!* Shortly thereafter my wife, Eleanor, and I met Salvador Dali by appointment in the Old King Cole bar at the St. Regis Hotel in New York. Subsequently, we purchased the *Average Atmospherocephalic Bureaucrat in the Act of Milking a Cranial Harp* from Gala Dali. From Dali's great portrait show at Knoedler's Gallery in 1943, we acquired the immortal watercolor *The Madonna of the Birds.* There we also first saw *Geopoliticus Child Watching the Birth of the New Man*, an important oil that came into our collection some years later, as our fascination and friendship with the artist grew. In 1944 Dali began to show his works at Bignou Gallery, run by the art dealer Georges Keller. This was to become an annual event. We obtained several works from Bignou and its successor, Keller's Carstairs Gallery on Fifty-seventh Street, where some of Dali's most notable shows took place.

Each season we went to New York and there began a long tradition of helping the Dalis hang their new shows. This special vernissage was always followed by a private dinner in Pierre's Wine Room. Sometimes it was to celebrate the acquiring of another Dali. And on other occasions it was to rejoice in such events as a major acquisition of an important work, such as the purchase of *Corpus Hypercubus* by the Metropolitan Museum of Art under the aegis of the great collector Chester Dale.

During the 1940s and 1950s Dali was becoming popularly known as a commercial artist and a showman. The art world in general, however, tended to look down on his painting because of the sensational publicity his antics aroused. The artist's television commercials also intensified the suspicions of the art critics and art-museum professionals that Dali was not a serious artist, so his comparatively few paintings were ignored, to a great extent, by museums and art collectors.

In 1954 Eleanor and I went to Rome with the Dalis to a large show of one hundred watercolors made by the artist to illustrate Dante's *Divine Comedy.* For a while it appeared the Rome State Press would publish a new illustrated edition of Dante, but the project collapsed because it was decided that it was inappropriate for the writings of Italy's greatest poet to be illustrated by a Spanish artist! A decade later in Paris, Joseph Foret finally issued the Dante, and it quickly became a great landmark in Dali's career. Today, two of the original Dali Dante watercolors are in the Morse Collection in St. Petersburg.

As our Dali collection grew, so did our friendship with the Dalis. By no means did all of this collection, however, come directly from Dali. We carried on an extended correspondence with many collectors and tracked down a number of privately owned works, many of which were acquired simply by chance. We happened, for example, to visit the Santa Barbara Art Museum while in Santa Barbara to see Wright Ludington's great collection. There we saw the *Profanation of the Host* on loan from the Julien Levy Gallery. To our horror, a large piece of the heavy white impasto had fallen out, apparently damaged in shipment. This powerful work was eventually repaired and we bought it from Julien Levy, the distinguished art dealer who sponsored Dali in America during the 1930s.

The growth of the collection over forty-five years was actually a series of Dalinian adventures. At one point, we started to make a collection of Surrealist art, including works by de Chirico, Tanguy, Miró, and Magritte. But as our fascination with Dali grew, along with the recognition of his true genius, we gradually sold the Surrealist collection. As our art education and our appreciation of Dali increased, so did the number of his works in the collection, along with our library of Dali-related material.

Dali's traditionally executed oeuvre of serious art is relatively small, and after Georges Keller closed Carstairs Gallery and retired, Dali had no regular art dealer at all. So, the majority of his inspired art was sold mainly by himself and his wife, Gala. They dealt directly with friends and aficionados, including the many celebrities who were attracted both by his creativity and by his notoriety, and for many of whom he painted stunning portraits.

Beginning in the early 1960s, Dali turned to making watercolors and gouaches for reproduction. These commissions were lucrative for both the artist and the agent who found the clients. As Dali's fame and public recognition grew, his then-biannual shows became less serious art events and more like

high-society parties. In the 1960s and 1970s he began experimenting with holograms and creative diversions such as the staging of the opera *The Roman Gladiator and the Spanish Lady* in Venice, under the aegis of the Metropolitan Opera's Lorenzo Alvary, and the staging of the popular *Don Juan Tenorio* in Madrid, which he did in three separate versions.

Concurrently, our belief in Dali as a painter never wavered, despite his usually poor critical reviews. As our collection expanded in size and prominence, the problems of maintenance and exhibition became more and more time-consuming because so many people wished to see it.

In 1969 we made one of our annual trips to see the Dalis in Port Lligat. There, on his movable easel, was a huge canvas, one of the largest to date. And we made the happy mistake of falling in love with this large paranoiac-critical portrait of the bullfighter Manolete concealed in a double image that emanated from the familiar photograph of Venus de Milo on the Venus pencil box. It was called *The Hallucinogenic Toreador* and was said also to be a tribute to the poet García Lorca.

Shortly after we acquired this monumental work, the great art collector Huntington Hartford put his equally large Dali canvas, *The Discovery of America by Christopher Columbus*, up for sale at auction. This 1958–59 work was painted in celebration of the coming three hundredth anniversary of the death of Velázquez in 1660 — a Spanish historical event that also moved Picasso to make many renditions of *Las Meninas*. Eleanor and I had seen Dali's work both in progress in Port Lligat and at Huntington Hartford's Gallery of Modern Art on Columbus Circle in New York when we moved our entire collection there for a huge Dali show in 1965. In the Hartford Gallery, however, the *Columbus* was virtually invisible, hung in a cramped stairwell. I finally saw the canvas again at Parke-Bernet the day before it went up for auction, and suddenly I perceived that the *Columbus* was indeed a far greater piece than I had first thought. The result was a heady conference with Dali and Gala at the St. Regis Hotel. They concurred that we should bid on the work. Dali felt that $100,000 would top all of his prices to date, so we determined to take a chance on the auction with that ceiling. Lo and behold, nobody topped the last bid!

We then realized we had two very large works that could not be housed. Meantime, serious interest in Dali had begun to grow. Indeed, the loan requests became so voluminous that we finally had a card printed stating that we could not lend any more works by Dali.

We learned a costly lesson the hard way from a loan to a Boston show in 1948: Dali's art does not travel well. By 1970, if we had granted requests to tour the collection, it would have been possible to keep most of it on the road all the time. But we weren't interested in aggressively promoting or in selling the works. The acquisition of the two massive paintings, the *Toreador* and the *Columbus*, however, necessitated the construction of a special room for them in a new wing of our office in Beachwood, Ohio. There, an "art wing" was opened to the public by appointment. From 1971 to 1980, thousands of people came to see works from the collection that for the past three decades had hung in a private home. It was not the first time we had built for the collection. A new wing had to be added to our house for the *Infanta* after it was acquired in 1958, along with *Nature Morte Vivante*.

Quite by chance, it developed that the Morse Collection represented a superb overview of the artist's easel paintings. It contained some ninety-three oils of the artist's output ranging in date from the 1920s to the 1970s. The collection by now also included a huge Dali reference library and numerous drawings and watercolors, uncounted graphics and other items of Daliana, as well as jewels and objects. So we decided to see if a permanent home could be found for the Dalis in order to keep this unique panoramic collection intact.

During the late 1970s, the art establishment as a whole still tended to look down on the Catalan as a serious artist. Surrealism itself was still barely understood as a movement in art. While Dali's draftsmanship was highly regarded by the critics, his oeuvre as a whole was not taken at all seriously by art professionals, museum directors, and the art media. Indeed, from 1941 to 1958, when the New York Graphic Society finally published my Dali study, there was not a single serious monograph on Dali's art in print!

The net result was that no art museum — large or small — would guarantee to keep this collection intact. The right to sell all or most of the works was an inescapable condition of every proposition. Ultimately, all hope was given up of donating the Dali art to a professional public museum. We also decided that keeping the collection intact was vital because it showed, quite by chance and not by design, Dali's growth from a Catalonian youth to a world-famous figure who, as he himself so often said, was "one clown who also paints."

Today, the Morse Collection is housed in a building funded by the state of Florida. (It cost two and a half million dollars to convert a former bayside boat repair building into a museum.) The collection is now held for the benefit of the people of Florida. The museum itself is run by the Salvador Dali Foundation, Inc., with the express aim of protecting it from all the vagaries of museum professionalism, on the one hand, and from changes in cultural policies by political parties on the other.

Presently, the future of the Dali Museum of

St. Petersburg seems fairly secure. The fame of Dali has recently brought record numbers of visitors from all over the world to see these examples of the Catalan's art and the products of his still little-understood paranoiac-critical method of creating new images from unique hypnogogic visions occurring *en sueño*.

As the shadows of Surrealism have lengthened, Salvador Dali as a major factor in twentieth-century art is becoming ever more clear even though this artist as yet has no established academic niche and no recognized standing in any modern art movement. The challenge of this one-man collection, therefore, is to provide a thorough and all-encompassing definition of this undefinable artist's oeuvre. Indeed it may yet provide the proof needed to sustain the role Dali proclaimed for himself long ago as the savior of modern art.

One final word is necessary in any realistic overview of the works and life of Salvador Dali. One must never forget that the era in which he lived saw "art" go from Impressionism through Pointillism and Surrealism to become a new sort of commodity, which now sells at all-time historical highs.

Dali's career in art, 1920–80, spanned the years from the decline of art with pictorial intellectual content to the emotional painting of the Abstract Expressionists, starting in the 1940s. By 1944, Dali was well into his brave attempts to "become classic." This step he undertook in the face of professional art critics' and dealers' efforts to establish a vogue for art confined to expressing only the painter's feelings.

In 1944, for example, Jackson Pollock in an interview in the *Journal of Arts and Architecture* commented about the European Surrealist movement, "I am particularly impressed with their concept of the source of art being the unconscious [sic]." This observation reveals just how little contemporary ac-

tion artists really understood the creative, intellectual explorations that Dali undertook to create "something new." For, of course, nothing can come from one's unconscious. It was, however, Dali who discovered in the early 1930s that new images, new ideas, *did* come from the subconscious. He also described how these images can be captured by his paranoiac-critical method in his booklet *The Conquest of the Irrational* of 1935. And there he also emphasized that to be effective in art, these hypnogogic images had to be precisely painted in color, and done so realistically — so photographically — that the viewer *had* to accept the reality of the existence of these new concepts from the truly creative artist's imagination.

Dali often showed us how the ultrarealism of Fortuny, Detaille, Meissonier, and even Bouguereau was based on skillful use of abstractions, with the result that an ultrarealism would appear, which carries Pointillism to the final limit of reality. The Catalan clearly practiced what he preached.

Today the trend swings to realism, to visual art with intellectual content. The importance of Dali's unique realism and imagery is being demonstrated ever more clearly in books and reproductions. His images catch and hold the popular imagination with their eerie, wholly believable quality. This is borne out by the record attendance and profitability of the seven blockbuster Dali retrospectives since 1980 (Paris, London, Barcelona, Madrid, Stuttgart, Zurich, and Montreal). As an enigma without end, Dali today holds the popular imagination far more firmly than almost any other single artist. In my opinion, this includes Picasso, who lacked Dali's intellectual and scientific curiosity despite his dynamic adeptness in drawing.

In this frenetic age where mere money is sweeping away all traditional aesthetic values in art, the reason for this particular art book is thus quite sim-

ple. It contains images that have totally enthralled people for over half a century because they are both valid and imponderable and are without any contradictions because they are so realistically painted.

There are few art books today that can concentrate both exclusively and successfully on one painter — especially an artist whose works can draw the viewer back over and over and refire his or her imagination, as Dali does. He persistently demands to be reconsidered, and upon reexamination, his works always offer the sentient viewer tremendous new rewards. Even after all these decades of looking at, and in our case actually living with, Dali's depictions, he remains the only painter of this century in whose works we invariably can still find "something new."

Today Dali's own prediction is coming true: "The crowds flock to see my paintings and will continue to do so because their instinct obscurely and amazedly suspects that my works hide treasures of blinding authenticity that nobody has yet perceived; artistic treasures that will be more and more coveted. . . ."

A. Reynolds Morse
St. Petersburg, Florida
February 1, 1990

Introduction, "Dali and Modernism: Vision and Its Representation" Robert S. Lubar

Of a cubist picture one asks: "What does that represent?" — Of a surrealist picture, one sees what it represents but one asks: "What does that mean?" — Of a "paranoiac" picture one asks abundantly: "What do I see?" "What does that represent?" "What does that mean?"

It means one thing certainly, — the end of so-called modern painting based on laziness, simplicity, and gay decorativism.[1]

Sounding the death knell of Modernism on the occasion of an exhibition in New York in 1939, Salvador Dali remained true to his public persona as a polemicist and agitator. For ten years, his painting had come to represent a challenge to the Modernist tradition, his dry photographic realism pitted against the idealist tendencies of Cubism and abstract art. Within the framework of the Surrealist movement, critics frequently viewed Dali's art as a reactionary countertradition, a return to the concrete subject and to the kind of "literary" painting that the century's abstract isms had attempted to banish from the surface of the canvas.[2] But this emphasis on Dali's style, focusing upon his work as a Surrealist and the perverse obsessions of his "painted dreams," did not adequately frame Dali's own antipathy to the very notion of style within the broader context of his artistic development. Most blatantly missing from the picture was a consideration of Dali's early, pre-Surrealist, work. Thus the full range (and cultural context) of his formative responses to Impressionism, Cubism, Futurism, and Purism, in addition to the theoretical underpinnings of his first adaptations of the techniques of photographic realism in 1925, remained obscure. Not until James Thrall Soby's ground-breaking Dali retrospective at the Museum of Modern Art in 1941 were we obliged to reconsider the Dali we thought we knew. Until that point, Dali remained incomplete to all but a select group of

collectors, among them Mr. and Mrs. A. Reynolds Morse.

The collection Mr. and Mrs. Morse have assembled over the course of nearly fifty years is striking in its breadth and diversity, spanning the complete range of Dali's career: from the primary images of Dali's adolescence in Figueres, Spain, to his accomplished student work in Madrid; from the fruits of his productive exchanges with Federico García Lorca, to his collaboration with Luís Buñuel; from his official entry into the French Surrealist movement in 1929 and his eventual break with its founder André Breton, to his postwar explorations of the relationship between history, science, and mysticism. Tracing Dali's varied career, the Morse Collection introduces us to an artist who is difficult to locate within traditional art histories, an artist for whom the idea of "style" itself seems an inappropriate basis for a critical judgment, and whose originality and significance must consequently be located within other discourses. Indeed, if the Morse Collection gives us pause to contemplate Dali's problematic relationship to the Modernist tradition, it also provides us with a unique opportunity to explore the terms of the alternative Dali himself proposed: his insistence on repositioning the role of painting at the juncture of vision and representation.

In a painting of 1925, Dali depicts his sister Ana María seated on a terrace, her back turned toward the viewer (fig. 1). Cramped in a space that is scarcely able to accommodate her, she is pushed up against the picture plane, anchored by a gridlike chair that locks her body into place and a distant house whose roofline frames the graceful curve of her shoulder. Immobilized by this rigid armature, her sole activities are confined to thinking and looking, the intensity of which we experience by their very indeterminacy. What, we ask, is the object of Ana María's gaze? What is its motivation? As we

probe the enigmatic situation that Dali has staged, our inability to fix specific meanings weighs heavily upon us. Indeed, the more we contemplate the problems inherent in looking at a figure whose gaze or nongaze remains inaccessible to us, we come to suspect that the subject of the painting is in fact *our* gaze, *our* vision. But what, then, is the *object* of our gaze: the girl? Her surroundings? Does our gaze in fact have an object, or is looking an act of will that engenders its own representations? Lest these questions remain unanswered, Dali will inform us: "To look is to invent."

The way in which Dali attacks traditional figuration in this early canvas, collapsing perspectival space and flattening form, at first seems to underscore his position as heir to early Modernism's critique of visual representation. Had not Braque, whose work Dali admired as a student in Madrid,[3] waged just such a challenge in his Cubist paintings, dismantling Renaissance space to the point of retaining only the vestiges of illusionism? Had not Picasso, and Cézanne before him, violated spatial relations by opening up the contours of the objects they painted? Indeed, as Dali's writings demonstrate, he was acutely aware of Modernism's challenge to representation, yet he strategically distanced himself from these predecessors. For Dali, a Cubist painting remains rooted in the discourse of aesthetics, whereas his painting addresses the physical, psychological, and (as we shall see) linguistic components of vision based on a "violent passion for the exterior world."[4]

In a letter to the Catalan critic Sebastià Gasch, circa 1926, Dali began to define the terms of his attachment to material reality. Rejecting both Impressionism's emphasis on the accidental and the fugitive, and the metaphysical ponderings of Symbolism, Dali declared:

Things have no meaning whatever beyond their strict-

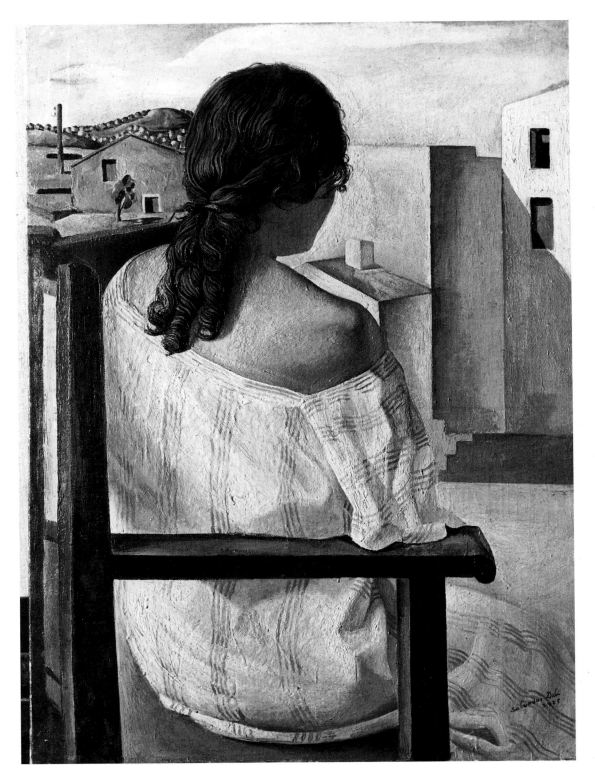

Fig. 1

Salvador Dali, *Noia d'esquena* (*Girl from the Back*), 1925. Oil on canvas, 40½ × 29 inches. Collection Museo Español de Arte Contemporáneo, Madrid.

est objectivity; herein resides, in my opinion, their miraculous poetry. . . . More than what a horse can suggest to a painter or a poet, I am interested in the horse or kind of horse the painter and poet can invent, *or better yet, encounter.* Let us strive to attain the maximum comprehension of reality by means of our senses and our intelligence and, instead of imitating or explaining our impressions of reality, our emotions (that is to say, its repercussions or resonances within us), let us create things that are its equivalent; and let the pathos of reality be derived not from our souls, but from things themselves, just as it occurs in reality.[5]

For Dali, the task confronting the painter or poet is not to interpret or create metaphorical substitutions for reality, but to learn how to see: the aesthetic act is defined as an encounter.

By 1926, Dali's materialism formed the ideological foundation of his campaign against modern art. His objections were perhaps most clearly spelled out in an article he published ten years later in the Surrealist journal *Minotaure.* Exposing Cézanne's professed materialism as a disguised idealism, he wrote: "From a morphological point of view Cézanne appears to us a kind of Platonic bricklayer who is satisfied with the plane of the straight line, of the circle, of regular shapes in general. . . ."[6] In subsequent writings, Dali charted a history of Modernism extending from Cézanne's "impulse toward the absolute idealism of formal lyricism"[7] to the "degrading example of mental debility. . . ."[8] that culminated with the Abstraction-Creation group in Paris. In Dali's analysis, artists as diverse as Mondrian (whom he referred to on one occasion as "Piet Niet"[9]) and Matisse [10] had fallen into, or were precariously perched upon, the abyss of abstraction.

In contrast, an early painting like Dali's *Basket of Bread* (cat. no. 25) provides a corrective to Modernism's aesthetic idealism, a healthy dose of "photographic" realism whose exactitude declares its

function as an invitation to see. Elaborating on this idea in an important article of September 1927 entitled "Photography, Pure Creation of the Mind," Dali advises: "Let us be satisfied with the immediate miracle of opening our eyes, becoming skillful in the apprenticeship of looking well. Looking is a way of inventing."[11] For Dali, photography exemplifies a new method of inquiry into physical appearances through which a simple operation like a change in scale can "motivate unusual resemblances and extant — though undreamed of — analogies."[12] The significance of this method is that such analogies will not be passively "imagined" — the manifest content of what he calls "obscure subconscious processes"[13] — but are discovered to exist already. Looking, for Dali, implies an active dialectic between physical reality and the creator's faculties of interpretation through which acts of will represent the world.

Dali's insistence upon active engagement and the subconscious underscores his interest in French Surrealism at this time, just as it reveals the theoretical distance that separated him from the movement's orthodoxy. In April 1926, Dali made his first trip to Paris, with a letter of introduction from his Barcelona dealer, Josep Dalmau, to André Breton.[14] Although Dali did not begin to frequent Surrealist circles for another year and a half (on the occasion of his second Paris sojourn in the autumn of 1928), clearly he had assimilated the essential tenets of Surrealist theory by 1927. Three years earlier André Breton had baptized the movement by manifesto, defining Surrealism as "Psychic automatism in its pure state, by which one proposes to express — verbally, by means of the written word, or in any other manner — the actual functioning of thought. Dictated by thought, in the absence of any control exercized by reason, exempt from any aesthetic or moral concern."[15] But if Dali was willing to abandon

aesthetic or moral directives in his art, as Breton had prescribed, he refused to abandon critical control. Dali objected to Surrealist psychic automatism as a passive state of consciousness in which the artist/poet is transformed into a kind of medium. Indeed, a month after his article on photography appeared, Dali more fully explained his position on Surrealism and the automatic process:

> To know how to look at an object, an animal, through mental eyes is to see with the greatest objective reality. . . . As I wrote recently, talking of photography: *To look is to invent.* All this seems to me more than enough to show the distance which separates me from Surrealism despite the intervention of what we could call the poetic transposition of the purest subconscious and the freest instinct."[16]

In this way, rejecting Surrealist automatism and mimetic painting alike, Dali defines artistic invention as the process through which the physical world is framed as representation.[17]

By 1927, Dali had begun to test these ideas. In *Apparatus and Hand* (cat. no. 27), an important transitional work of that year, a series of incongruous and fantastic objects are assembled in a landscape that can be immediately identified as the rocky coast of Cape Creus, near Dali's home in Cadaques. Within this deep illusionistic vista that the artist defines through the techniques of the most academic illusionism, chance encounters of disparate objects occur. While the device of perspective provides a coherent syntax for Dali's imagery, the objects themselves function as disembodied signs. Freed from the tyranny of reason — the conventional relationships through which objects and words are assigned specific meanings — Dali's images are endowed with apparently limitless poetic associations.

Apparatus and Hand may be one of the paintings Dali referred to in a letter to Miró dated Sep-

tember 1, 1927, in which he informed his friend and mentor of having inaugurated a new phase in his art that better corresponded to his thinking than his previous work.[18] Not only was Miró instrumental in securing Dali a contract with the Parisian dealer Camille Goemans,[19] but Miró's important role in attacking the ideality of art, and its attendant cultural institutions, ultimately served as a model for Dali in his campaign against Modernism.

For Miró, Dali, and the group of Catalan intellectuals that formed around the journal *L'Amic de les arts*, including Josep Vicenç Foix, Sebastià Gasch, and Lluís Montanyà, the idea of "assassinating art" (a phrase attributed to Miró) constituted an attack on the institution of art in general, and the provincial torpor of Catalan culture in particular. In March 1928, Dali, Gasch, and Montanyà issued their infamous *Manifest Groc* (*Yellow Manifesto*), denouncing the racial sentimentalism endemic to Catalan art and literature, and the generally "grotesque and sad spectacle of today's Catalan intelligentsia, sealed in a stale and putrefied atmosphere." As an antidote to this malaise, the authors invoked Futurist rhetoric, extolling the machine "which has revolutionized the world," and the spectacle of modern life itself — jazz, automobile and air shows, music halls, et cetera. In this regard, they allied themselves with the project of a slightly earlier generation,[20] intent upon ridding Catalan culture of its persistent anachronisms.[21] Indeed, the many cabarets that Dali painted in 1922, before his involvement with Gasch and his colleagues, combined social commentary — the desire to address the multiple experiences of modern urban life — with advanced pictorial strategies in an obvious affront on Catalan art and society. However, if form and iconographic content enjoyed a reciprocal relationship at this time, by 1928 Dali had begun to view the very institution of art as a kind of cultural fraud. By championing

the "marvelous mechanical industrial world" and the strictly utilitarian standards by which commercial advertisements are created,[22] Dali intended, in effect, to separate himself from the aesthetic sphere. His aesthetic nihilism more closely approximated the machine anti-aesthetic of Francis Picabia, whose fantastic drawings of industrial apparatuses[23] are in evidence in the central image of *Apparatus and Hand*, as are Giorgio de Chirico's spectral mannequins.

Dali maintained his attacks on Catalan art and culture throughout 1928 in a series of articles and lectures. In the autumn of that year Dali submitted two paintings to the Saló de Tardor at the Sala Parés in Barcelona, *Dit gros, platja, lluna i ocell podrit* (*Big Thumb, Beach, Moon and Rotting Bird*)[24] and *Diàleg a la platja* (*Dialogue on the Beach*, fig. 2). The latter painting, with its explicit theme of frustrated desire and autoeroticism, provoked a scandal involving Dali, Joan Maragall of the Sala Parés, Josep Dalmau, and Dali's own father. In the end, the painting did not appear in the Saló de Tardor, but was exhibited instead by Dalmau at his establishment — with a piece of wood covering the objectionable phallic hand with raised finger![25] This incident, perpetrated against Dali by those individuals he would later describe as "middle-men of culture,"[26] surely confirmed his contempt for the Catalan art world. Continuing to separate his activity from the institution of art as it is socially defined and mediated, Dali explained his position in a lecture delivered at the Sala Parés precisely as the controversy over *Diàleg a la platja* was unfolding:

Only by means of irrationality is it possible to reendow things with their real value. . . . [A]rt generated on the margins of the intelligence — on the margins of all culture, of any system of culture, [an art of] pure consequence, a pure product of inspiration and instinct —

arrives at intuitive truths of an absolute value and exactitude.[27]

He then repeated the idea of mechanization as the paradigm of a new "state of mind" that is free of "artistic decay." From this point onward, Dali irrevocably defined his position as a painter in terms of moral rather than aesthetic activity, waging his attack on Modernist idealism upon the battlefields of vision and language.

The key to Dali's position at this time is provided by Surrealist theory, in particular the Surrealists' disdain for "aesthetic preoccupations." As we have seen, throughout 1927 and 1928 Dali's writings demonstrate his growing familiarity with Surrealism, though he continued to have doubts about the efficacy of the automatic process. In March 1929, however, precisely as his interest in photography as an "active" mechanism of encountering reality yielded brilliant results in his collaboration with Luís Buñuel on the film *Un Chien andalou*, Dali seemed to lend his unconditional support to Surrealism. In a special issue of *L'Amic de les arts*,[28] Dali declared that Surrealism, operating upon the plane of reality itself, was uniquely capable of liberating consciousness by releasing thought and desire through acts of moral and aesthetic subversion. Clarifying his position in a discussion of the "Imagination Without Strings Attached," Dali distinguished imagination from inspiration:

Imagination is something which is put together in a more or less inspired way. Imagination is the spout whose force obeys our will. In contrast, inspiration is something involuntary, like the geyser which bursts forth unexpectedly on the calmest part of the coast, raising its salty and boiling jet to unexpected heights of passion.[29]

For Dali, the task confronting the artist/investigator

is to plunder the realm of pure inspiration — the instinctive, spontaneous, and involuntary — in a precise and methodical manner. As Dali would define the moral position of Surrealism a year later:

> [W]e are interested in . . . everything that can contribute to the discrediting and ruin of the tangible and intellectual world which, in the process initiated in reality, can be condensed in the violently paranoiac desire to systematize confusion. . . . Above all else, we must consider the birth of the new Surrealist images to be the birth of images of demoralization.[30]

Thus, the idea of systematizing confusion involves constructing a bridge between inspiration and imagination, passive and active states, the intangible and the concrete, with the singular aim of achieving the dialectical resolution of reality and desire.

Dali, however, discredits the tangible world within the framework of his "demoralized" imagery, suggesting that his global ideological project is in the end limited to the narratives of his painting. Much Dali scholarship has concentrated on the ways in which Dali's works of this period function as both psychoanalytic exegeses and purgings of his fantasies, fears, and obsessions. *The First Days of Spring* of 1929 (cat. no. 34) and *La Main (Les Remords de conscience)* of 1930 (cat. no. 37) abound with autobiographical references to Dali's fear of castration, of paternal retribution, his childhood trauma, guilt, frustrated desire, and onanism. Indeed, the presence of Freud in the center right of *The First Days of Spring* invites the view that these pictures are tan-

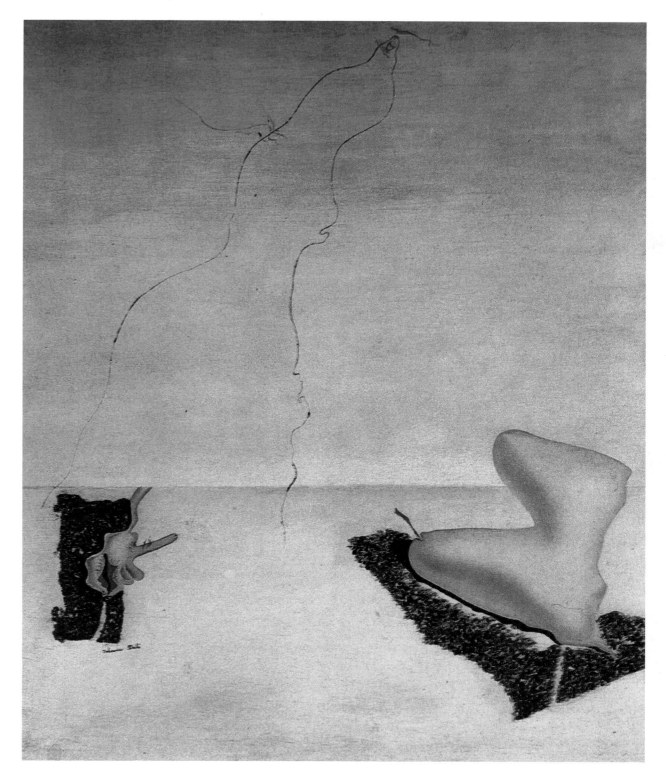

Fig. 2

Salvador Dali, *Diàleg a la platja (Dialogue on the Beach)*, 1928. Oil, sea shells, and sand on canvas, 30 × 24⅜ inches. Private collection.

tamount to psychoanalytic case histories. Yet these paintings, which mark Dali's official entry into the Surrealist movement, are also important for the subtle ways in which they direct the viewer's attention *away* from the picture plane toward an interpretation of visual representation. In both paintings, Dali's tight academic realism is held up against the illusions of popular prints and actual photographs, which are affixed to the canvas. In *La Main*, the highlighted area of the woman's face, a photograph, has been touched up with paint, thereby confounding the distinctions between the two media. By contrast, in *Memory of the Child-Woman* of 1932 (cat. no. 45), Dali has gone a step further, adapting the conventions of stylized shading and crisp outlining often found in popular botanical prints to the painted roses surrounding the bust of the male figure. In short, in these literally and ironically "hand-painted dream photographs," as Dali called them, the process of looking itself is critically engaged. In this regard, Dali's photographs, chromolithographs, and trompe-l'oeil illusions function both as iconographic details within his personal symbology and as signs for different representational conventions. As such, Dali's paintings offer more than a clever transcription of his systematized confusion.

By 1930, with his full participation in the Surrealist movement, Dali integrated his theoretical position concerning Modernism, the psychology of vision, and the relationship between representation and cognition into an extended analysis of what he termed the "paranoiac-critical" process. In "L'Ane pourri" ("The Stinking Ass"), an important essay that appeared in *Le Surréalisme au service de la révolution*,[31] Dali prophesied:

> I believe that the moment is near when, by a process of thought with active paranoiac characteristics, it will be possible simultaneously with automatism and other

passive states to systematize confusion and contribute to the total discredit of the world of reality. . . . Paranoia uses the outside world to make the most of an obsessive idea, with the troubling particularity that the reality of this idea becomes evident to others. The reality of the outside world serves as an illustration and proof, and is put into the services of the reality of our mind.[32]

In Hegelian terms, Dali argues that reality both acts upon, and is subordinate to, the demands of our will. Building upon his earlier distinction between imagination and inspiration, Dali now demonstrates how the paranoiac-critical method verifies this process.

In his classic essay "The Dali 'Case,' " André Breton observed how paranoiac delirium subjects the world to its actions and necessities, "lend[ing] itself to the coherent development of certain errors to which the subject shows a passionate attachment."[33] Here, the term *coherent* is of the utmost importance, as the paranoiac will logically and methodically find "proofs" of his delusions and obsessions in the concrete objects and experiences of the physical world. Of course, Dali, unlike the clinical paranoiac, remained in control of his "delusions," subjecting them to a systematic process of interpretation/criticism. As Dali himself explained, in a much-quoted statement, "The only difference between me and a madman is that I am not mad."[34] In this way, as Breton recognized, Dali "has shown himself strong enough to participate in these events as actor and spectator simultaneously. . . . [He] has succeeded in establishing himself both as judge of and party to the action instituted by pleasure against reality."[35]

In the process of championing the concrete irrational subject, Dali maintained his campaign against modern art. In a polemical defense of fin de siècle architecture in Barcelona — particularly An-

toni Gaudí's extravagant organic edifices, which critical opinion held in low esteem at this time — Dali lashed out against "pragmatist intellectualism." Arguing, in a calculated attack on Le Corbusier's functionalism, that "erotic desire is the ruin of intellectualist aesthetics," Dali concluded that "Beauty is but the epitome of consciousness of our perversions."[36] Elsewhere, Dali condemned the "sticky and retarded Kantians of scatalogical *sections d'or*,"[37] whose belief in a priori categories of experience was diametrically opposed to Dali's adherence to a Hegelian dialectical model. Rejecting the notion that forms have absolute (aesthetic) value in themselves, Dali argued that even the most *arriviste* devices of illusionism and academicism "can become sublime hierarchies of thought"[38] in their ability to communicate "new and objective 'significances' in the irrational."[39] Form, for Dali, is meaningful only in its function as a signifier circumscribed within complex networks of association that paranoiac-critical activity reveals.

But to what, we ask, do Dali's signs refer? Is it possible to fix specific meanings within Dali's system of signification, or does paranoiac-critical activity itself open fissures in meaning through a process of constant transformation? On one level, Dali informs us that "the 'paranoiac phenomenon' (delirium of systematic interpretation) is consubstantial with the human phenomenon of sight,"[40] that is to say, vision both objectifies, and is the object of, desire. Using vision to discredit reality, Dali establishes a substitute world whose appearance is mediated by volition.

Dali discussed on numerous occasions how his paranoiac-critical analysis of vision might be applied. In the third issue of *Le Surréalisme au service de la révolution*,[41] he published a horizontally oriented photograph of figures sitting before a tribal hut, which he then turned vertically to expose its

latent content, a face in three-quarter view(fig. 3). The accompanying text read:

> At the end of some research, during the course of which I had been obsessed by a lengthy reflexion on Picasso's faces and particularly those of his African period, I was looking for an address in a stack of papers and was suddenly struck at finding a reproduction of a face which I believed to be by Picasso, but a completely unknown face.
>
> All at once this face disappeared and I was aware of the illusion. The analysis of the paranoiac image in question made it worthwhile to recall through symbolic interpretation all the ideas which had preceded the sight of the visage. [42]

This discussion emphasizes the importance in Surrealist theory of the *trouvaille* — the found object — revealed through the action of what the Surrealists called "objective chance." Of course, as Dali insisted, the initial encounter with the *trouvaille* is not really fortuitous, for the discovery of special meaning (a latent content) in the object is a condition of unconscious desire, just as the paranoiac "finds" confirmation of his delusions in the world. Unlike the true paranoiac, however, Dali then sets to the task of analyzing the circumstances surrounding paranoiac vision through a process of symbolic — and critical — interpretation.

Dali adapted this analysis to the problem of vision in his own paintings. Beginning with *The Invisible Man* of 1929–32 (now in a private collection in Paris), and achieving memorable results in such works as *Enchanted Beach with Three Fluid Graces*, 1938 (cat. no. 67), and *Slave Market with the Disappearing Bust of Voltaire*, 1940 (cat. no. 71), the active paranoiac-critical process of transformation is adjusted to the viewer's own perceptual apparatus. In *Slave Market*, the possibility of an objective vision of the world is called into question

as the image of Houdon's famous likeness of Voltaire alternately (but not simultaneously) yields to that of two women dressed in seventeenth-century Spanish costume. Similarly, in *Enchanted Beach*, the rational organization of linear perspective, which systematically guarantees the fixed position of an object in space and thereby its unique identity, is unraveled, as the face of the central figure in the foreground (to cite but one example) disintegrates before our eyes, yielding the image of six figures and a horse in the background. In both paintings, as appearances dissolve, as objects are transformed, and as our faculties of reason and visual perception are strained, we come to understand that the world of appearances is not *given* but is *constructed*, mediated by our will. As Dali later said, "We see what we have some reason for seeing, above all what we believe we are going to see. If the reason or the belief is upset — we see something else." [43]

For Dali, however, the mechanisms by which paranoiac-critical activity transforms the world are themselves implicated in a broader process of signification. Just as Dali engages vision directly in his art, he explores how vision is mediated by language. The value of this kind of analysis is that it allows Dali to critique the ways in which language itself renders the world "intelligible," and thus to examine the conditions that make signification — rational or delusional — possible.

In two paintings of the mid-thirties entitled *Morphological Echo* (cat. nos. 64 and 65), the paranoiac-critical mechanism engenders a series of substitutions in which the status of the signifier — the graphic mark or image that evokes a concept or meaning — is fully activated. In the second version, the image of the girl with the hoop is transformed into that of a bell on a distant tower and a rocky outcropping on a barren plain. As each of these formally similar — but not identical — images is called

upon to modify the other two, a network of associations and transferences is established that locates individual signs within a larger semantic field in which meaning is established through difference.

In the first version, the system functions in the same way, but has become considerably more complex. On a deep illusionistic stage, Dali aligns nine objects in rows of three, mapping the coordinates of a regular grid. The regularity of this grid, which spreads across the picture's surface horizontally and vertically, levels each object to a singular status and size. Reading the painting horizontally, each row corresponds to a particular classification of object: the glass, crust of bread, and bunch of grapes belong to the category "food" (the glass and spoon signifying consumption); the woman, nurse, and reclining figure of Lenin belong to the category "human"; and the tower, mountain, and wall to the category "structure" (man-made or natural). Within each category, the objects also respond to a consistent set of physical conditions, alternating in their axial placement from a vertical to a horizontal orientation. Reading the painting vertically, we again move between the three levels of classification in a consistent order, the specificity of the individual images in turn collapsed by their morphological similarities. But just as the grid threatens to reduce everything to sameness, and thereby annihilate the complex play of oppositions through which meaning itself is engendered, the objects return to assert their unique presences.

Defying the boundaries of their rigid container, the nine objects cast long shadows that serve to define their physical orientation in three-dimensional space. And once these objects are understood to be mediated by perspective, their apparent uniformity is negated. Governed by the physical laws of spatial recession, the largest elements, relegated to the background, merely "appear" to be equal in size to

the considerably smaller objects assembled on the foreground table. In this way, by analyzing the systems and relationships by which signification is established, and by exposing the arbitrary liaisons that tie words and images to objects and concepts, Dali articulates a primary condition of paranoiac-critical activity itself: the constant shifting of meanings within the systematic structure of language.

Through this analysis of vision and language, seeing and representing, Dali returns us to the girl on the terrace (fig. 1). Too easily dismissed as a reactionary painter, Dali sought nothing less than the liberation of desire through a critique of language and visuality. His attack on Modernist aesthetics represented a moral posture within the context of the Surrealist project to restore to mankind the fullness of human experience. If, one may argue, Dali nevertheless shared High Modernism's preoccupation with language and the structures of signification, he resolutely defined his activity outside the aesthetic domain. The artist's notoriety for exploiting the culture industry notwithstanding, we are obliged to look upon his art and ideas critically, and chart the full course and implications of his development. The comprehensive collection of Dali's art that Mr. and Mrs. A. Reynolds Morse have assembled gives us access to the wide range of his activities as both a painter and a theorist, and provides the means through which we may reclaim Dali's important position in twentieth-century art and intellectual history.

Fig. 3

Salvador Dali, "Communication: Visage paranoïaque," text and illustrations published in *Le Surréalisme au service de la révolution* No. 3 (1931).

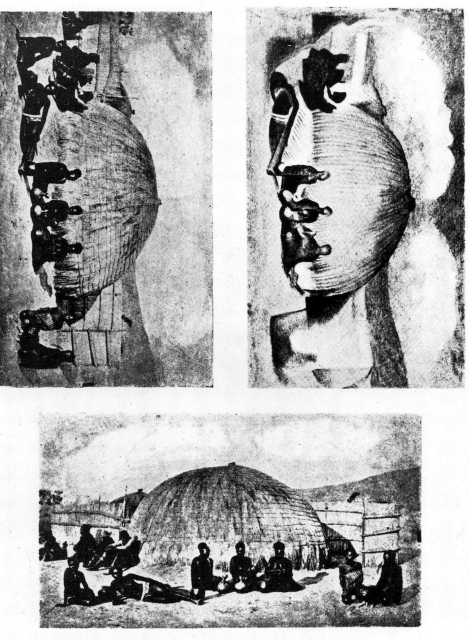

COMMUNICATION : Visage paranoïaque.

A la suite d'une étude, au cours de laquelle m'avait obsédé une longue réflexion sur les visages de Picasso et particulièrement ceux de l'époque noire, je cherche une adresse dans un tas de papiers et suis soudain frappé par la reproduction d'un visage que je crois de Picasso, visage absolument inconnu.

Tout à coup, ce visage s'efface et je me rends compte de l'illusion (?) L'analyse de l'image paranoïaque en question me vaut de retrouver, par une interprétation symbolique, toutes les idées qui avaient précédé la vision du visage.

André Breton avait interprété ce visage comme étant celui de Sade, ce qui correspondait à une toute particulière préoccupation de Breton quant à Sade.

Dans les cheveux du visage en question Breton voyait une perruque poudrée, alors que moi je voyais un fragment de toile non peinte, comme il est fréquent dans le style picassien.

Salvador DALI

Notes

I am indebted to my colleague Patricia Gray Berman of Wellesley College for editing this essay and offering numerous suggestions for its revision.

1. Salvador Dali, "Dali, Dali!," statement in *Salvador Dali*, exhibition catalog, Julien Levy Gallery, New York, 1939.

2. For a classic statement of this position, see Clement Greenberg's 1939 essay "Avant-Garde and Kitsch," in Greenberg, *Art and Culture: Critical Essays* (Boston, 1961): pp. 3–21.

3. See the artist's discussion in Salvador Dali, *The Secret Life of Salvador Dali* (New York, 1942), p. 162.

4. Dali to Sebastià Gasch, undated letter cited in full in: Sebastià Gasch, *Expansió de l'art català al món* (Barcelona, 1953), pp. 145–147.

5. Ibid., pp. 145–146. According to Rafael Santos i Torroella, *La Miel es más dulce que la sangre: Las Épocas lorquiana y freudiana de Salvador Dalí* (Barcelona, 1984), p. 236, n. 2, the undated letter was probably written in 1926.

6. Salvador Dali, "Le Surréalisme spectral de l'Éternel Féminin préraphaélite," *Minotaure* No. 8 (June 15, 1936), pp. 46–49; excerpted and translated in Marcel Jean, *The Autobiography of Surrealism* (New York, 1980), p. 339.

7. Ibid.

8. Salvador Dali, *Dali on Modern Art: The Cuckolds of Antiquated Modern Art* (New York, 1957), p. 59.

9. Ibid., p. 57.

10. For Dali's remarks on Matisse, see the transcript of a lecture he delivered at the Sorbonne on December 17, 1955; reprinted in *Salvador Dalí Rétrospective: 1920–1980* (Musée National d'Art Moderne, Centre Georges Pompidou, Paris, December 18, 1979–April 21, 1980), pp. 144–145.

11. Dali, "La fotografia, pura creació de l'esperit," *L'Amic de les arts* No. 18 (September 1927); in Jaime Brihuega *Manifiestos, proclamas, panfletos y textos doctrinales: Las vanguardias artísticas en España. 1910–1931* (Madrid, 1979), pp. 123–126.

12. Ibid., p. 124.

13. Ibid., p. 124.

14. For a discussion see Santos i Torroella, *La Miel*, p. 240. The author suspects that Dali did not make use of this and other letters of introduction at this time.

15. André Breton, *Manifestos of Surrealism*, translated by Richard Seaver and Helen R. Lane (Ann Arbor, Michigan, 1969), p. 26.

16. Salvador Dali, "Els Meus quadros del Saló de Tardor," *L'Amic de les arts*, supplement to No. 19 (October 1927); reproduced in full in Brihuega, op. cit., pp. 126–128; excerpted in translation in Dawn Ades, *Dalí* (London, 1988), p. 46.

17. In an illuminating essay on Surrealist photography, Rosalind Krauss has argued that the "experience of *reality as representation*" is at the core of Surrealist thinking. I would argue, however, that Dali places his accent on the process itself through which reality is actively transformed or reconfigured as representation. See Rosalind E. Krauss, "The Photographic Conditions of Surrealism," in Krauss, *The Originality of the Avant-Garde and Other Modernist Myths* (Cambridge, Mass., 1986), pp. 87–118.

18. Dali to Miró, unpublished letter, archives of the Fundació Joan and Pilar Miró, Palma de Mallorca. Dali's comments seem to contradict Robert Descharnes's assertion that Dali had completed only one painting (*Cenicitas*, Collection Museo Español de Arte Contemporáneo, Madrid) in the nine months since he began military service in February 1927. Robert Descharnes, *Salvador Dali: The Work, The Man* (New York 1984), p. 53. In October of that year, Dali exhibited *Apparatus and Hand* and *La Mel és més dolça que la sang* (*Honey Is Sweeter than Blood*), in Barcelona's Saló de Tardor. It is likely that Dali's letter to Miró refers to at least one of these paintings.

19. In a letter to Miró of March 2, 1929, Dali asked his friend's advice about a possible Paris exhibition of his work. Shortly afterward, Dali's father wrote to Miró on May 17, 1929, thanking him for his part in helping Dali secure a contract with Goemans. Archives of the Fundació Miró, Palma de Mallorca. Dali's exhibition at the Goemans Gallery ran from November 20 to December 5, 1929.

20. For a discussion and analysis, see Jaime Brihuega, *Las Vanguardias artísticas en España, 1909–1936* (Madrid, 1981); Enric Jardí, *Els Moviments d'avantguarda a Barcelona* (Barcelona, 1983); Robert S. Lubar, "Joan Miró Before *The Farm*, 1915–1922: Catalan Nationalism and the Avant-Garde," unpublished Ph.D. thesis, Institute of Fine Arts, New York University (October 1988); and Joaquim Molas, ed., *La Literatura Catalana d'avantguarda: 1916–1938* (Barcelona, 1981).

21. In "Per al 'meeting' de Sitges," *L'Amic de les arts* No. 25 (May 31, 1928), Dali continued this discourse, stating: "The Parthenon was not built in ruins. The Parthenon was created new and without patinas, just like our automobiles. Let us not indefinitely carry the cadaver of our father upon our shoulders, no matter how much we love him." Demanding the suppression of all that is regional, typical, and local in Catalan culture and society, Dali concluded his remarks with his estimation of artists "as obstacles to civilization."

22. Salvador Dali, "Poesia de l'útil standarditzat," *L'Amic de les arts* No. 23 (March 31, 1928). In contrast, Dali vehemently denounced advertisements that, in assimilating visual strategies from the world of high culture, have been "infected by all the germs of artistic decay."

23. Undoubtedly, Dali was familiar with Picabia's work. Several of Picabia's machine drawings were reproduced in the first four issues of his journal *391*, which he published in Barcelona between January and March 1917. Additional machine drawings and paintings were exhibited from November 18 to December 8, 1922, at the Galeries Dalmau

in Barcelona, where Picabia celebrated a one-man show. Three years later, Josep Dalmau mounted Dali's first one-man exhibition.

24. Two versions of this painting exist, one of which is in the Collection of the Salvador Dali Museum (cat. no. 30). Owing to an error in the translation of the Catalan word *platja* (''beach''), the title *Big Thumb, Plate, Moon, and Decaying Bird*, by which this painting is identified in an earlier catalog of the Salvador Dali Museum, is incorrect.

25. See Rafael Santos i Torroella's detailed account of the incident in ''Salvador Dali i el Saló de Tardor,'' Discurs d'ingrés de la Reial Acadèmia Catalana de Belles Arts de Sant Jordi, February 27, 1985. Santos i Torroella notes that the painting currently known as *Unsatisfied Desires* was originally titled *Diàleg a la platja*.
 Dali treated the theme of onanism repeatedly in paintings of 1928 and 1929, including two works of 1928 entitled *Bather* (cat. nos. 27 and 28).

26. Salvador Dali, *Declaration of the Independence of the Imagination and the Rights of Man to His Own Madness* (New York, 1939).

27. Salvador Dali, ''Art Català relacionat amb el més recent de la jove intel.ligència,'' *La Revista* XIX, No. 2 (1928), pp. 111–117; in Molas, op. cit., pp. 337–344.

28. *L'Amic de les arts*, IV, No. 31 (March 31, 1929).

29. ''Revista de tendències anti-artístiques: Imaginació sense fil,'' *L'Amic de les arts*, IV, No. 31 (March 31, 1929).

30. Salvador Dali, ''Posició moral del Surrealisme,'' lecture delivered at the Ateneu Barcelonès, Barcelona, on March 22, 1930. Originally published in *Hèlix* No. 10 (1930), pp. 4–6; reprinted in Molas, op. cit., pp. 364–368.

31. ''L'Ane pourri,'' *Le Surréalisme au service de la révolution* No. 1 (July 1930), pp. 9–12. Reprinted in Salvador Dali, *La Femme visible* (Paris, 1930). See Eleanor

R. Morse's translation of this important essay in Louis Pauwels and Salvador Dali, *The Passions According to Dali* (St. Petersburg, 1985), pp. 209–214.

32. Ibid., pp. 209–210.

33. André Breton, ''The Dali 'Case' '' (1936); in André Breton, *Surrealism and Painting* (New York, 1972), pp. 130–135.

34. Cited by William S. Rubin, *Dada and Surrealist Art* (New York, 1969), p. 216.

35. Breton, ''The Dali 'Case,' '' p. 133.

36. Salvador Dali, ''De la Beauté Terrifiante Comestible, de l'Architecture Modern Style,'' *Minotaure* Nos. 3–4 (December 12, 1933), pp. 69–76; as translated in Dali, *Dali on Modern Art*, pp. 31–45.

37. Dali, *The Conquest of the Irrational* (New York, 1935), p. 19.

38. Ibid., p. 12.

39. Ibid., p. 17.

40. Salvador Dali, ''Dali, Dali!''

41. Salvador Dali, ''Communication: Visage paranoïaque,'' *Le Surréalisme au service de la révolution* No. 3 (1931), p. 40.

42. Ibid. Translation by Mrs. A. Reynolds Morse; archives of the Salvador Dali Museum.

43. Salvador Dali, ''Total Camouflage for Total War,'' *Esquire* (August 1942), pp. 65–66, 130.

The Salvador Dali Museum Collection

Paintings

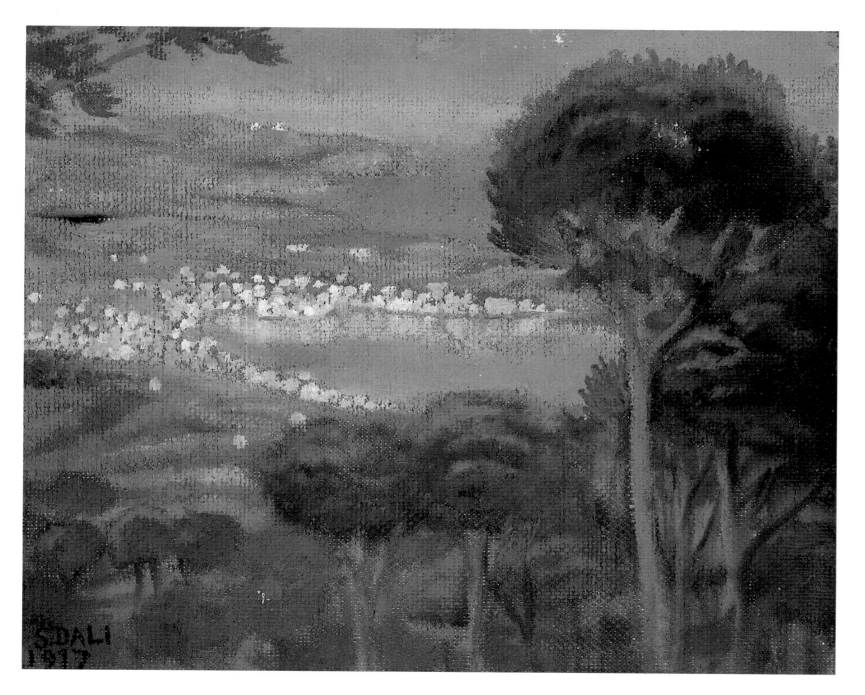

1. *View of Cadaques with Shadow of Mount Pani* (1917)

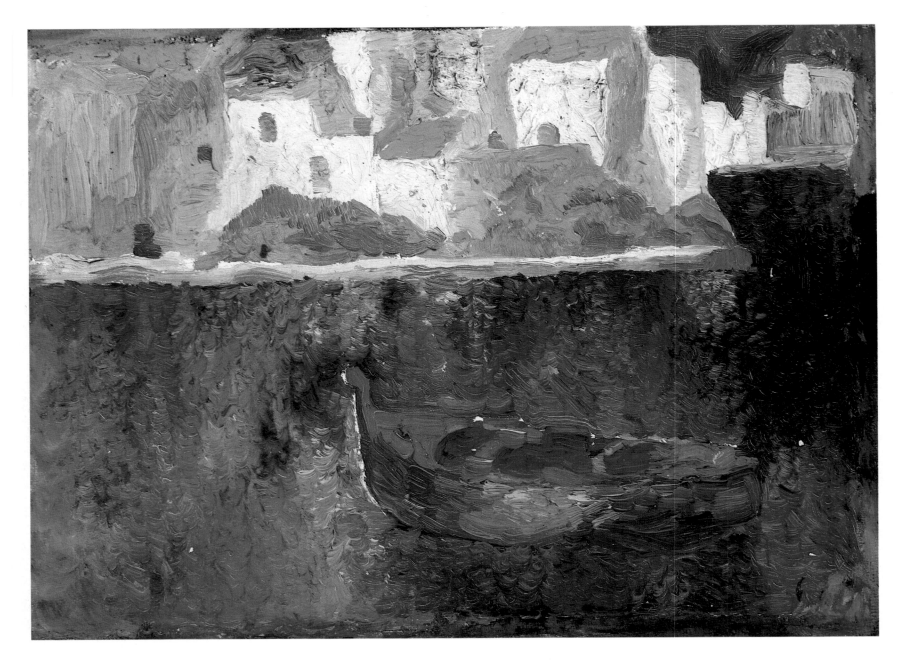

2. *Punta es Baluard from Riba d'en Pitxot, Cadaques* (1918–19)

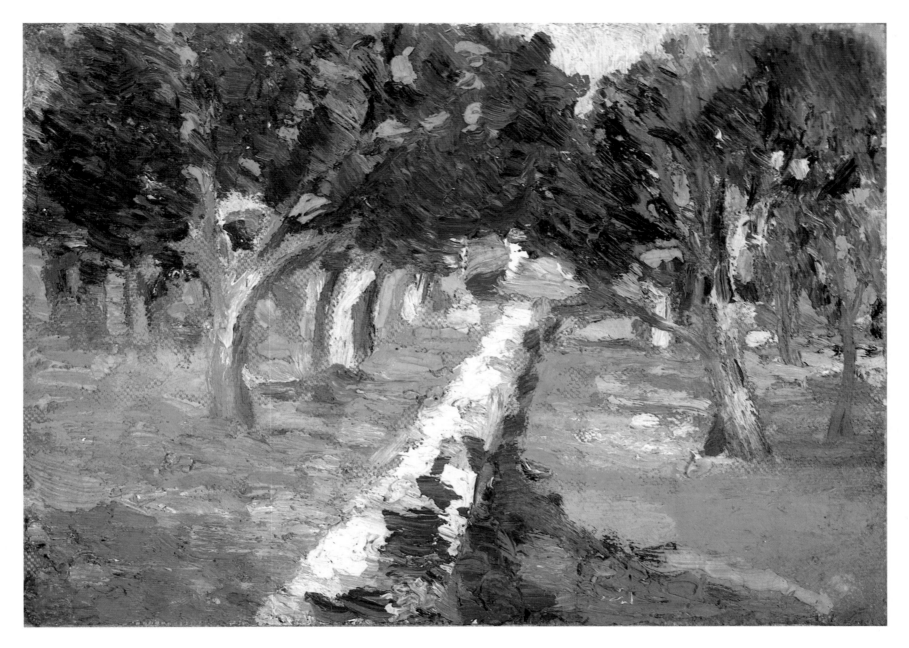

3. *Hort del Llane, Cadaques* (1918–19)

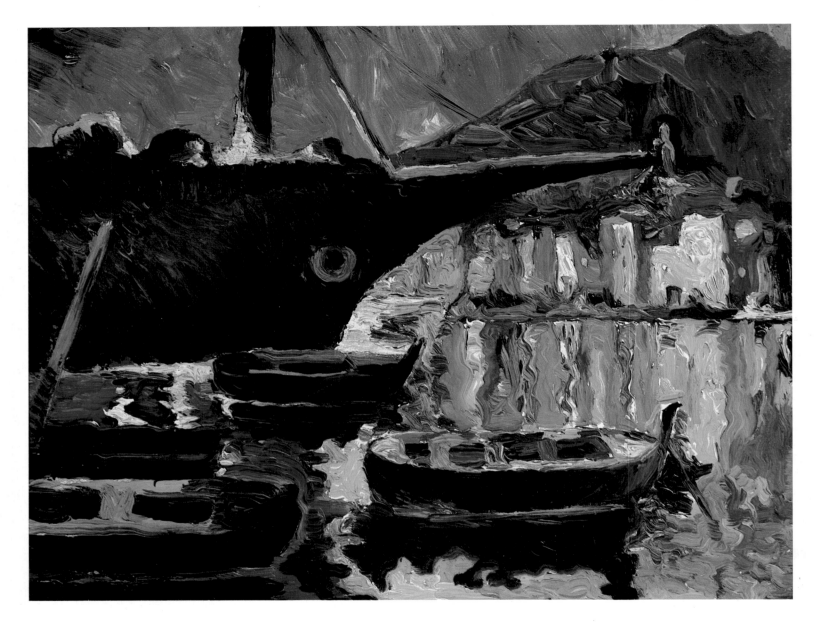

4. *Port of Cadaques (Night)* (1918–19)

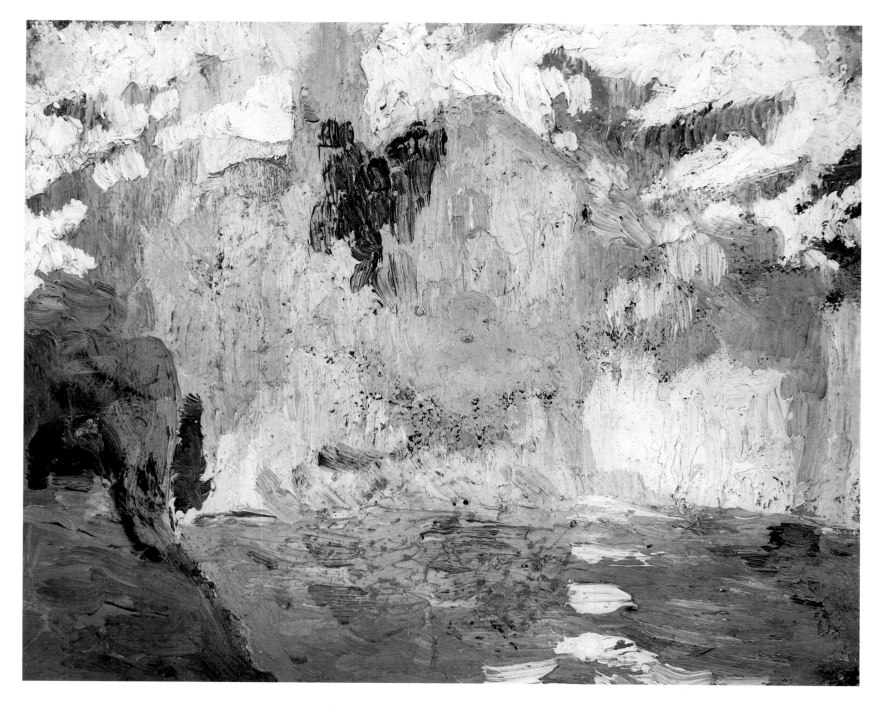

5. *Playa Port Alguer from Riba d'en Pitxot* (1918–19)

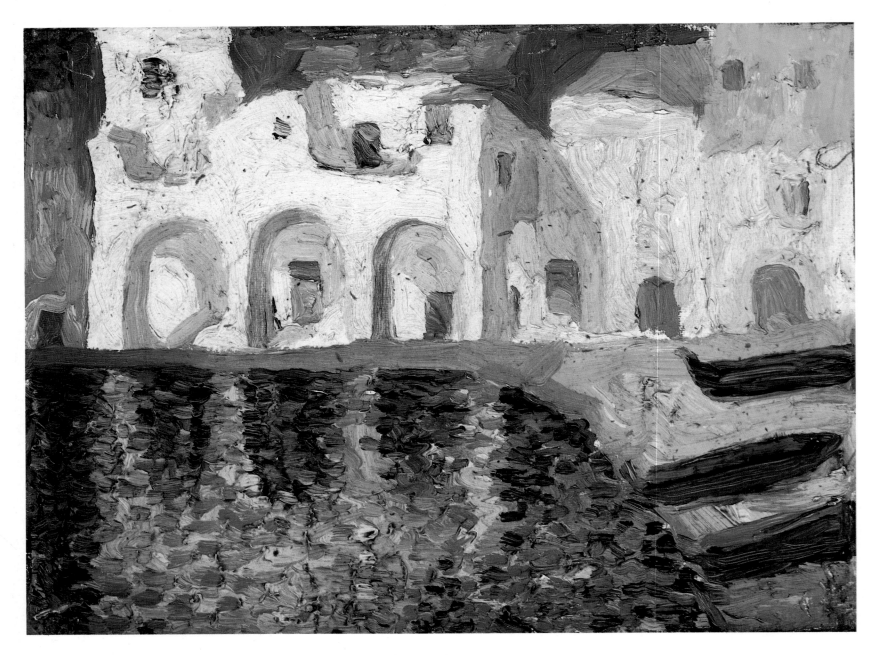

6. *Portdogué, Cadaques* (1918–19)

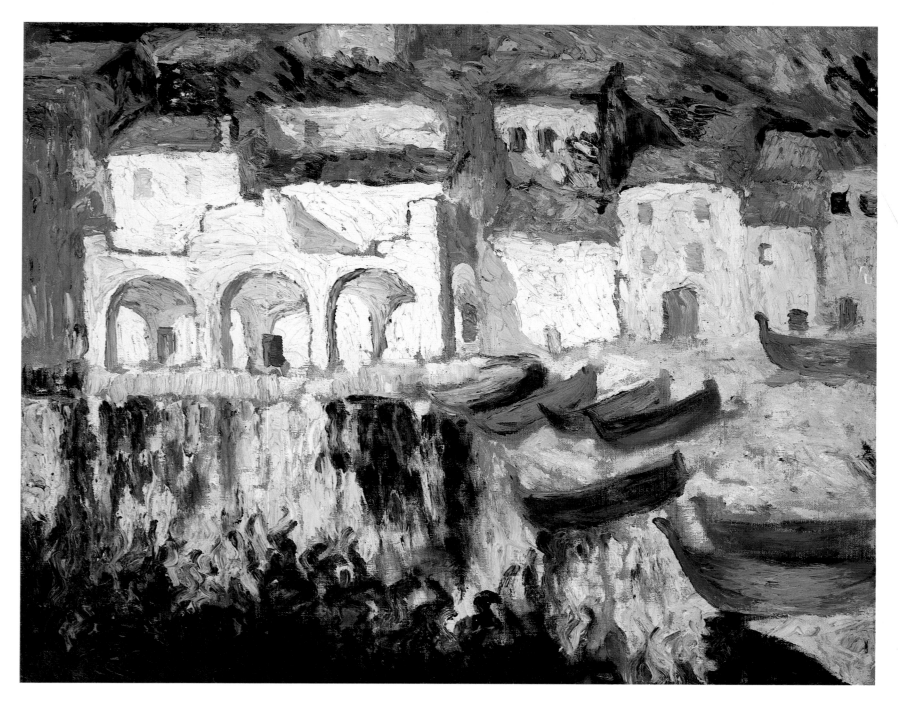

7. *View of Portdogué (Port Alguer), Cadaques* (1920)

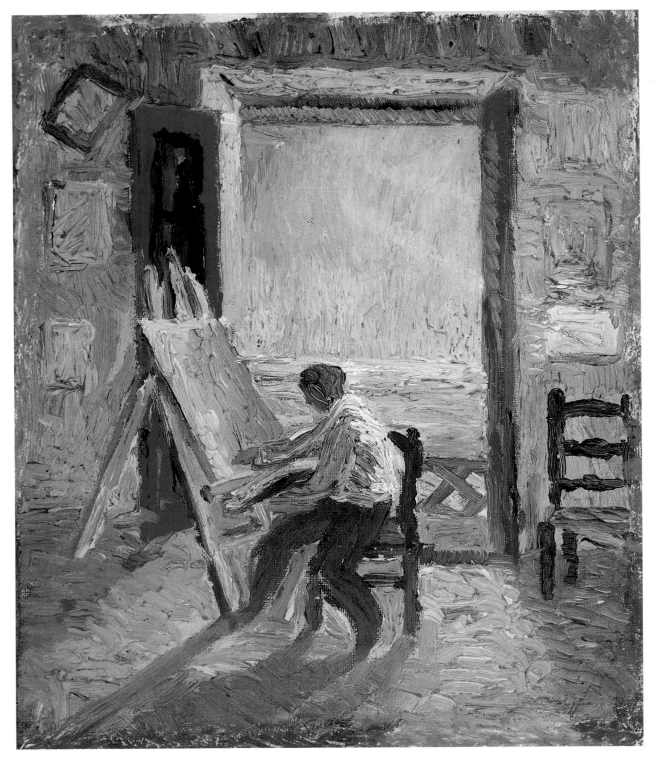

8. *Self-portrait* (1918–19)

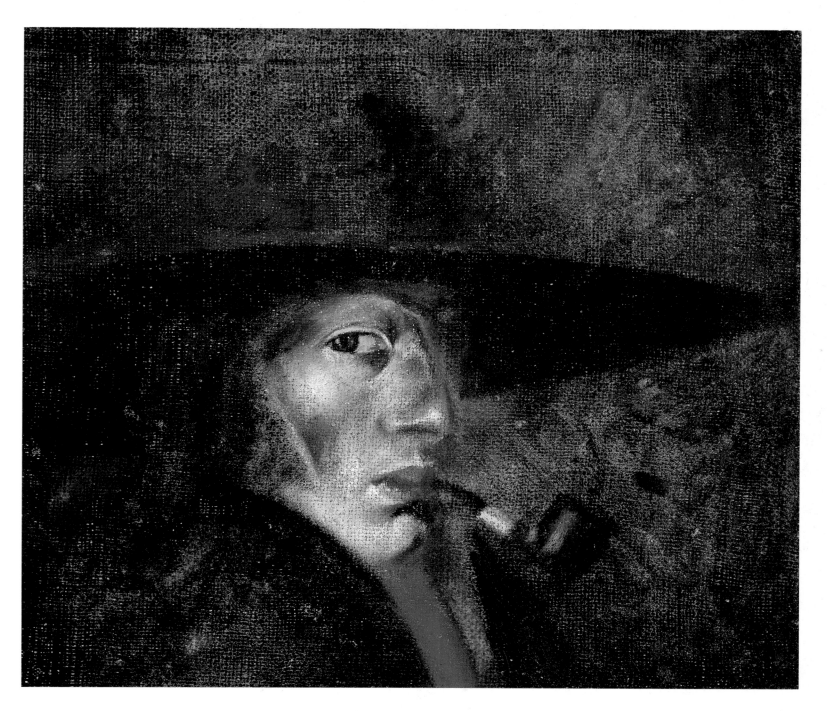

9. *Self-portrait (Figueres)* (1921)

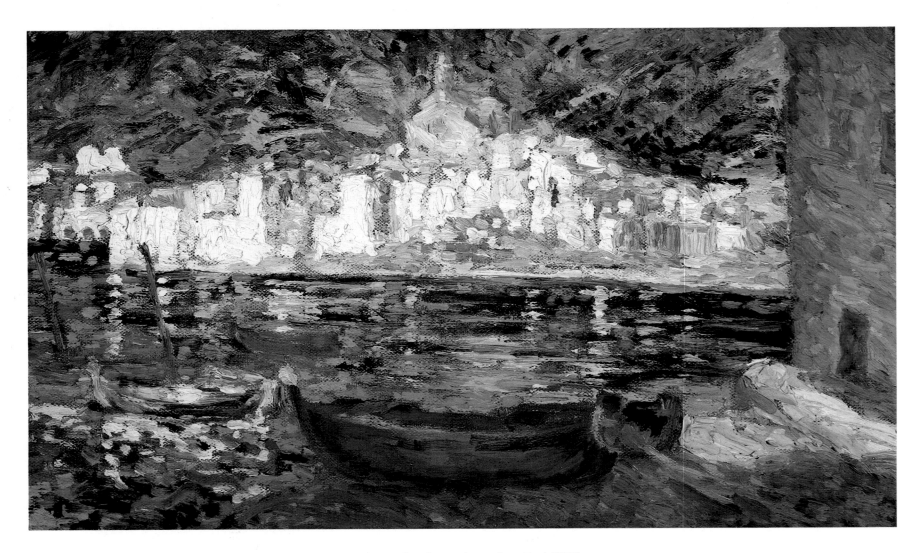

10. *View of Cadaques from Playa Poal* (1920)

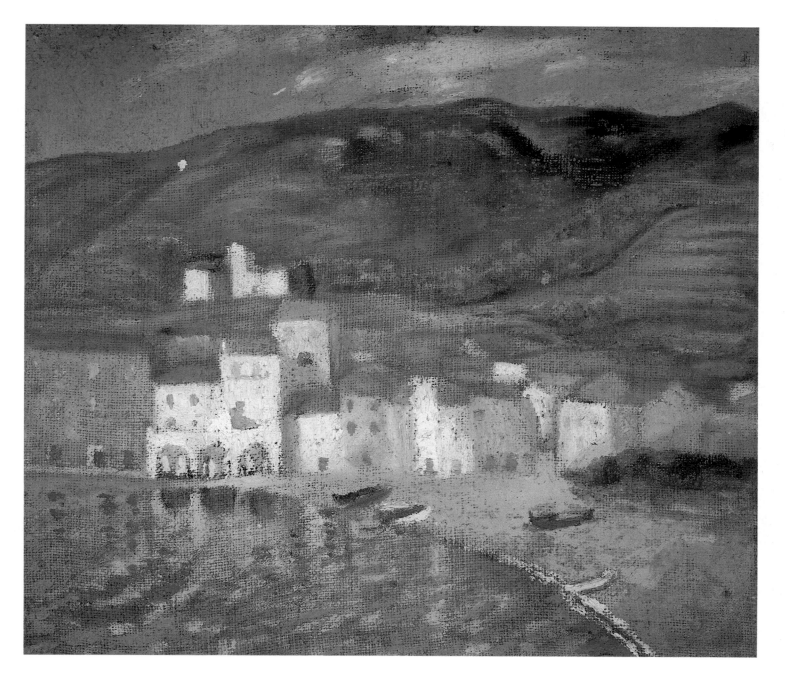

11. *Portdogué and Mount Pani from Ayuntamiento* (1922)

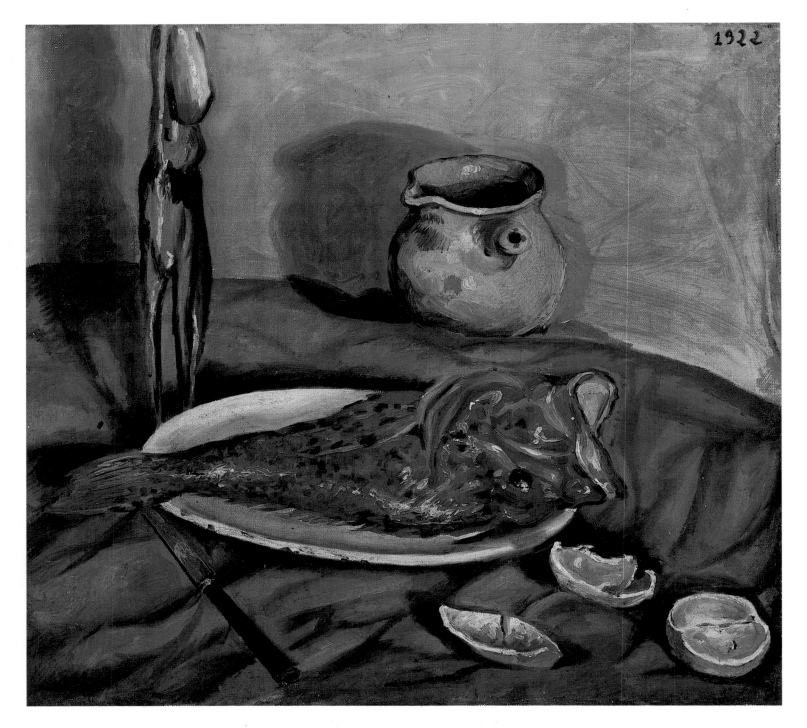

12. *Still Life: Pulpo y Scorpa* (1922)

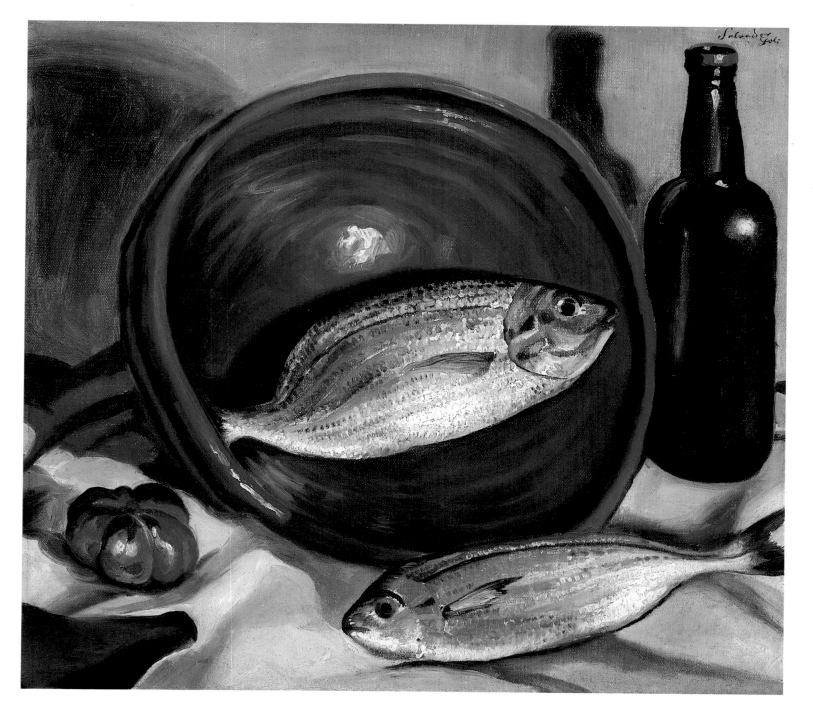

13. *Still Life: Fish with Red Bowl* (1923–24)

14. *The Lane to Port Lligat with View of Cape Creus (1922–23)*

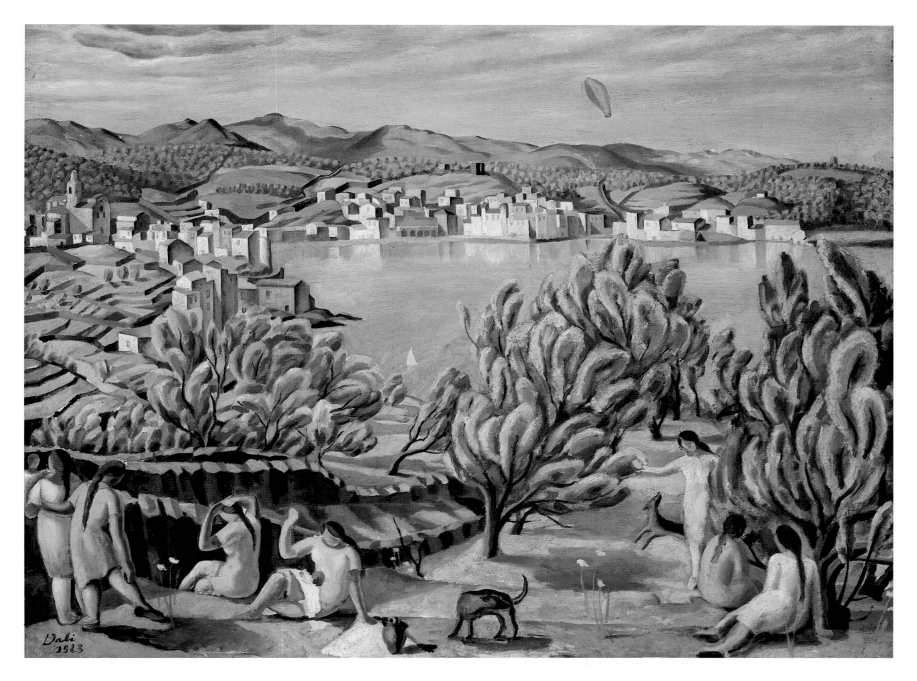

15. *Cadaques* (1923)

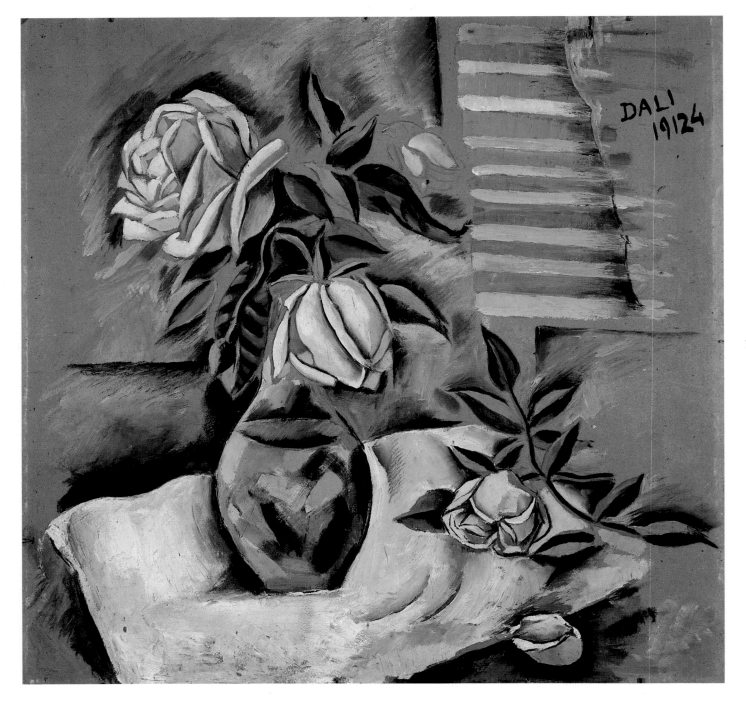

16. *Bouquet (L'Important c'est la rose)* (1924)

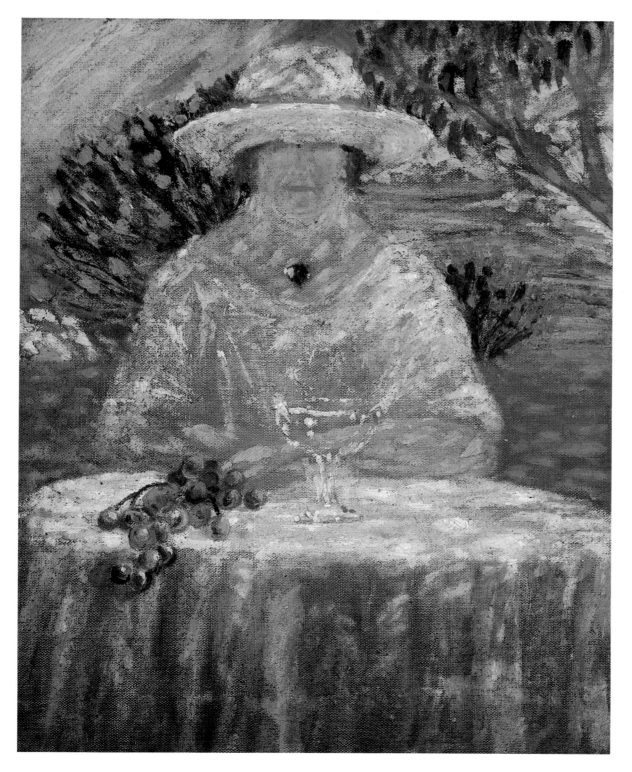

17. *Tieta, "Portrait of My Aunt," Cadaques* (1923–24)

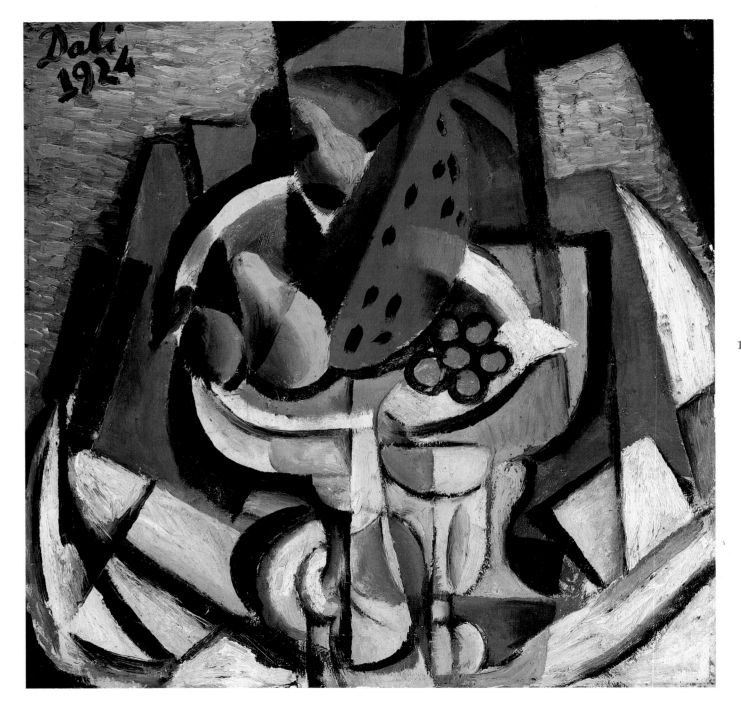

18. *Still Life: Sandia* (1924)

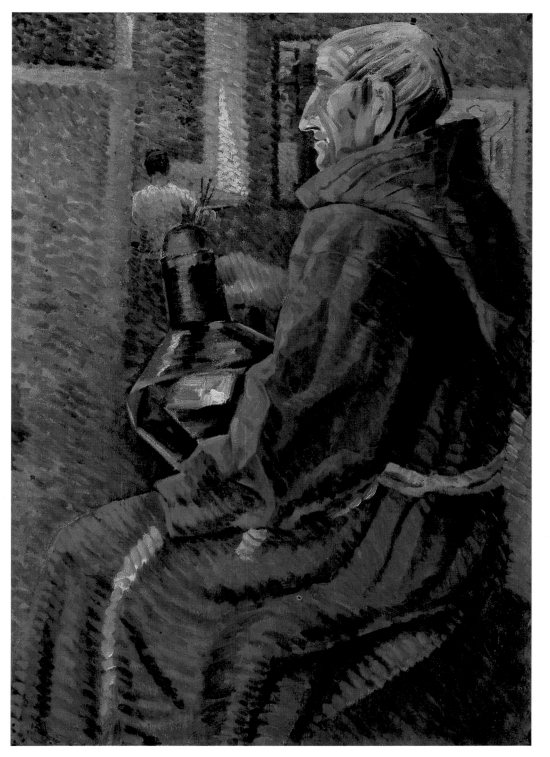

19. *Seated Monk* (1925)

20. *(Double-sided Verso "Studio Scene")*

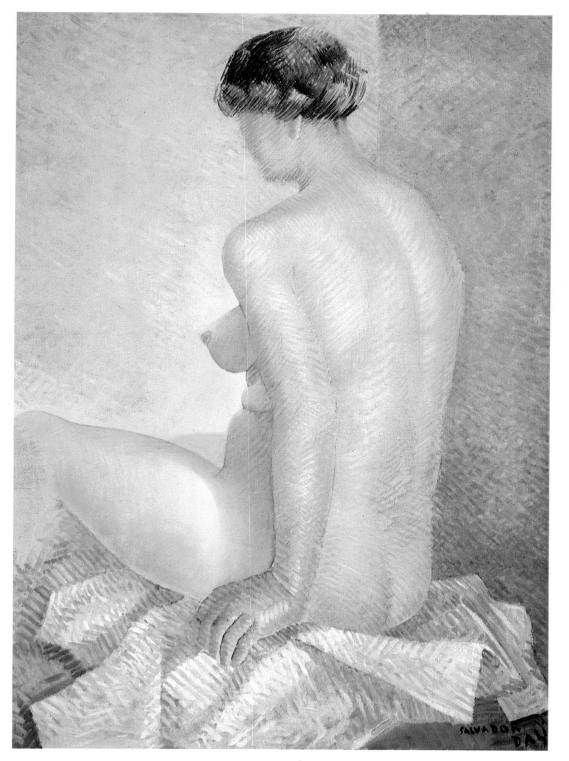

21. *Study of a Nude* (1925)

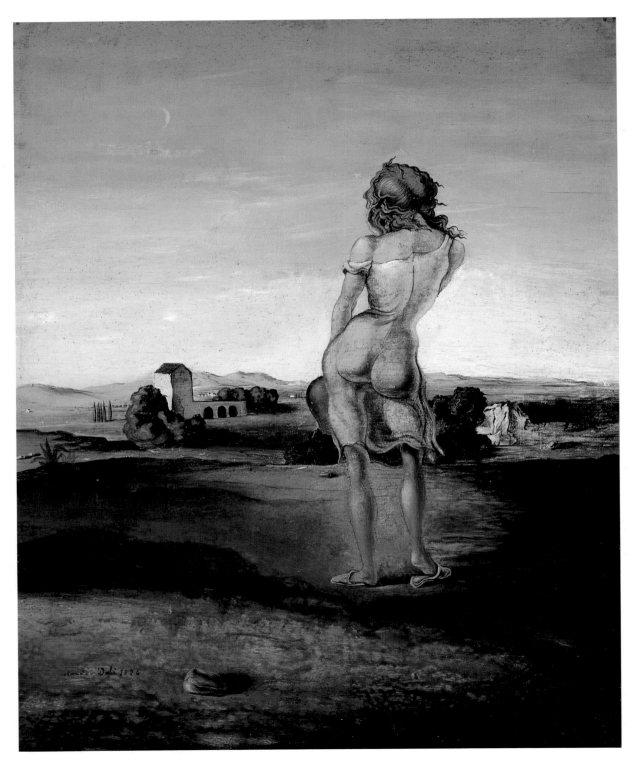

22. *Girl with Curls* (1926)

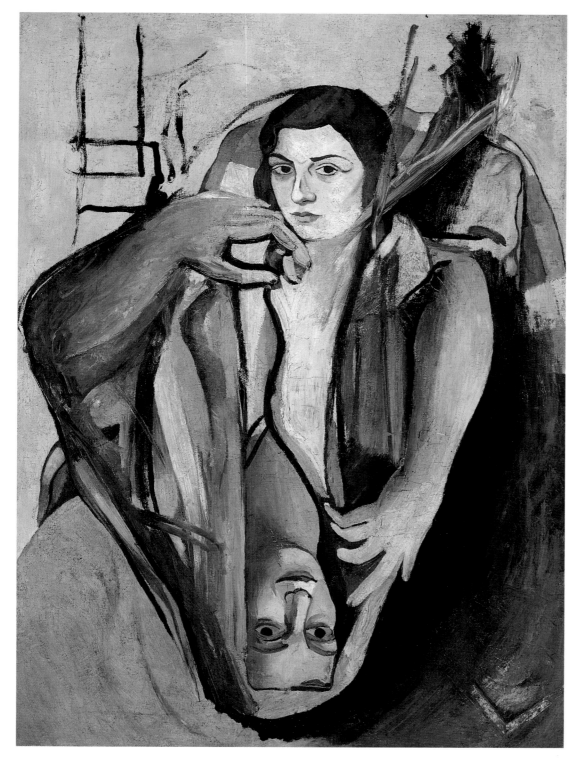

23. *Portrait of My Sister* (1923)

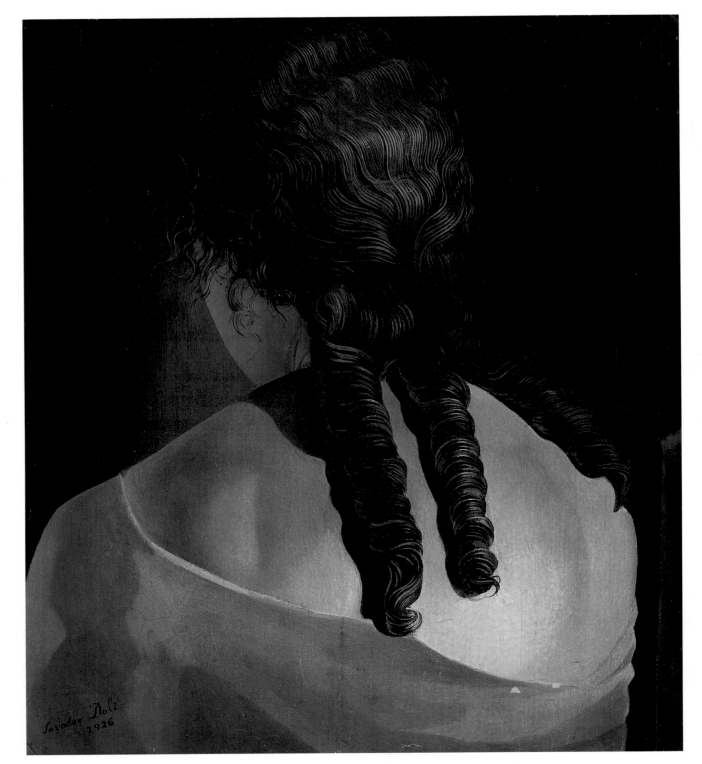

24. *Girl's Back* (1926)

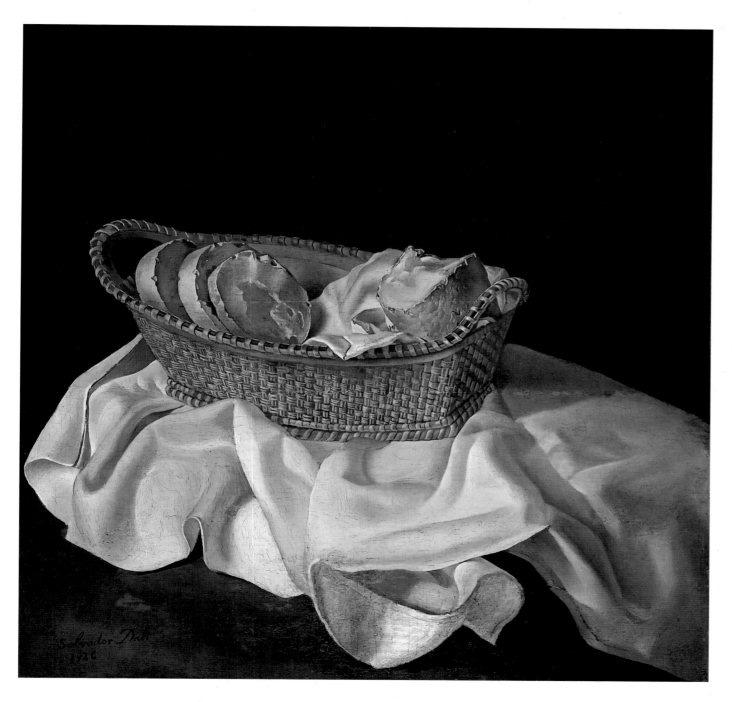

25. *The Basket of Bread* (1926)

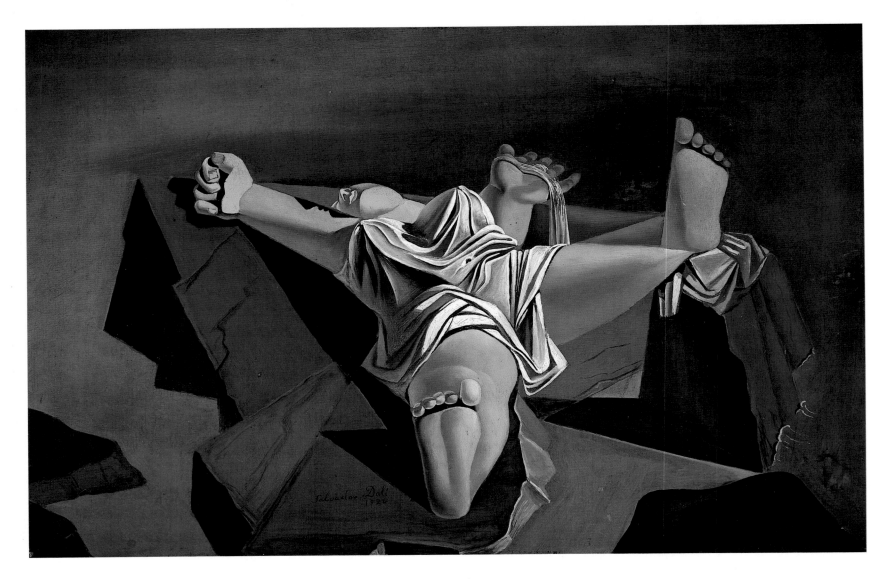

26. *Femme Couchée* (1926)

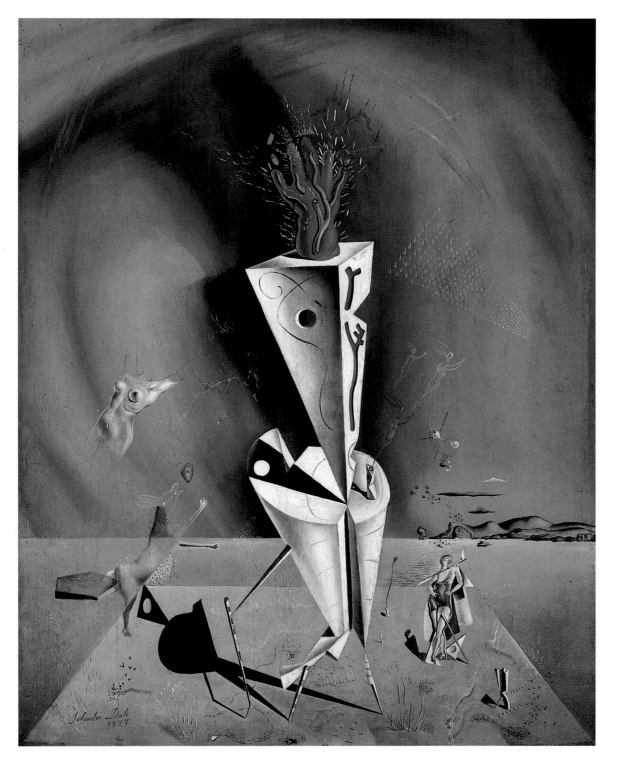

27. *Apparatus and Hand* (1927)

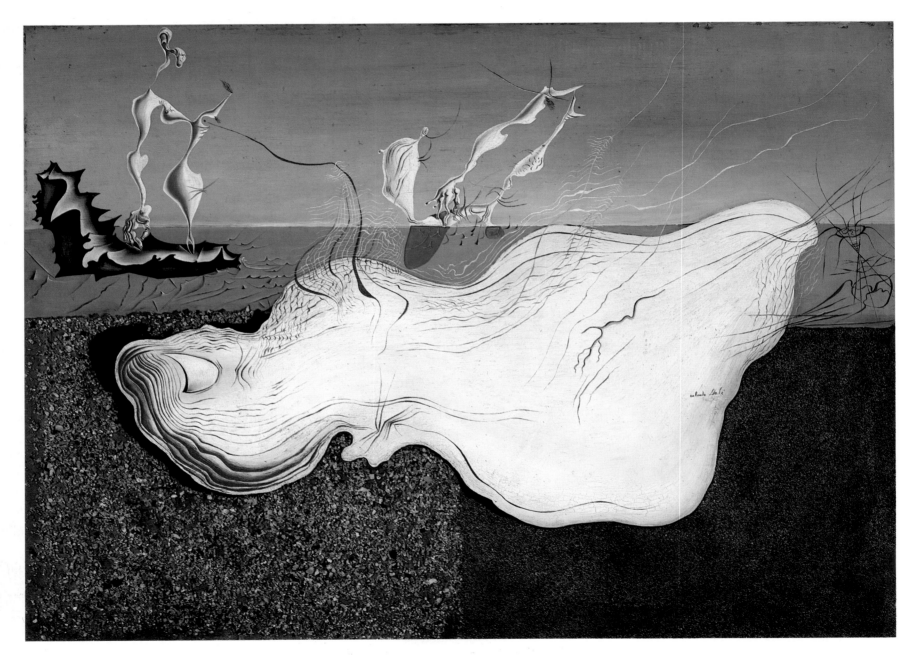

28. *The Bather* (1928)

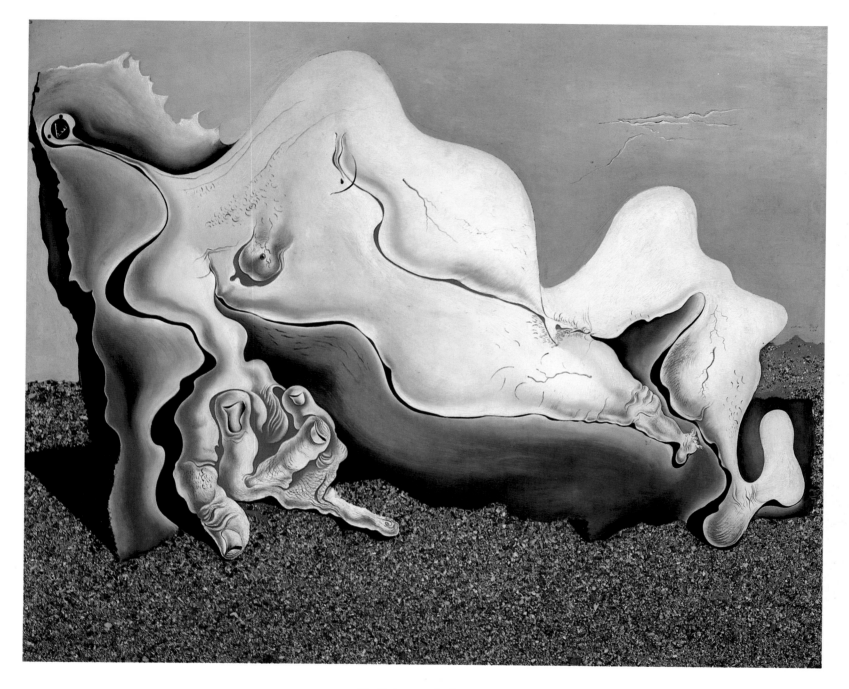

29. *Beigneuse* [sic] (1928)

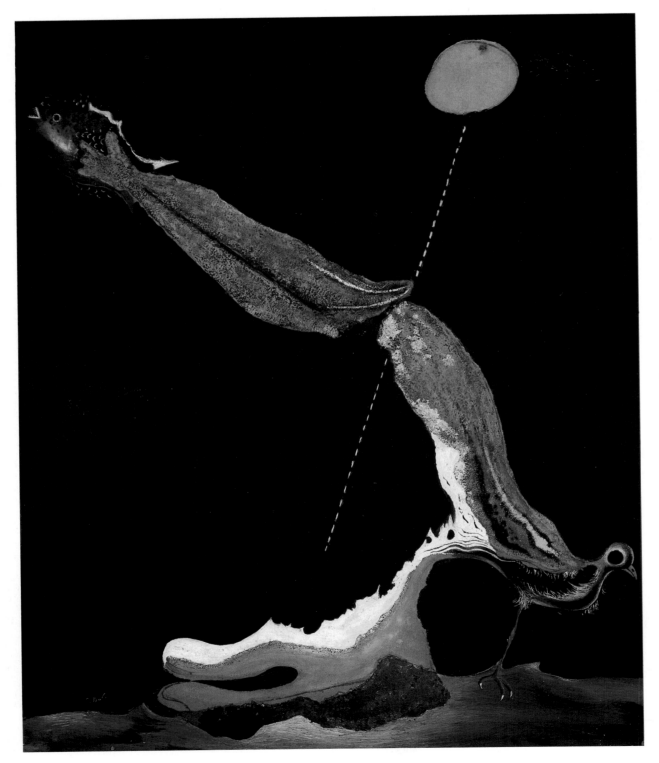

30. *Ocell . . . Peix* (1927–28)

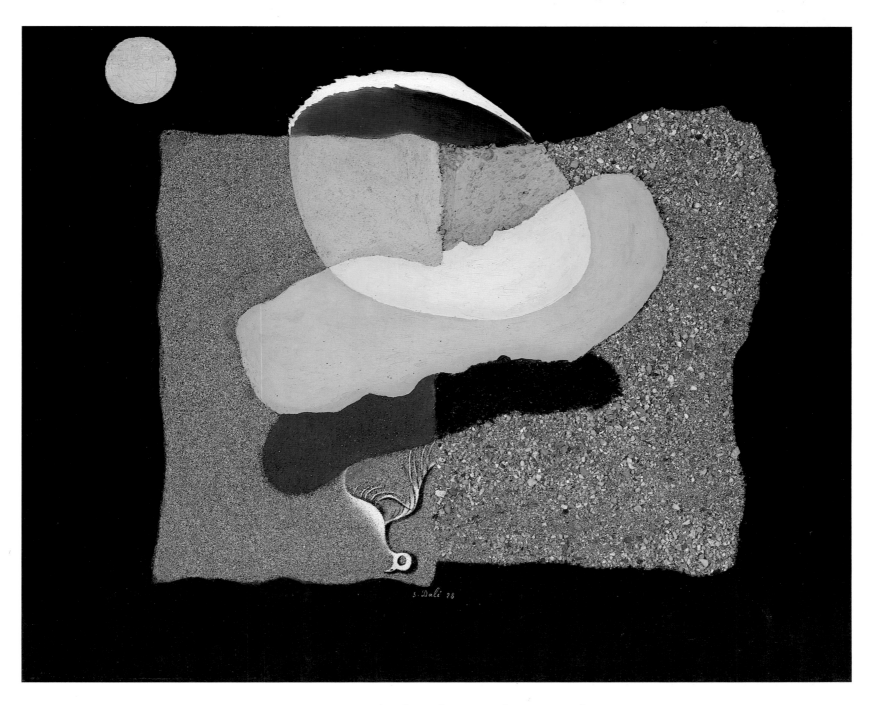

31. *Dit Gros etc. (Big Thumb, Beach, Moon and Decaying Bird)* (1928)

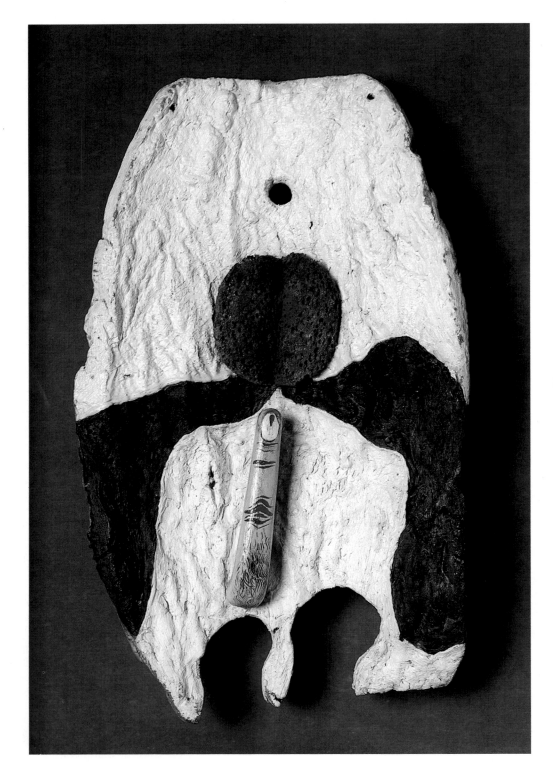

32. *Anthropomorphic Beach* (fragment) (1928)

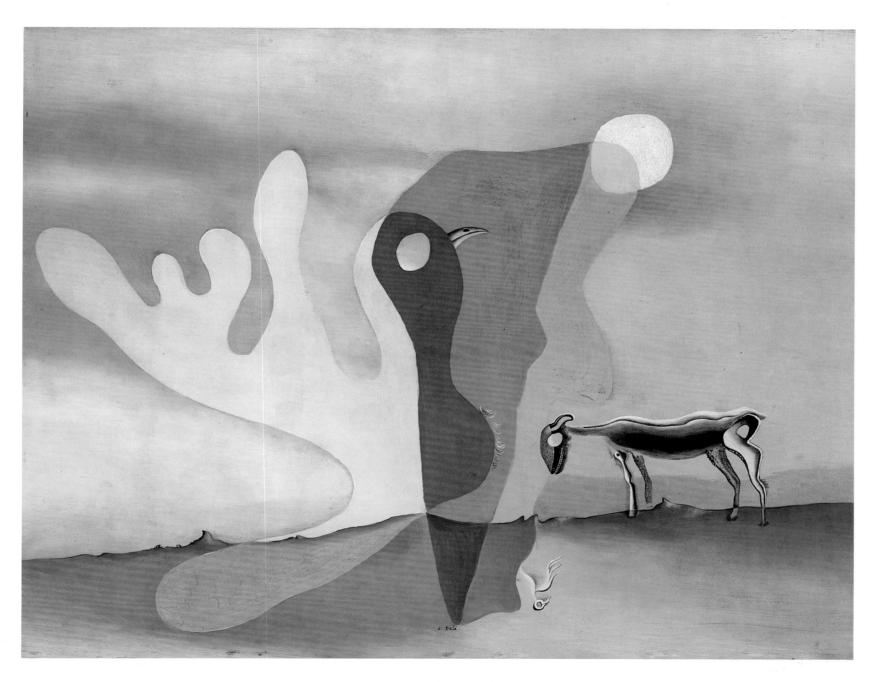

33. *The Ram (Vache Spectrale)* (1928)

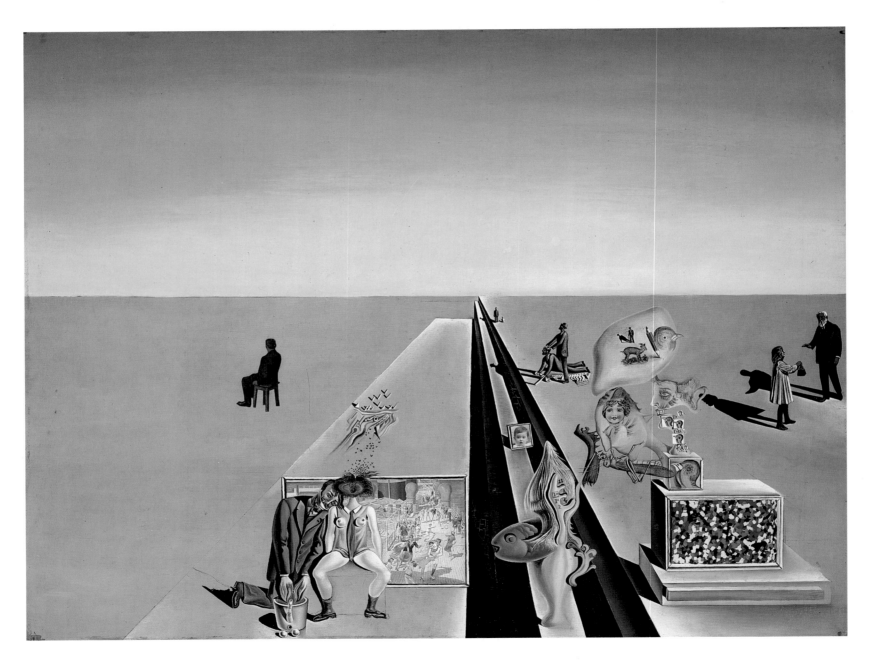

34. *The First Days of Spring* (1929)

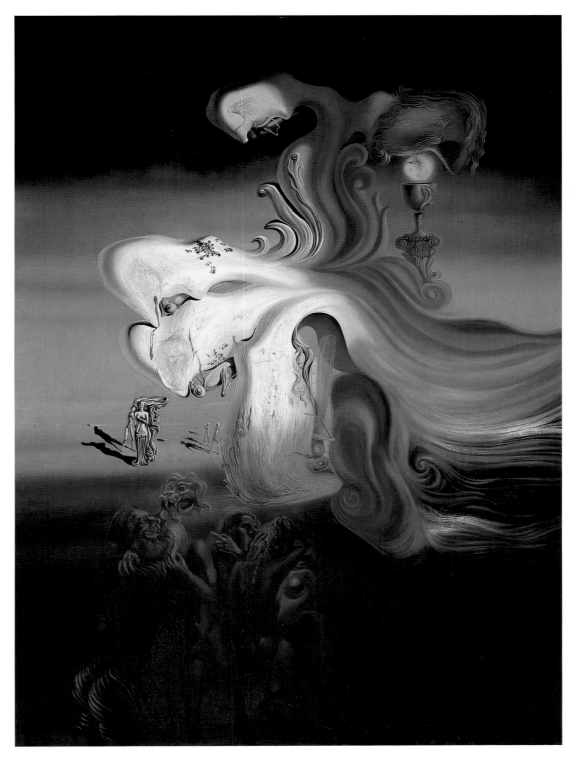

35. *Profanation of the Host* (1929)

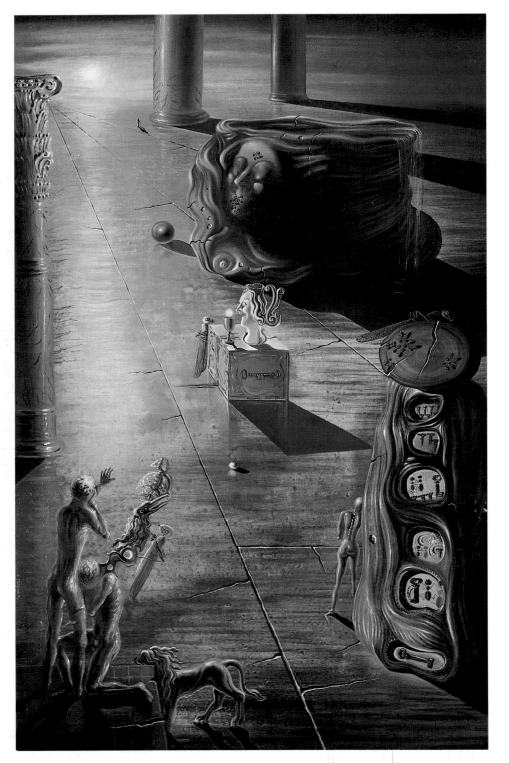

36. *The Font* (1930)

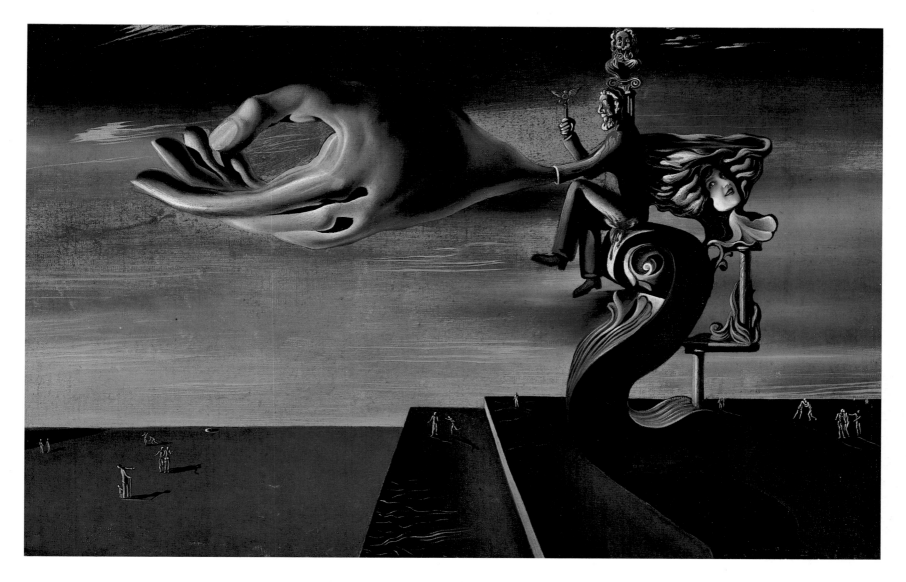

37. *La Main (Les Remords de conscience)* (1930)

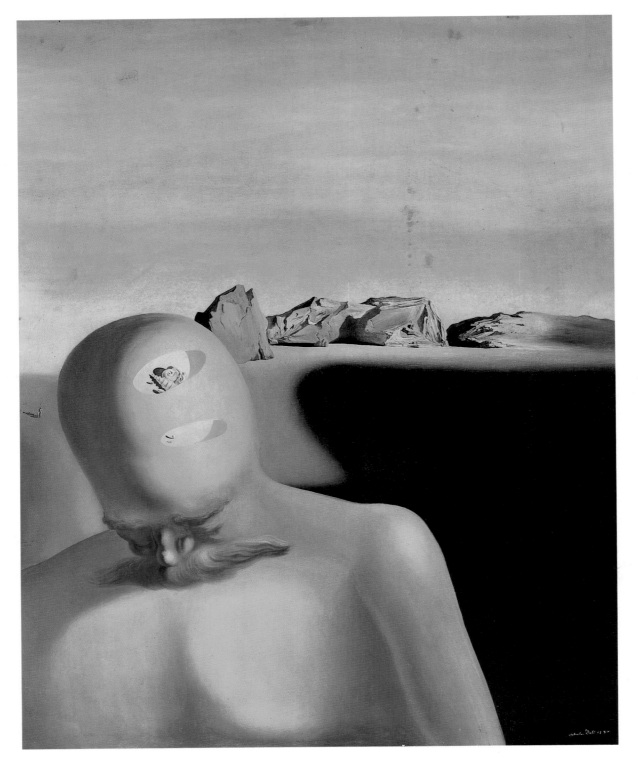

38. *The Average Bureaucrat* (1930)

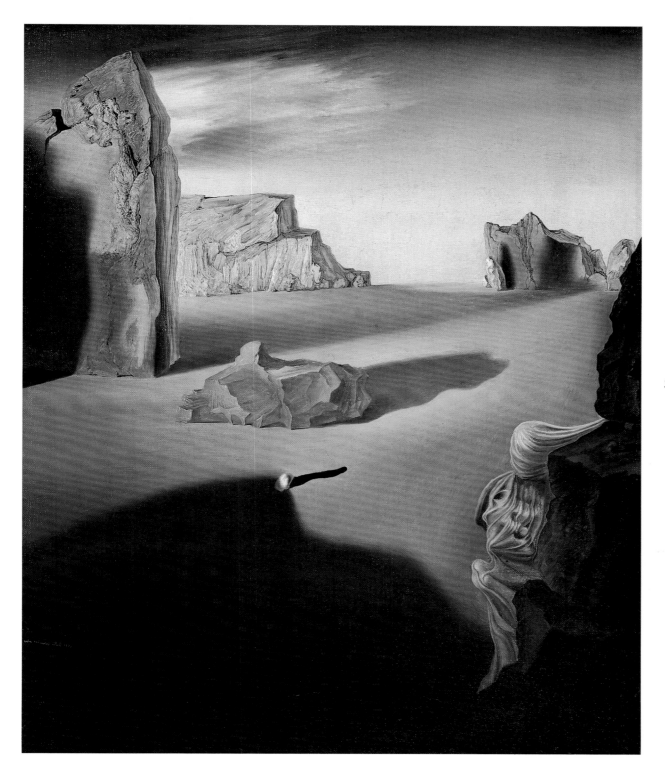

39. *Shades of Night Descending* (1931)

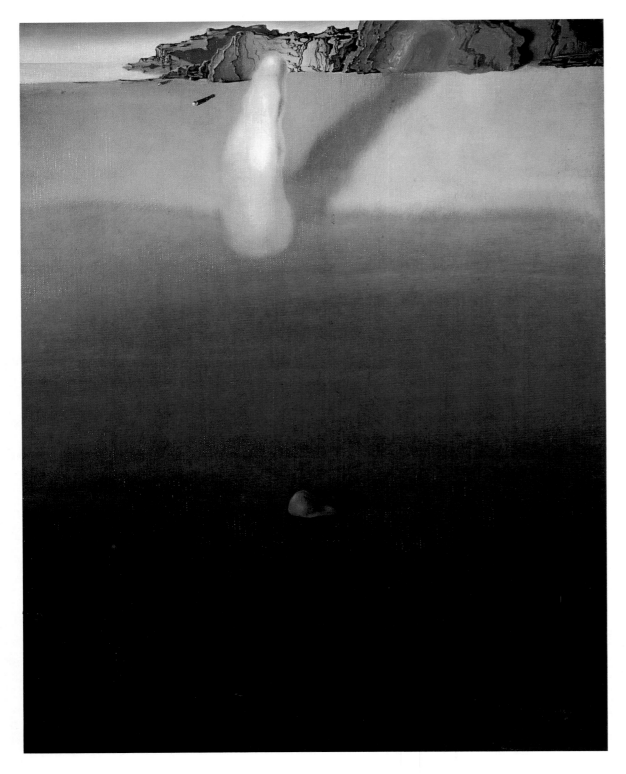

40. *Au Bord de la Mer* (1931)

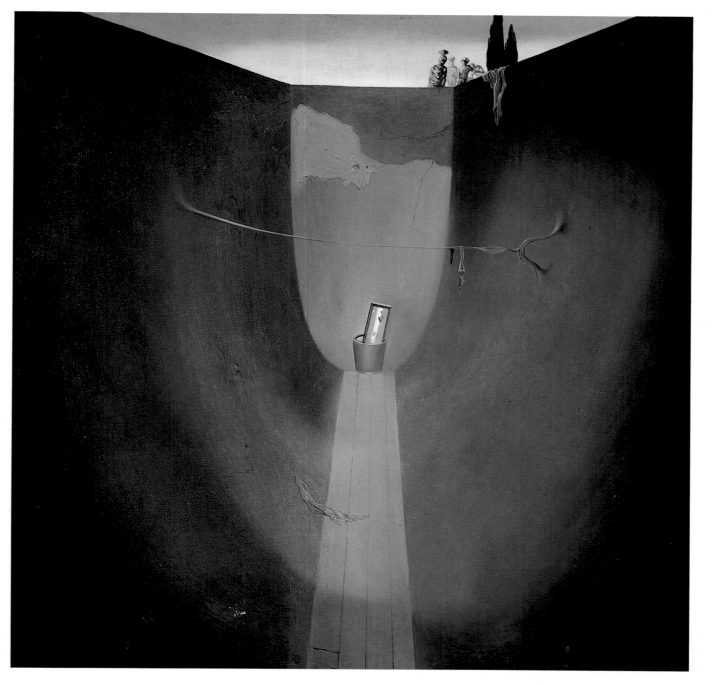

41. *Suez* (1932)

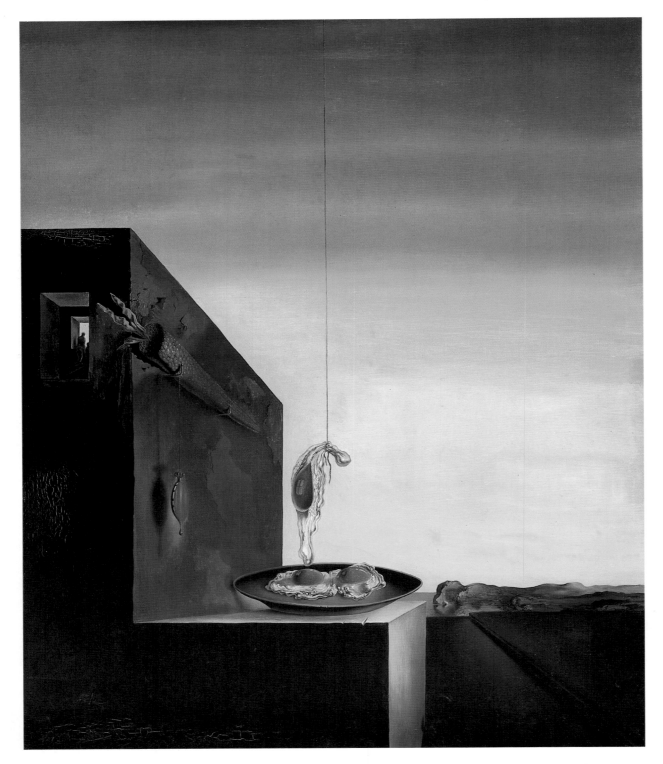

42. *Oeufs sur le Plat sans le Plat* (1932)

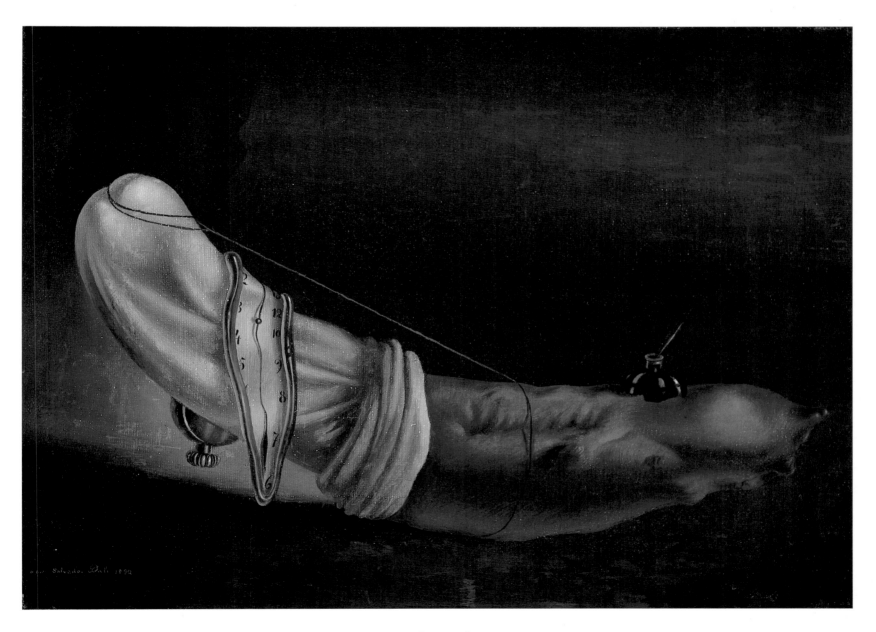

43. *Catalan Bread* (1932)

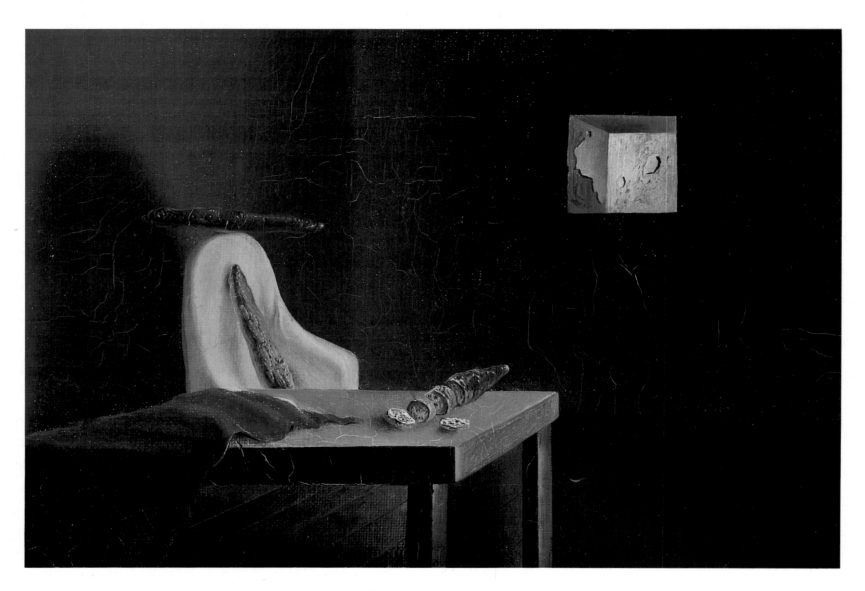

44. *The Invisible Man* (1932)

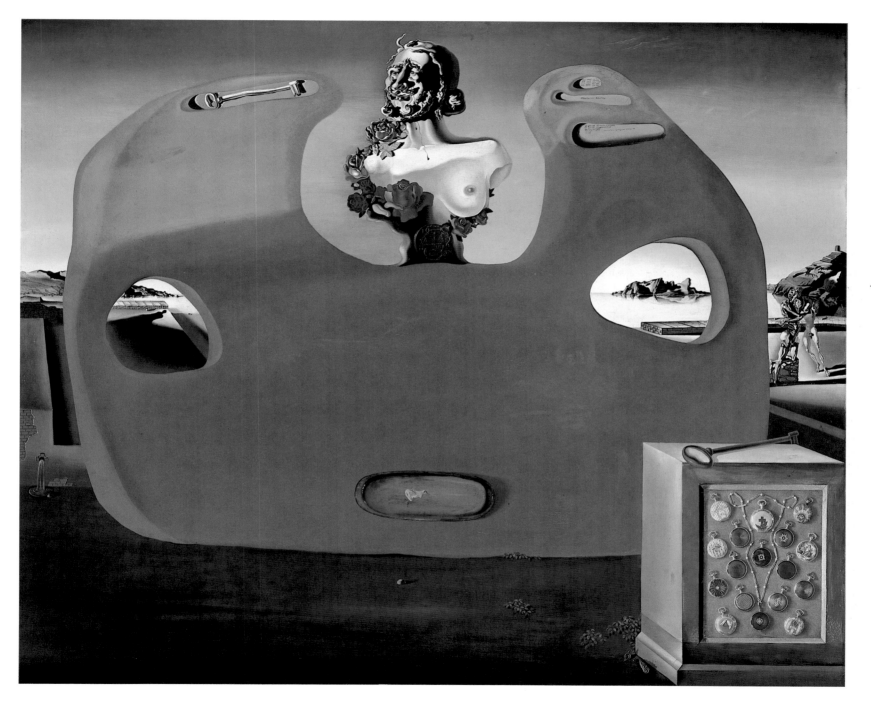

45. *Memory of the Child-Woman* (1932)

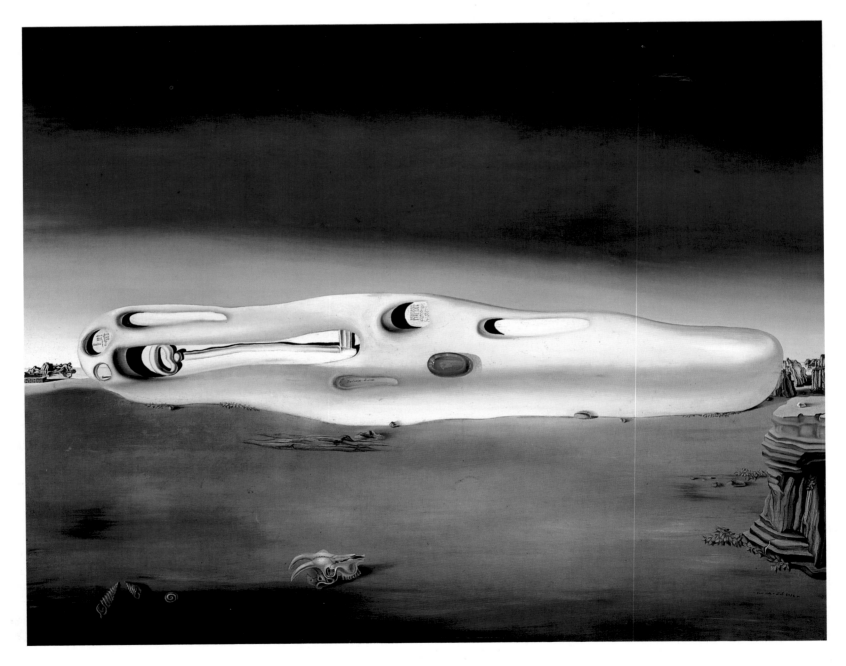

46. *Fantasies Diurnes* (1932)

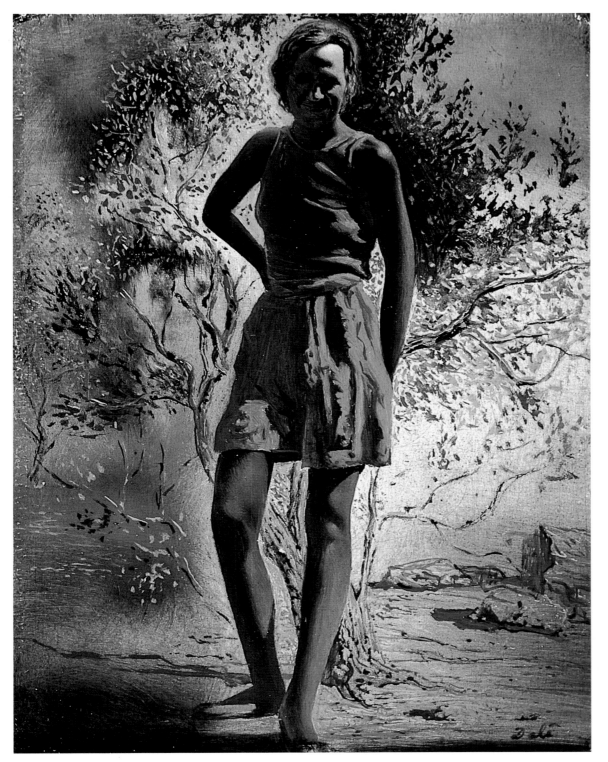

47. *Portrait of Gala* (1932–33)

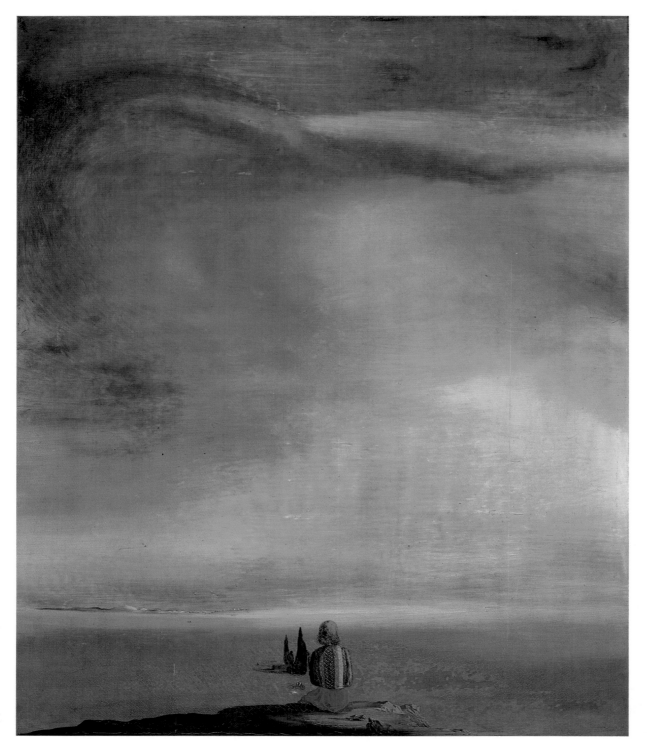

48. *Sugar Sphinx* (1933)

49. *Untitled (Persistence of Fair Weather)* (1932–34)

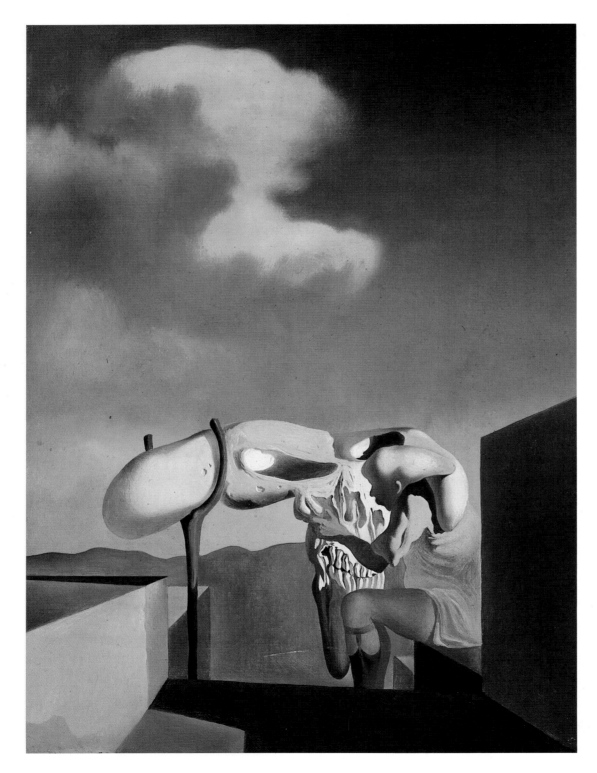

50. *Average Atmospherocephalic Bureaucrat in the Act of Milking a Cranial Harp* (1933)

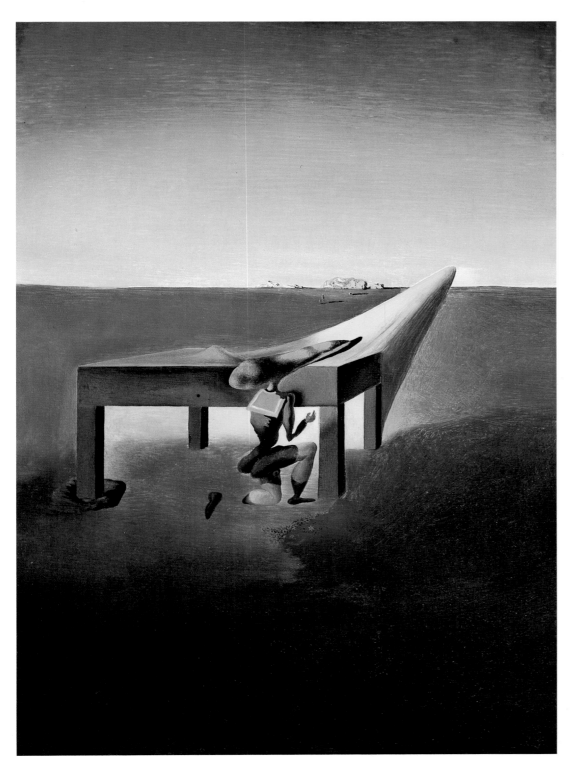

51. *Myself at the Age of Ten When I Was the Grasshopper Child* (1933)

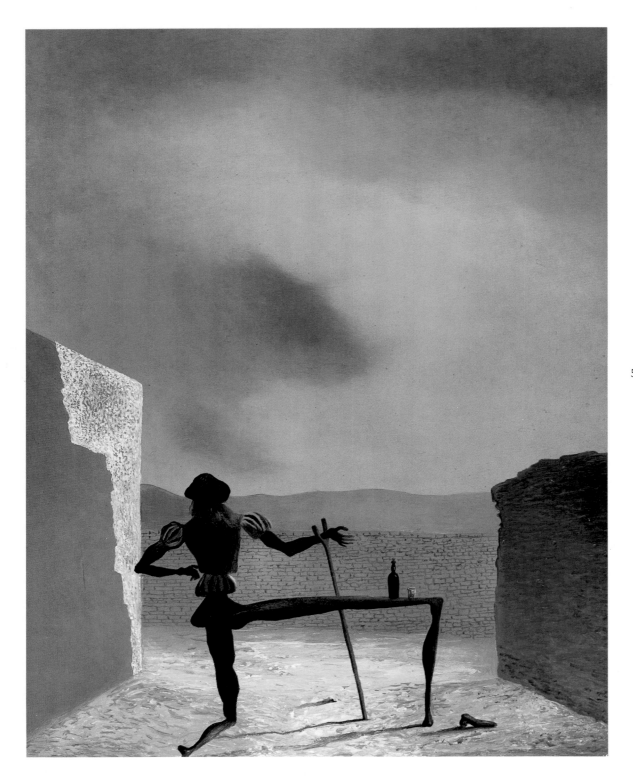

52. *The Ghost of Vermeer of Delft Which Can Be Used as a Table* (1934)

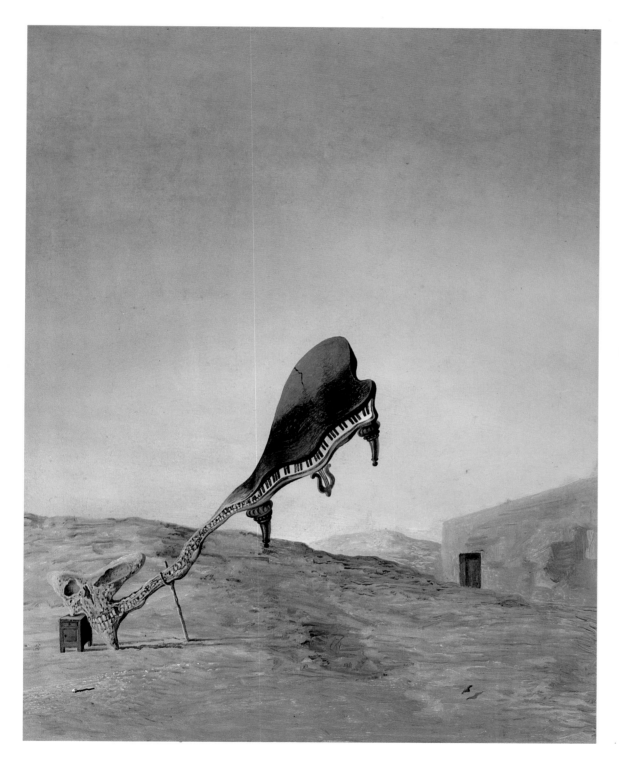

53. *Skull with Its Lyric Appendage Leaning on a Night Table Which Should Have the Exact Temperature of a Cardinal Bird's Nest* (1934)

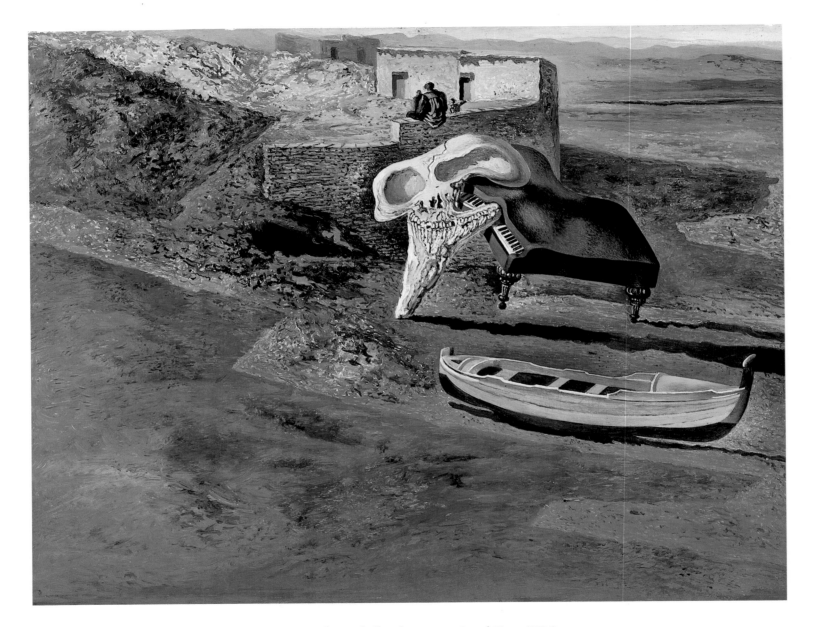

54. *Atmospheric Skull Sodomizing a Grand Piano* (1934)

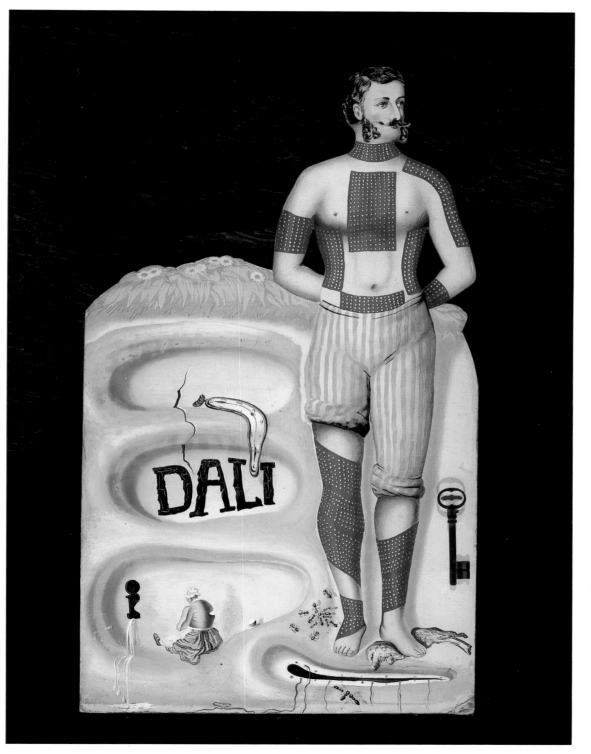

55. *Surrealist Poster* (1934)

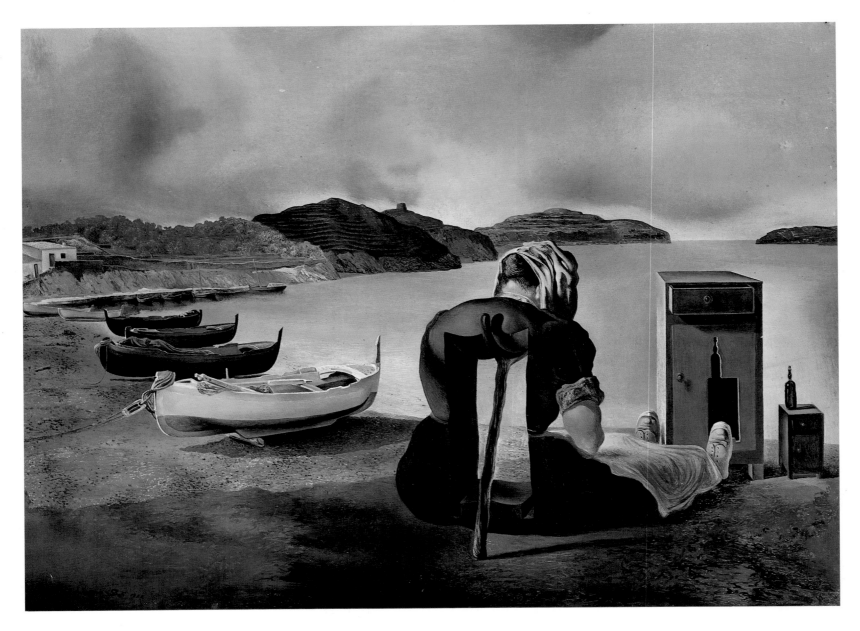

56. *The Weaning of Furniture-Nutrition* (1934)

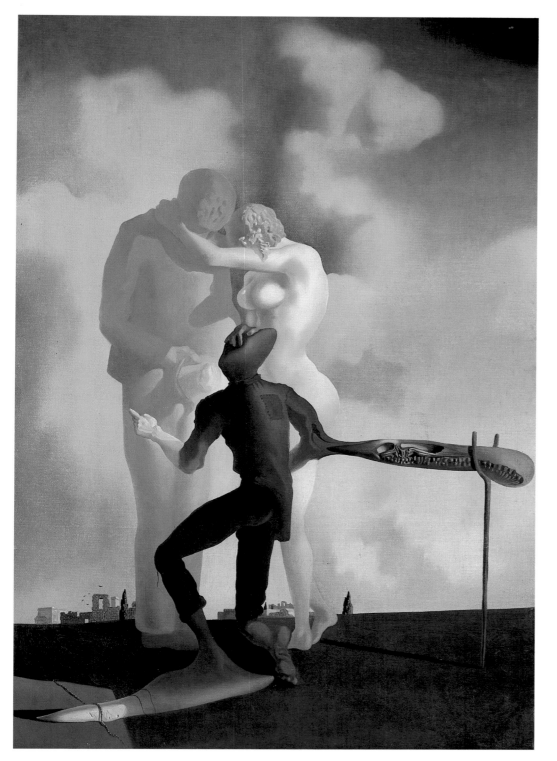

57. *Meditation on the Harp* (1932–34)

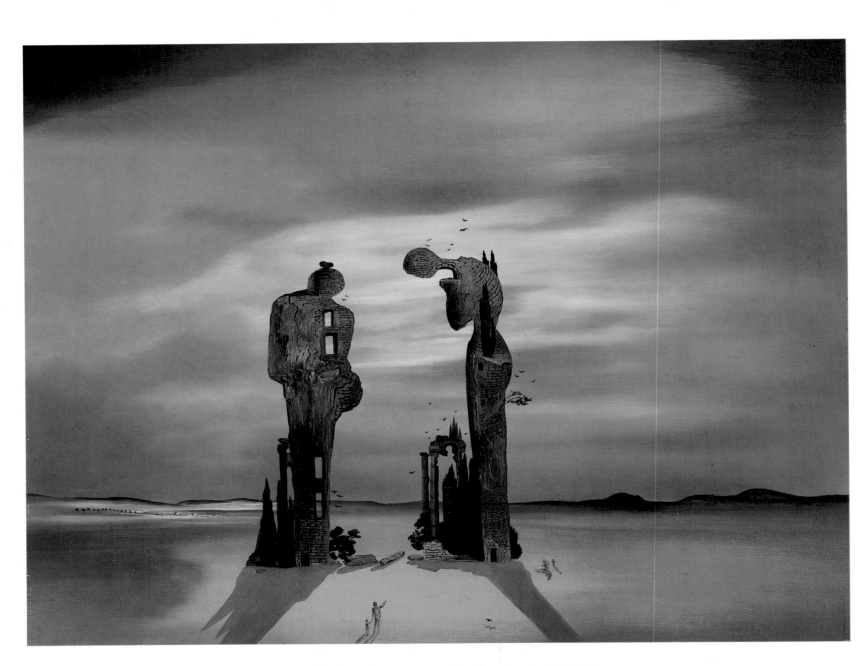

58. *Archeological Reminiscence of Millet's Angelus* (1933–35)

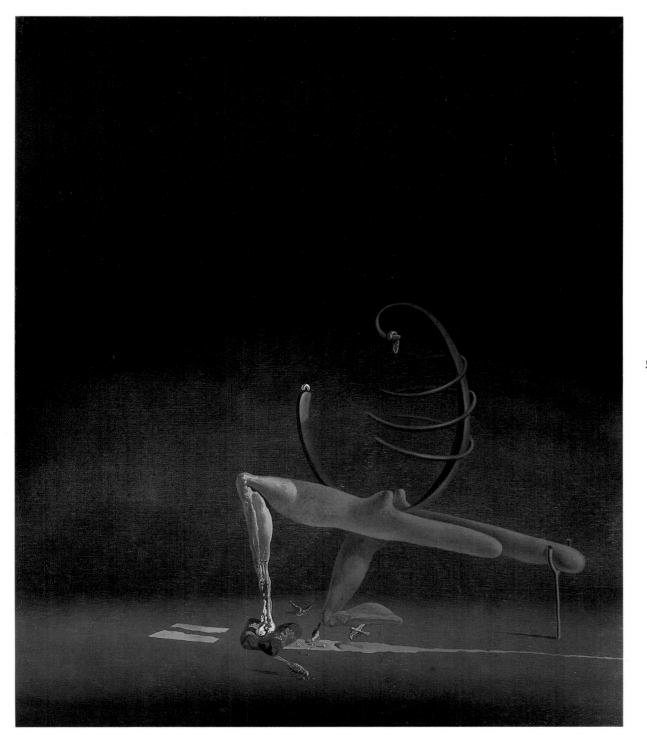

59. *The Javanese Mannequin* (1934)

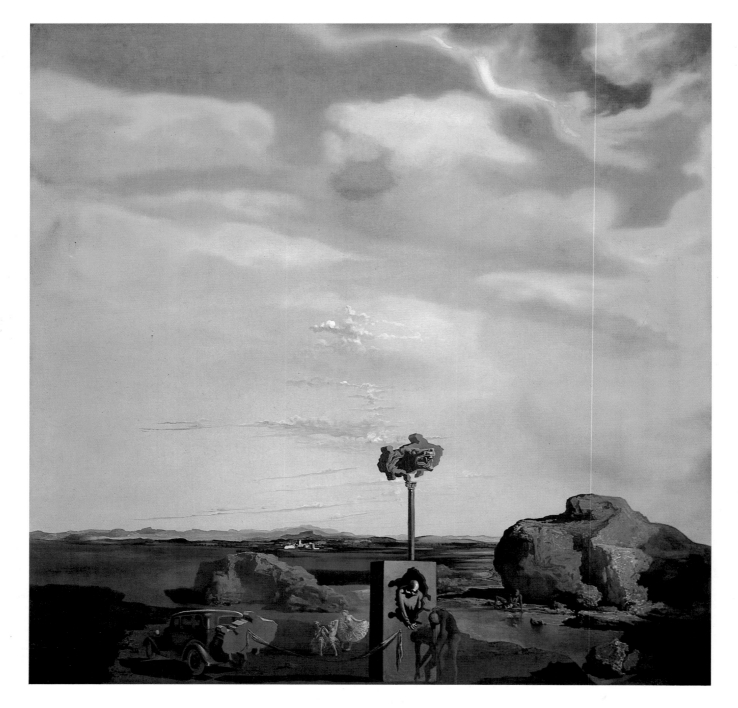

60. *Puzzle of Autumn* (1935)

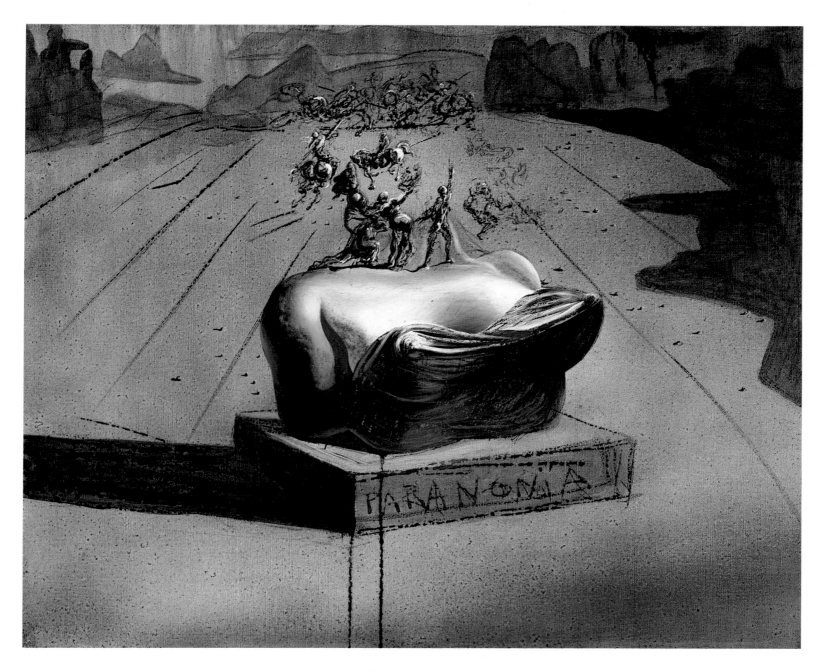

61. *Paranonia* (1935–36)

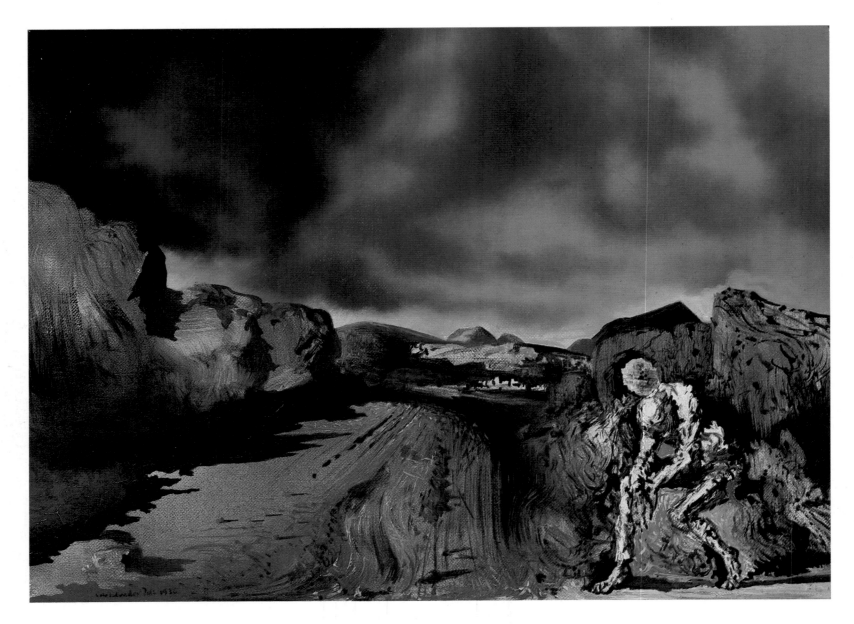

62. *The Man with the Head of Blue Hortensias* (1936)

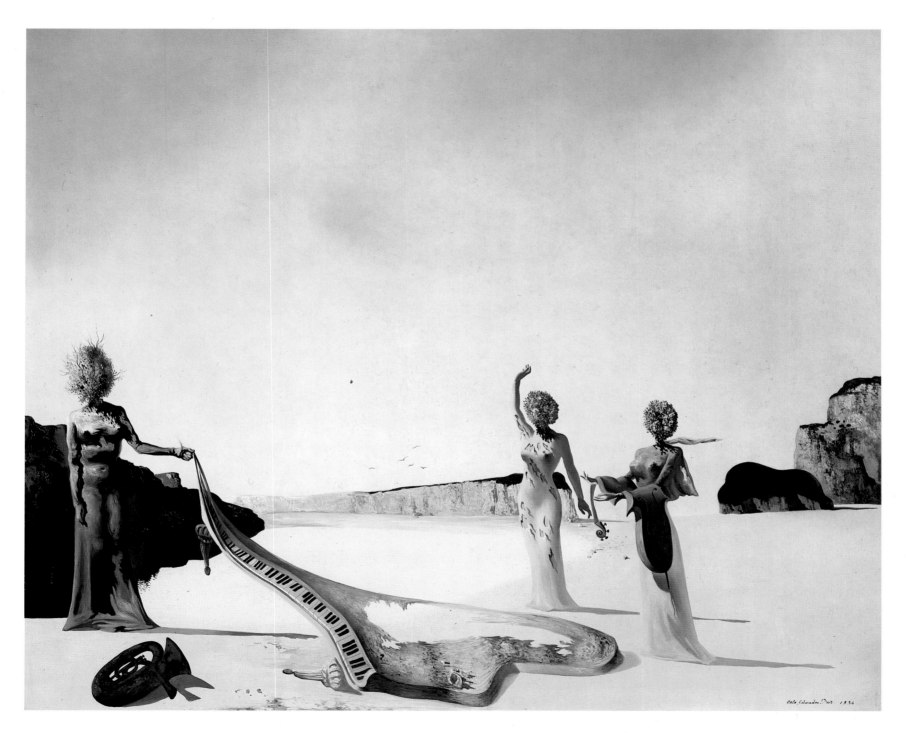

63. *Three Young Surrealist Women Holding in Their Arms the Skins of an Orchestra* (1936)

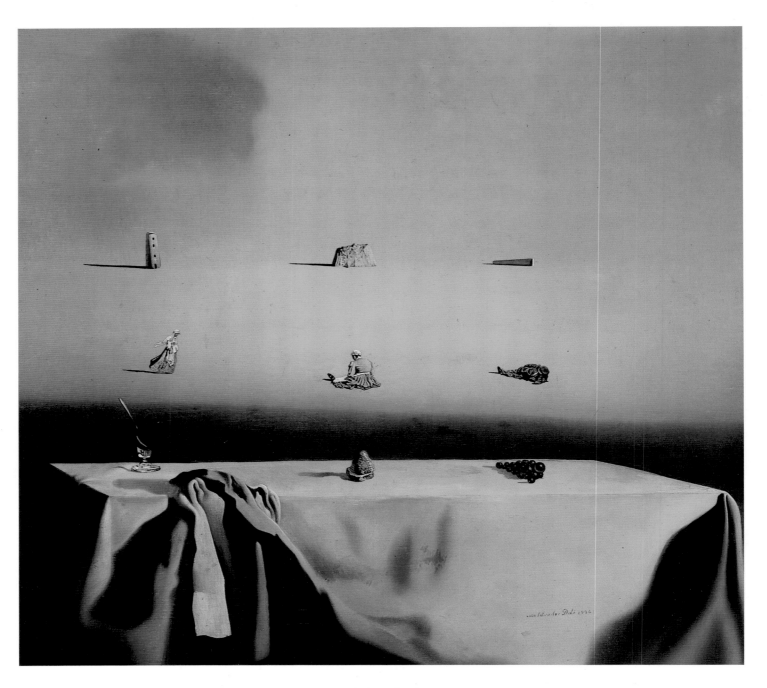

64. *Morphological Echo* (1936)

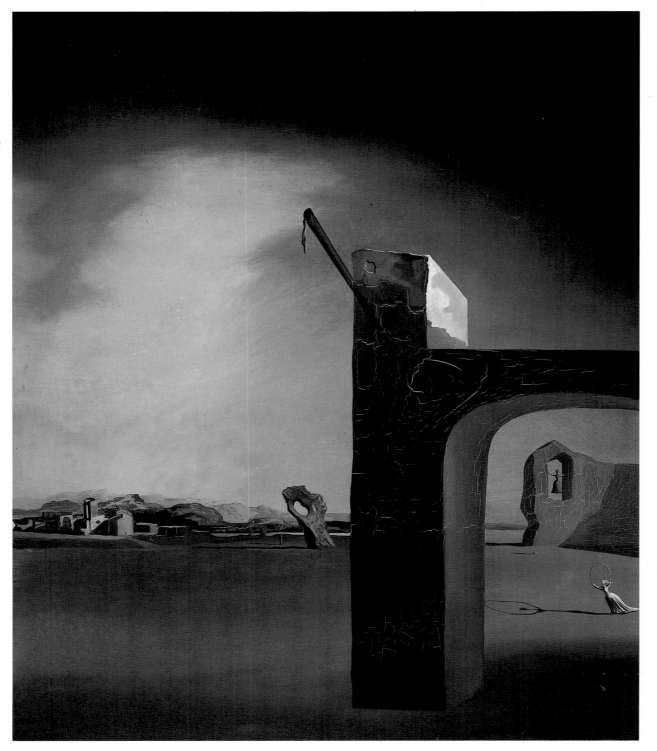

65. *Morphological Echo* (1934–36)

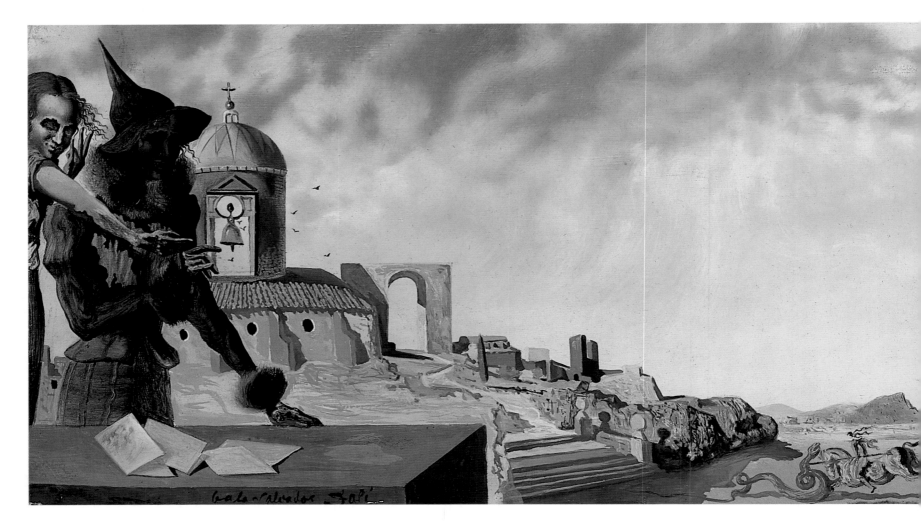

66. *Anthropomorphic Echo* (1937)

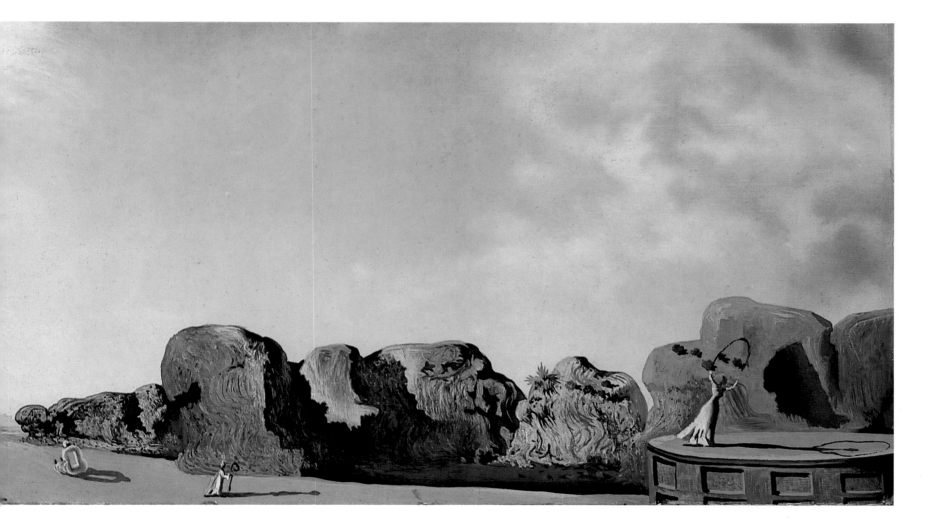

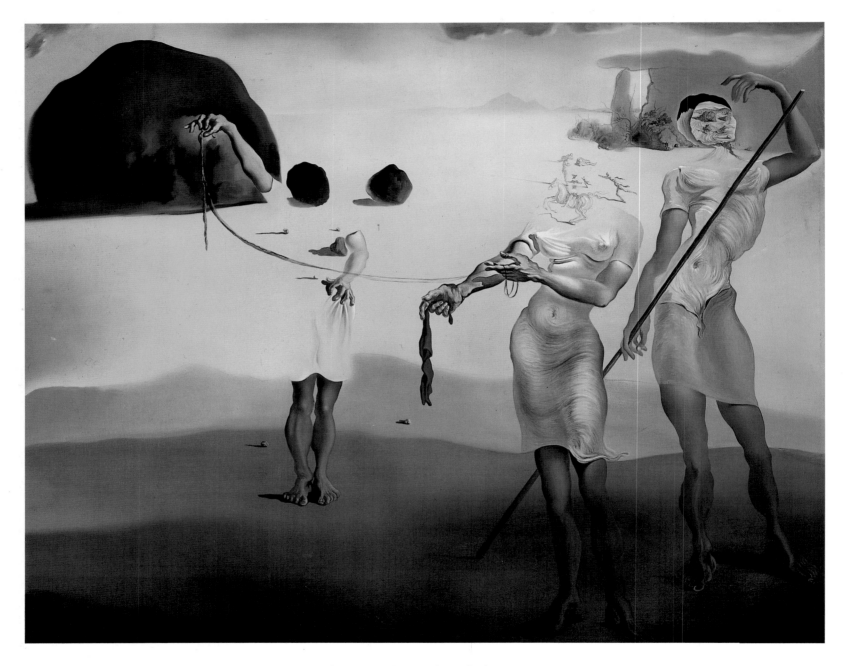

67. *Enchanted Beach with Three Fluid Graces* (1938)

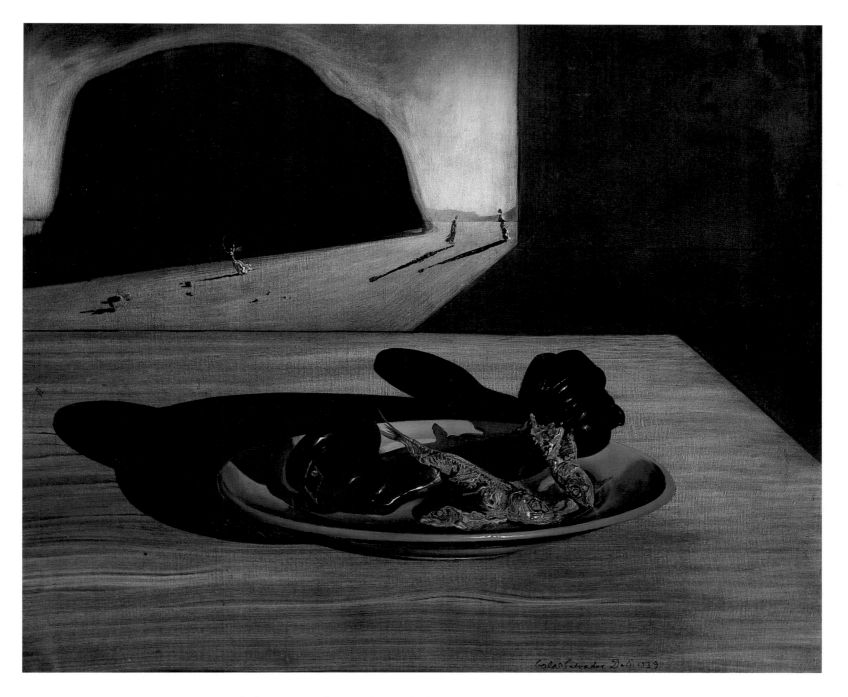

68. *Telephone in a Dish with Three Grilled Sardines at the End of September* (1939)

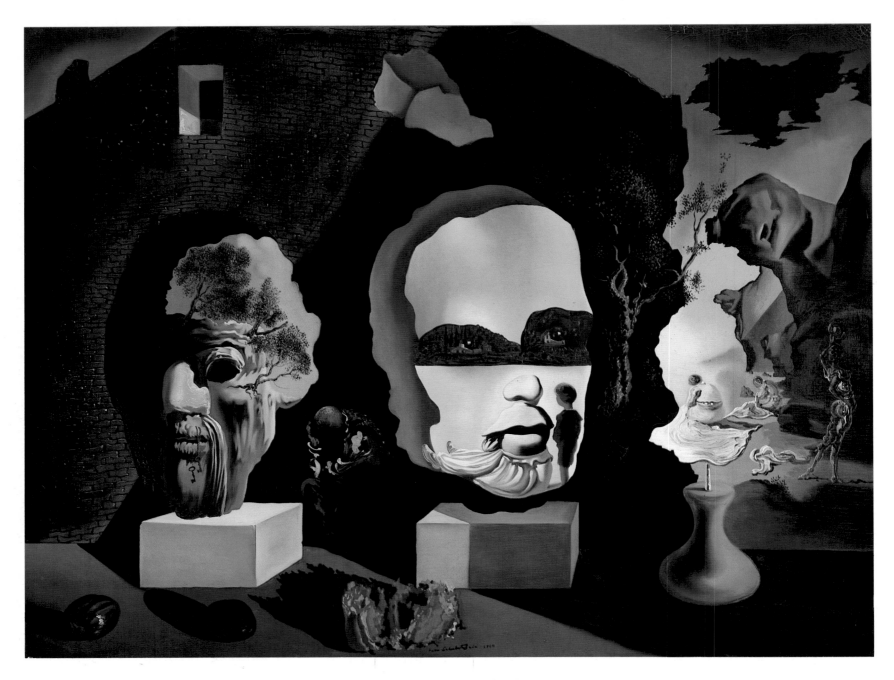

69. *Old Age, Adolescence, Infancy (The Three Ages)* (1940)

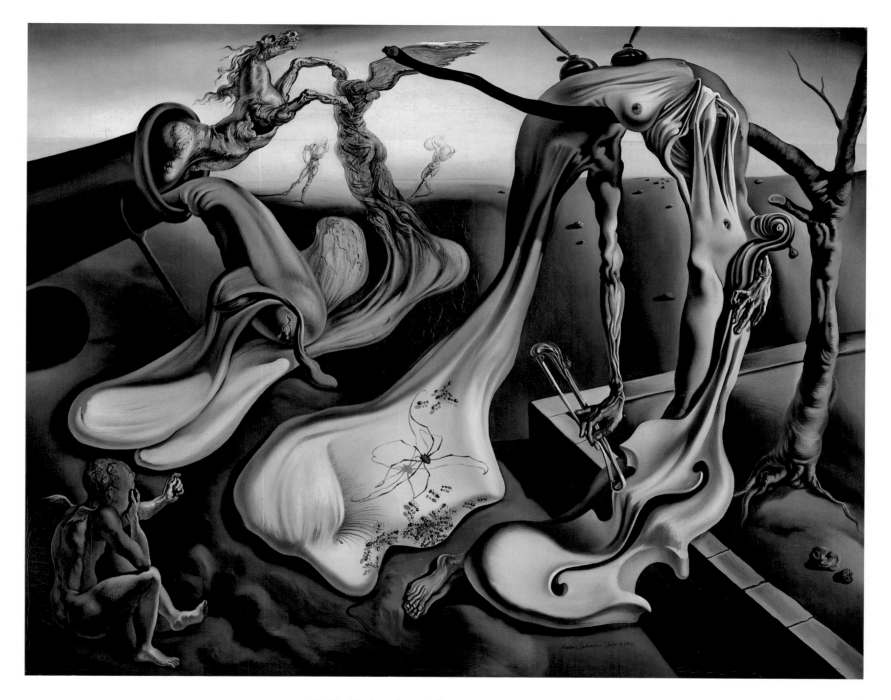

70. *Daddy Longlegs of the Evening — Hope!* (1940)

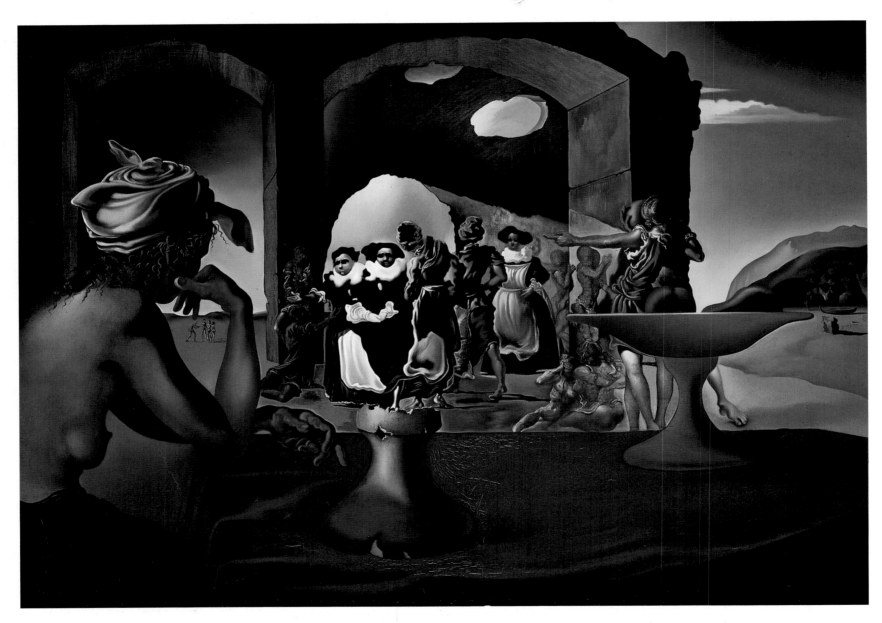

71. *Slave Market with the Disappearing Bust of Voltaire* (1940)

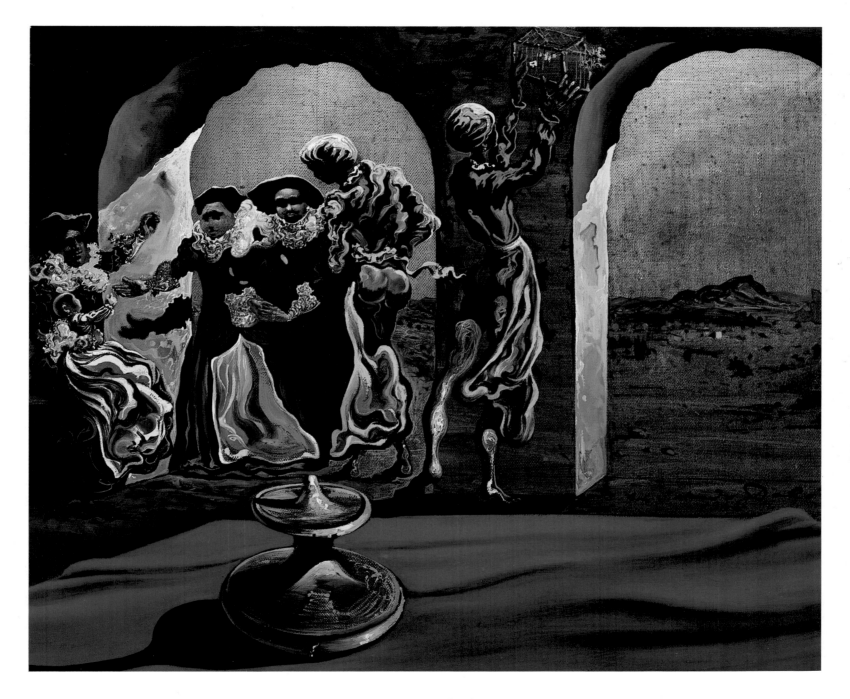

72. *Disappearing Bust of Voltaire* (1941)

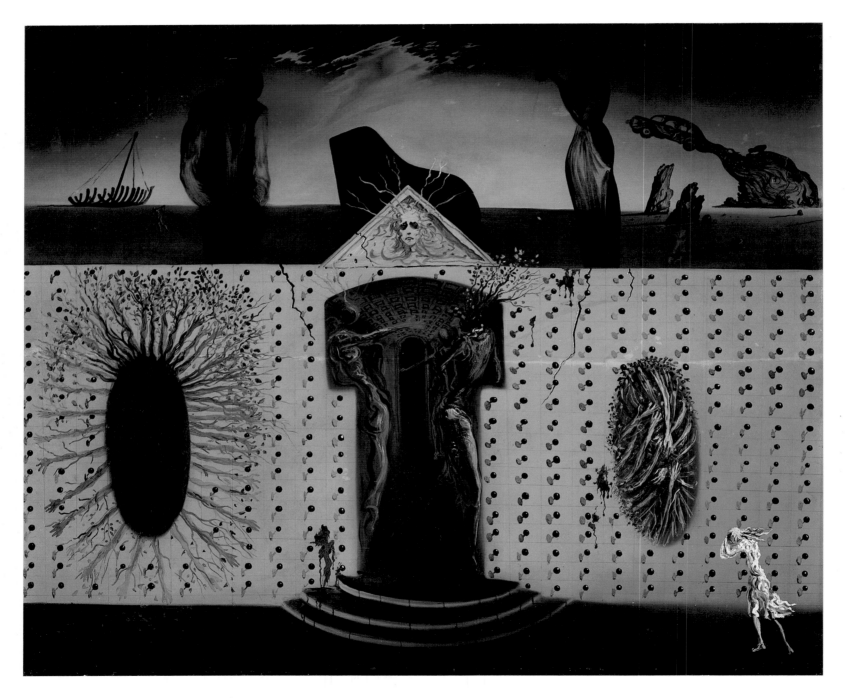

73. *Tristan Fou* (1938–39)

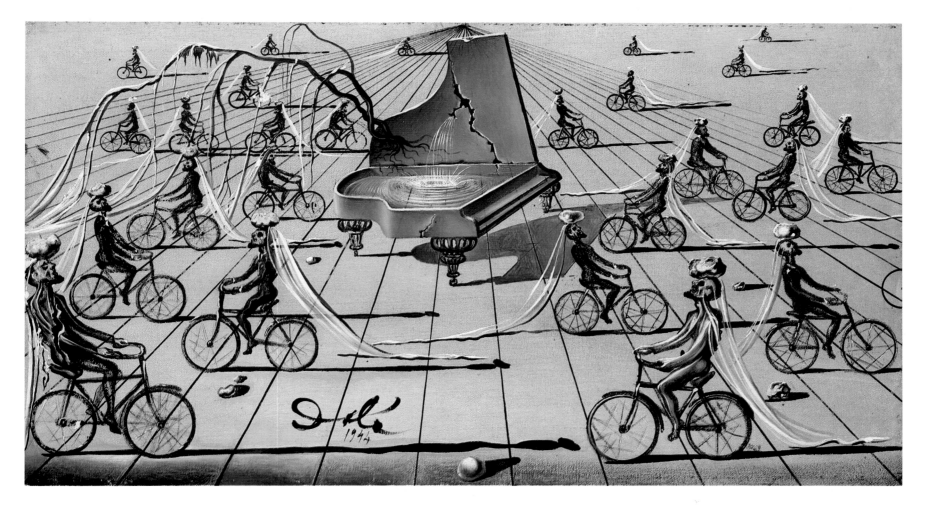

74. *Sentimental Colloquy* (1944)

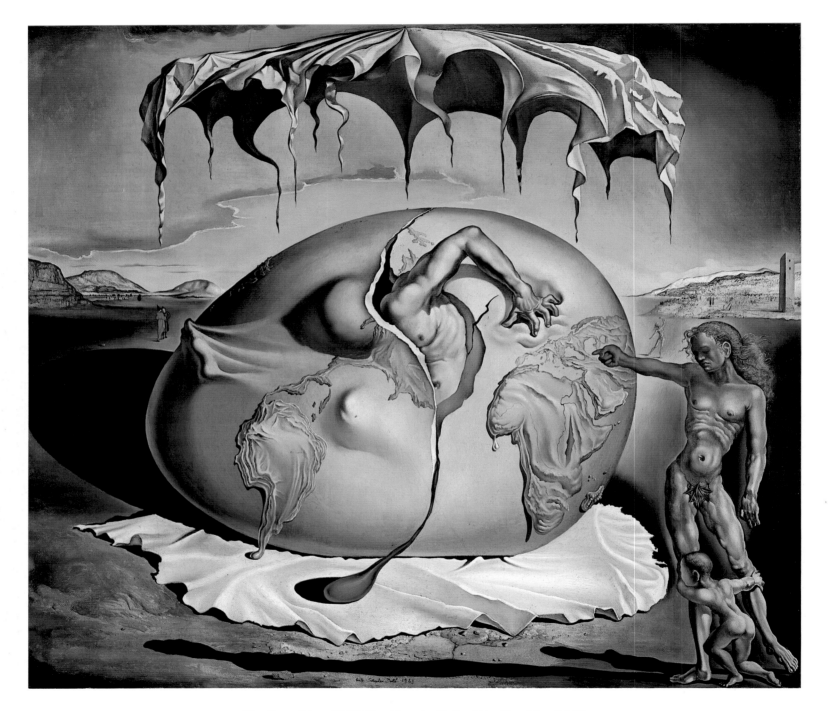

75. *Geopoliticus Child Watching the Birth of the New Man* (1943)

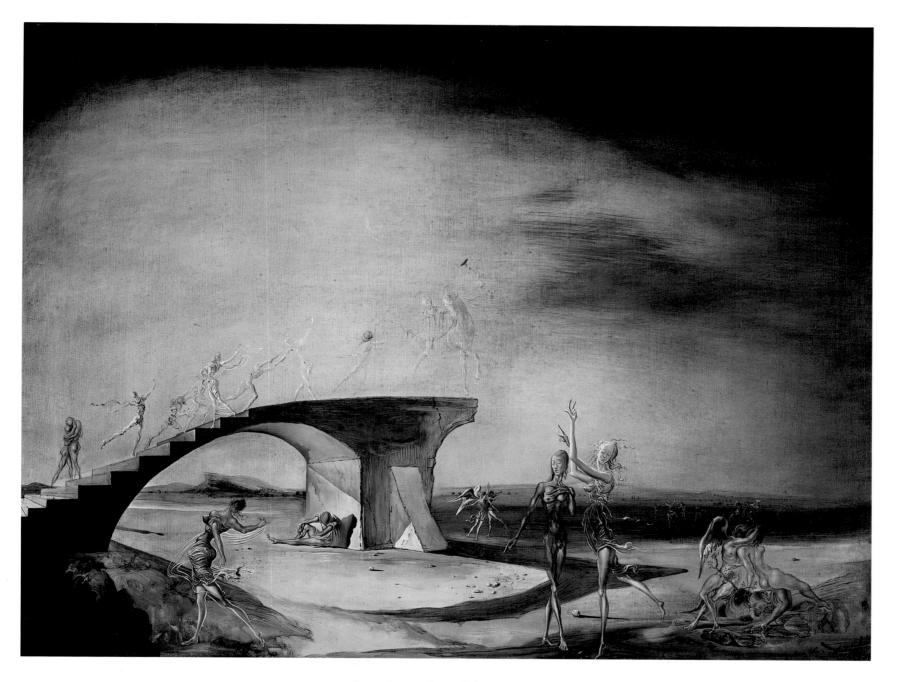

76. *The Broken Bridge and the Dream* (1945)

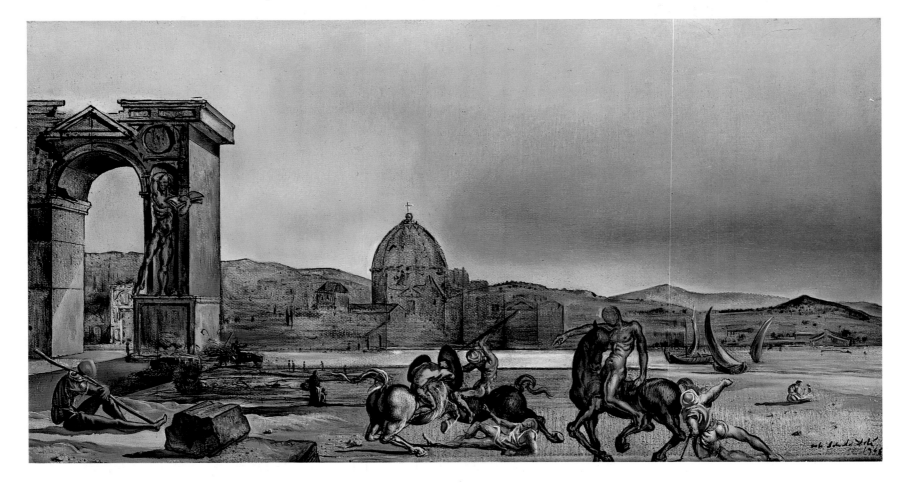

77. Autumn Sonata (1945)

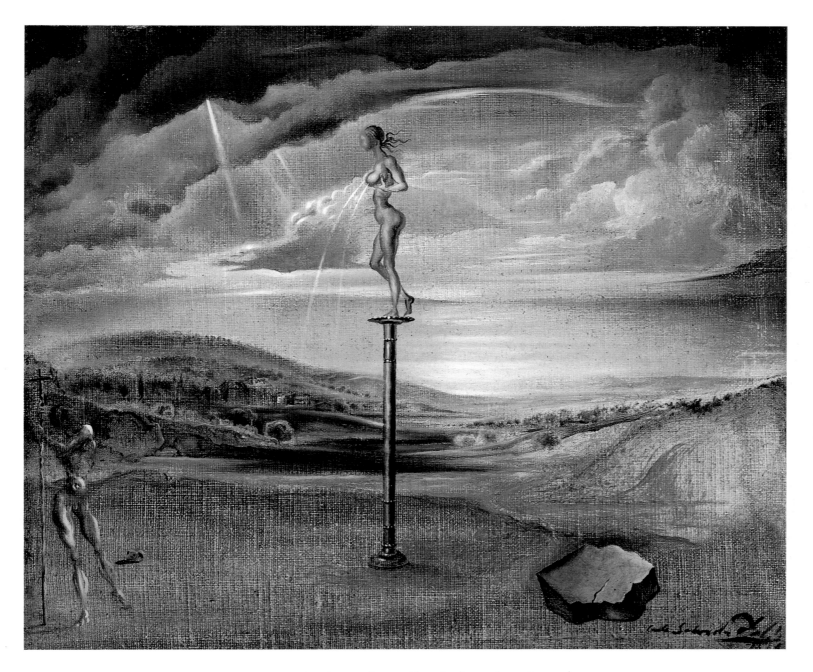

78. *Fountain of Milk Spreading Itself Uselessly on Three Shoes* (1945)

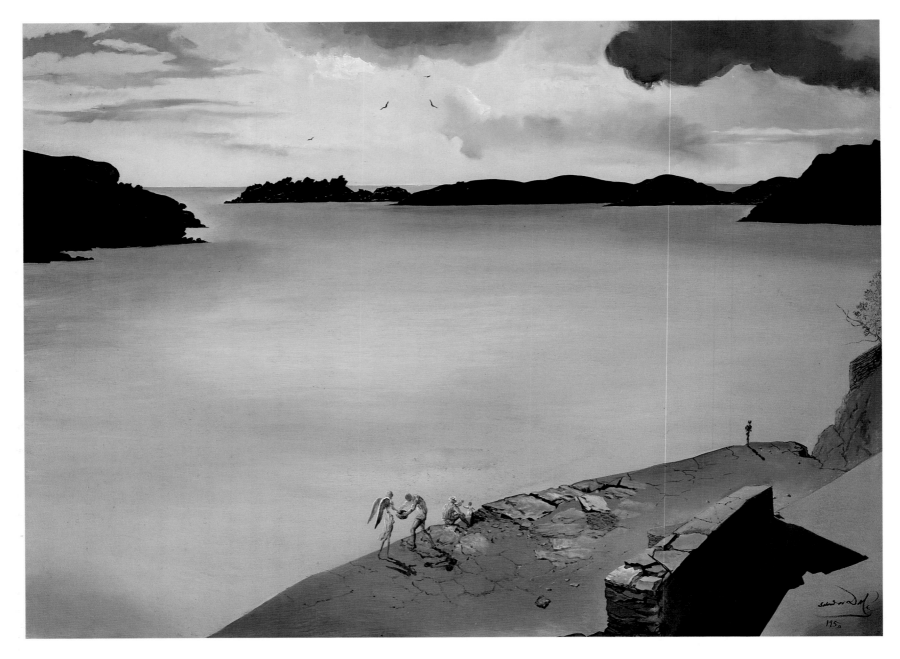

79. *Landscape of Port Lligat* (1950)

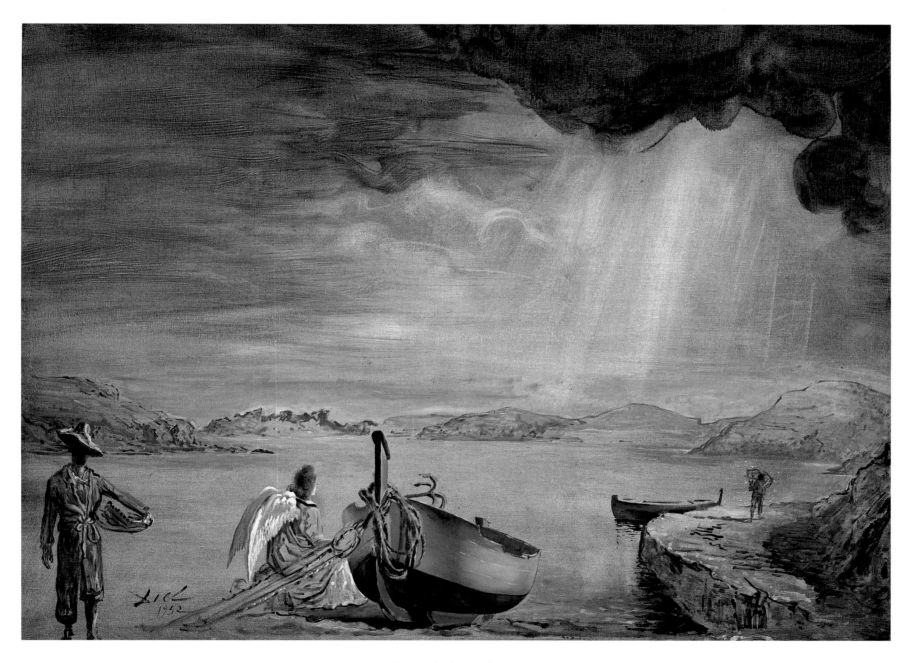

80. *The Angel of Port Lligat* (1952)

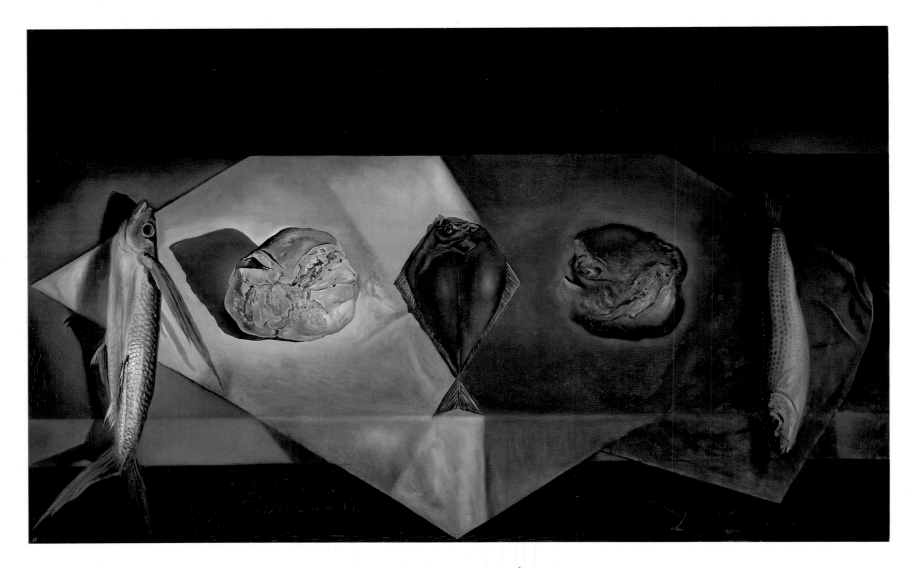

81. *Eucharistic Still Life (Nature Morte Évangélique)* (1952)

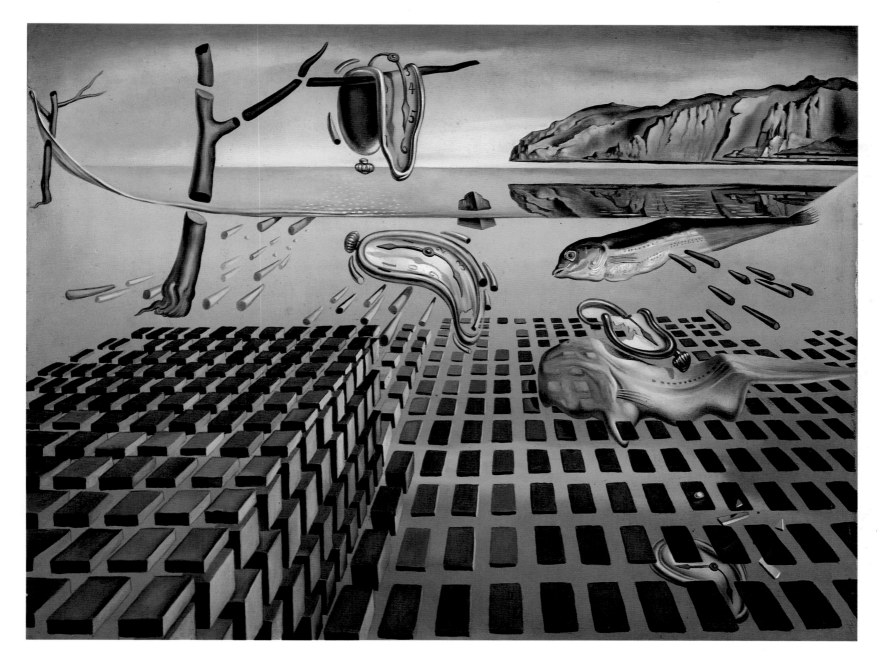

82. *The Disintegration of the Persistence of Memory* (1952–54)

83. *Noon (Barracks Port Lligat)* (1954)

84. *Two Adolescents* (1954)

85. *Nature Morte Vivante (Still Life — Fast Moving)* (1956)

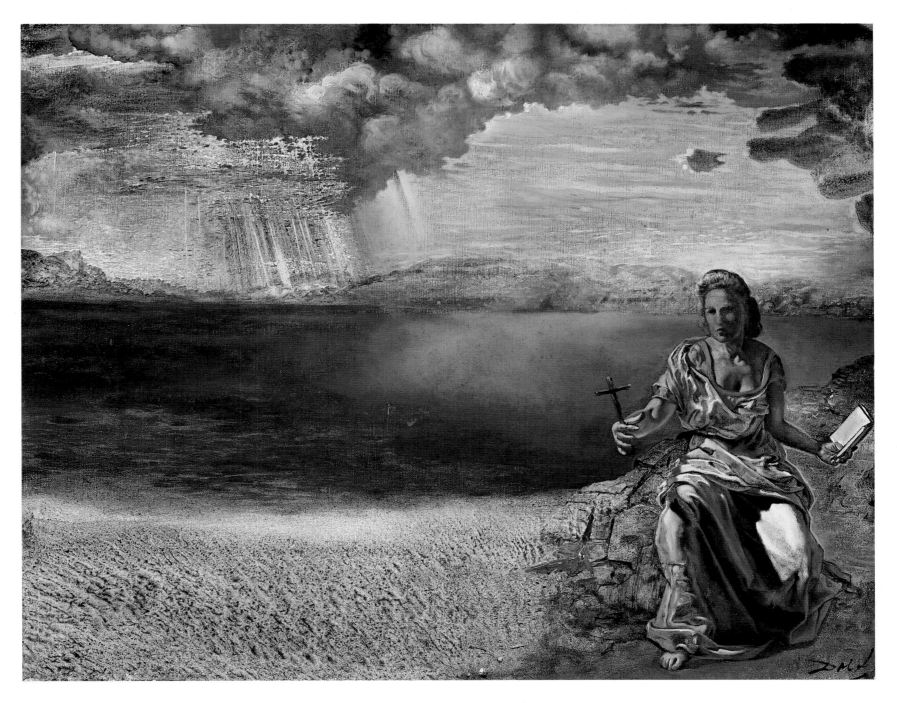

86. *Sainte Hélèna à Port Lligat* (1956)

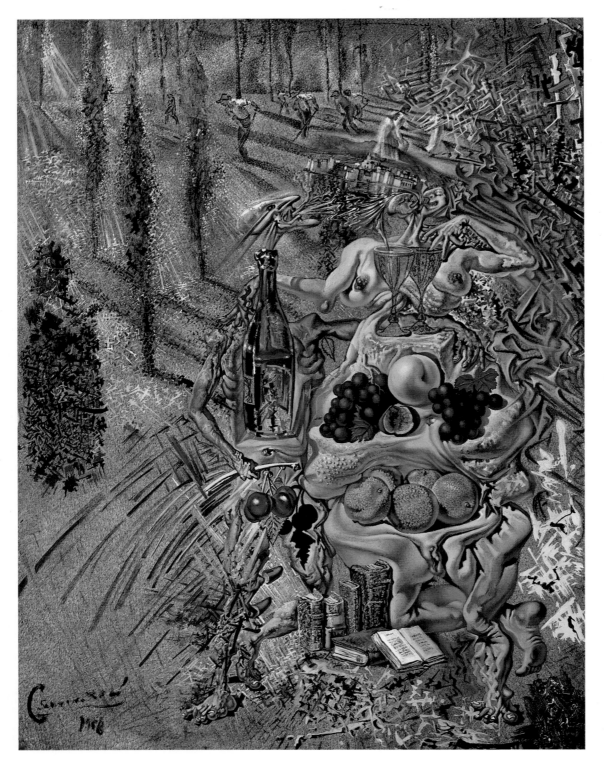

87. *Dionysus Spitting the Complete Image of Cadaques on the Tip of the Tongue of a Three-Storied Gaudinian Woman* (1958–60)

88. *Velázquez Painting the Infanta Margarita with the Lights and Shadows of His Own Glory* (1958)

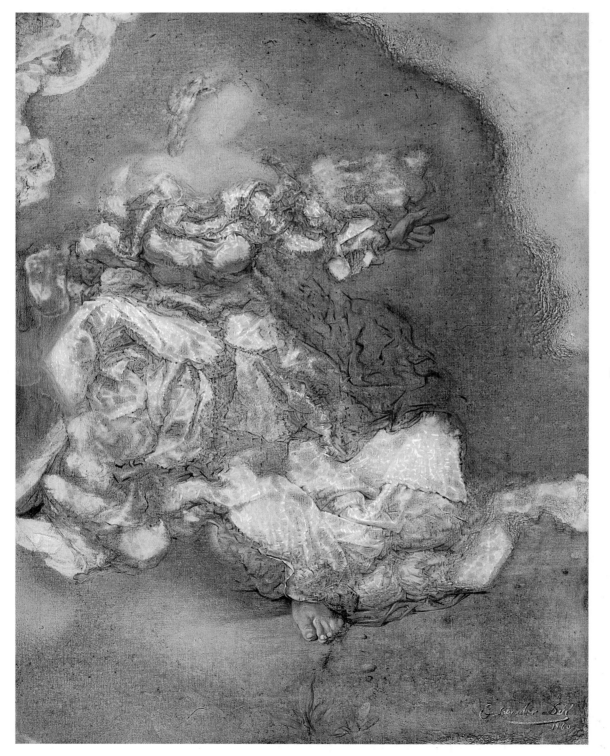

89. *Beatrice* (1958–60)

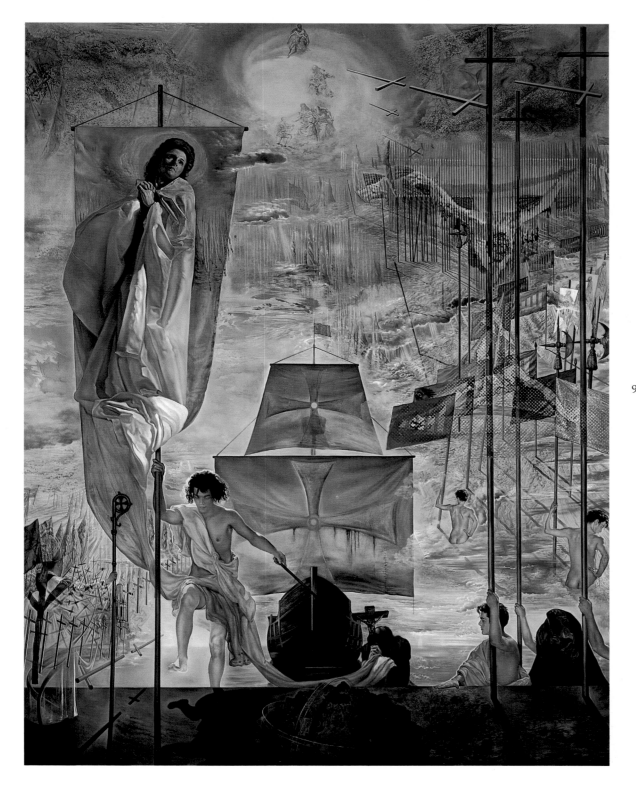

90. *The Discovery of America by Christopher Columbus*
 (1958–59)

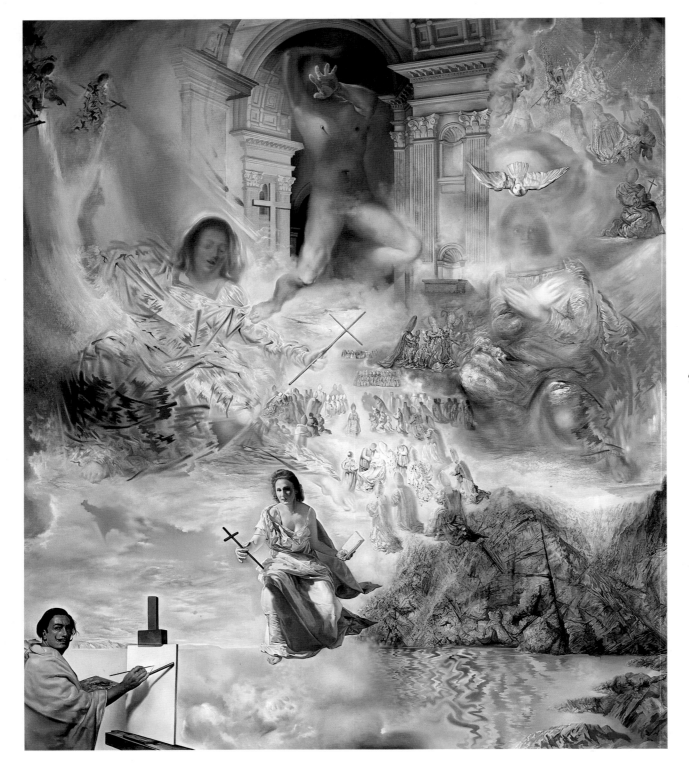

91. *The Ecumenical Council* (1960)

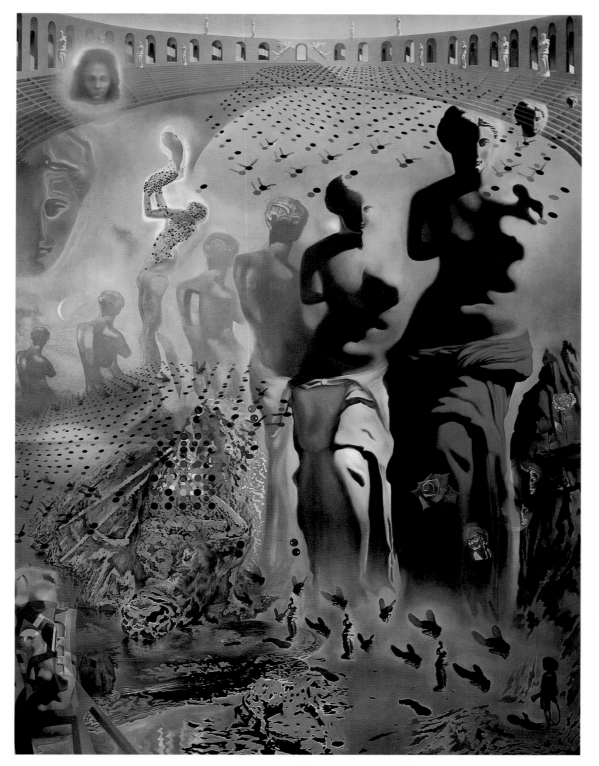

92. *The Hallucinogenic Toreador* (1969–70)

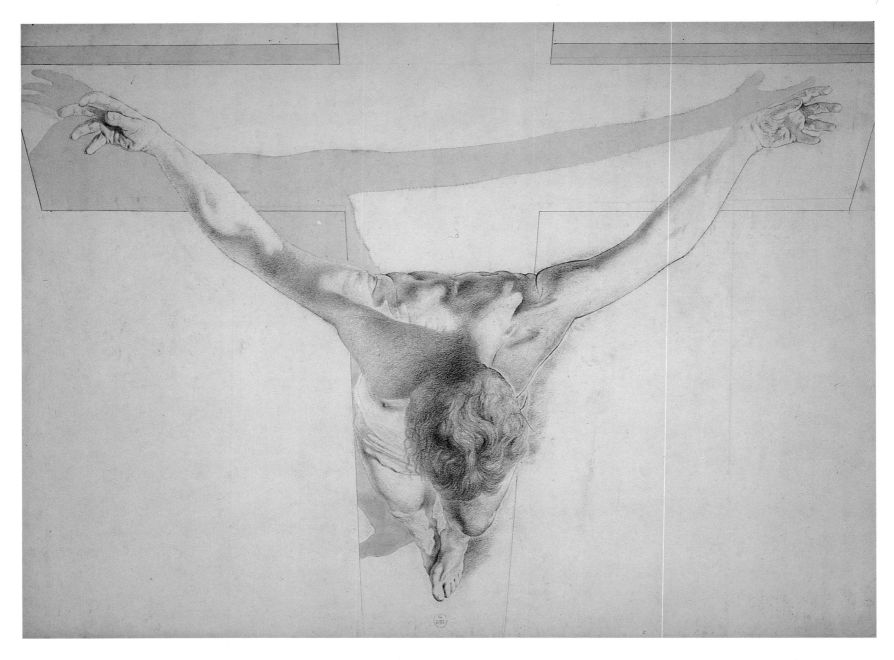

93. *Christ en Perspective* (1950)

Drawings and Watercolors

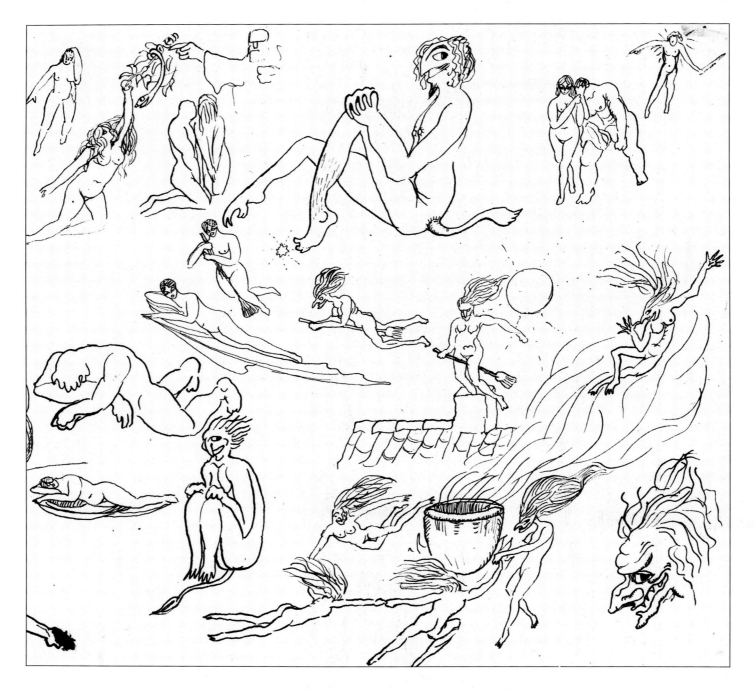

94. Childhood Sketch, *Witches and the Fall of Eve* (1916–18)

95. *Cadaques* (1917–18)

96. *Portrait of Joaquim Montaner (Alegória del Navigante)*
(1919–20)

97. *Cubist Study of Figures on a Beach* (1923–25)

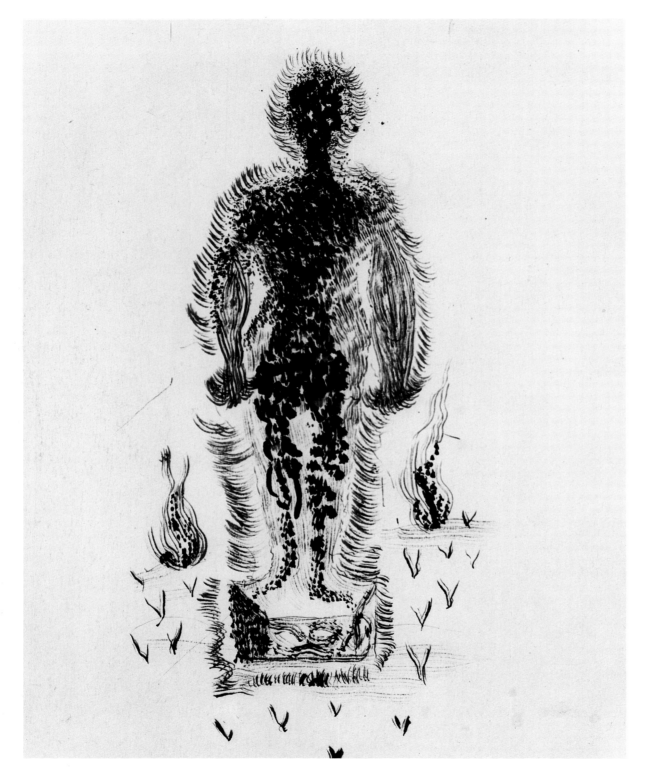

98. *Figure in Flames* (1923–25)

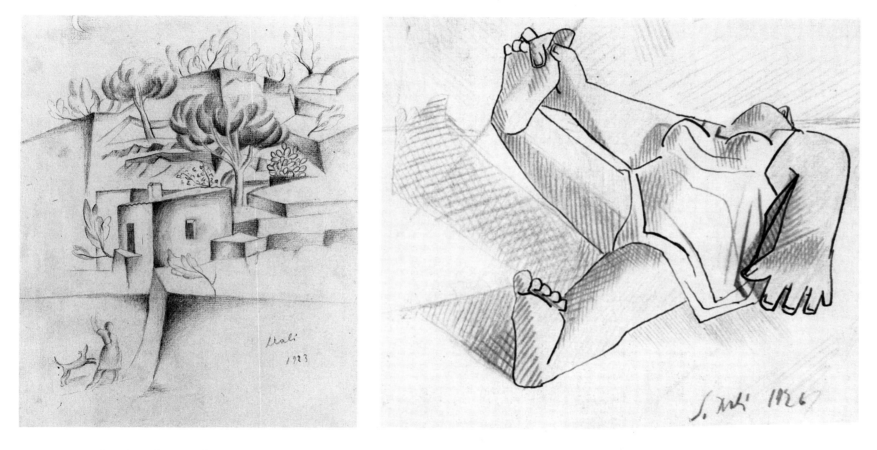

99. *Barracks — Cadaques* (1923) 100. *Femme Couchée (Nu Allongé)* (1926)

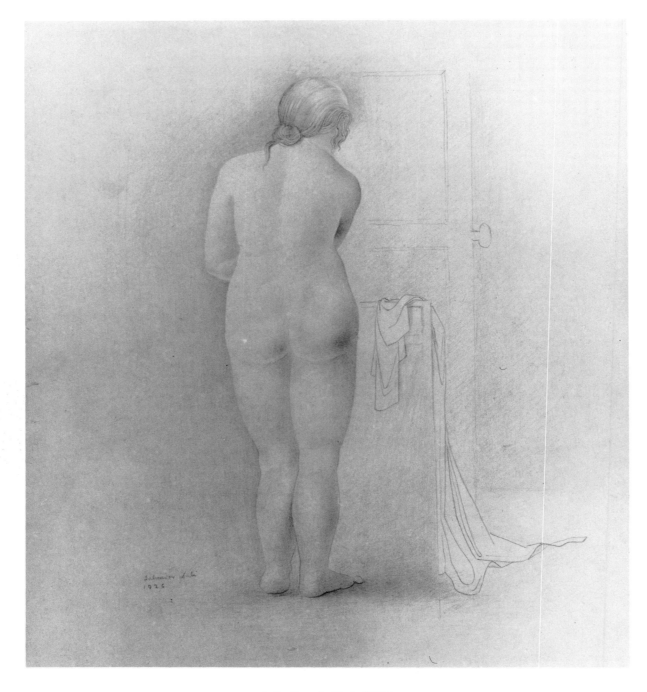

101. *Female Nude* (1926)

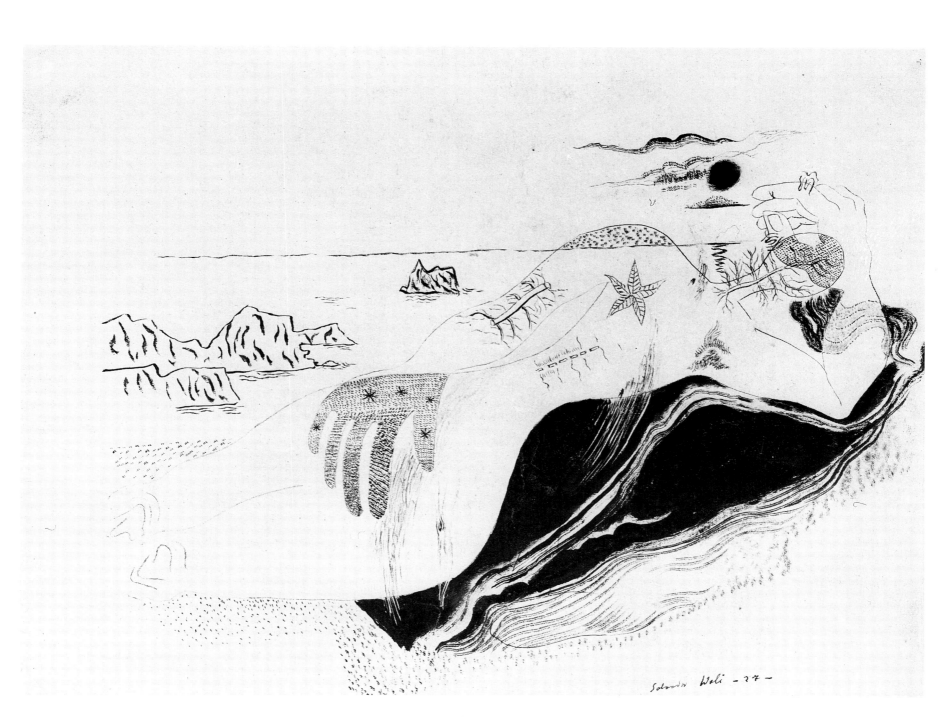

102. *The Bather* (1927)

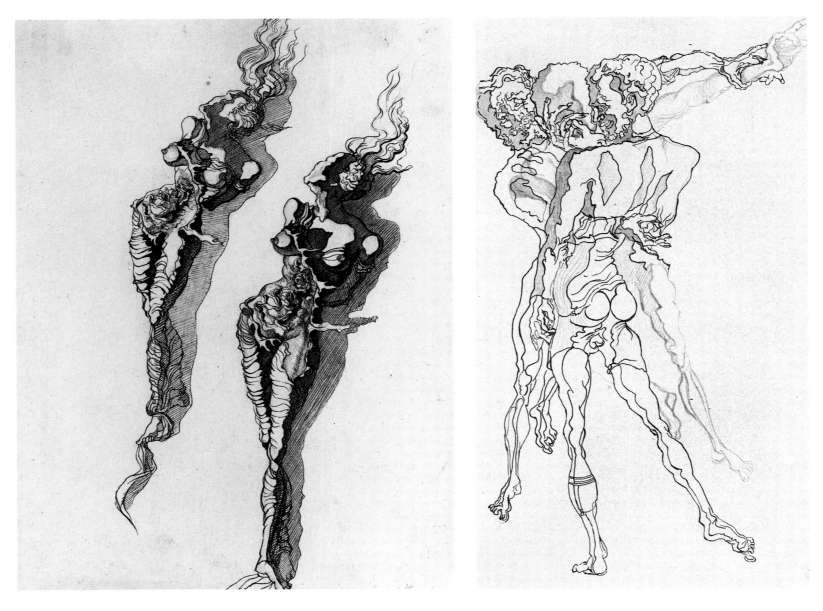

103. *Gradiva* (1930)

104. *Figures after William Tell* (1932)

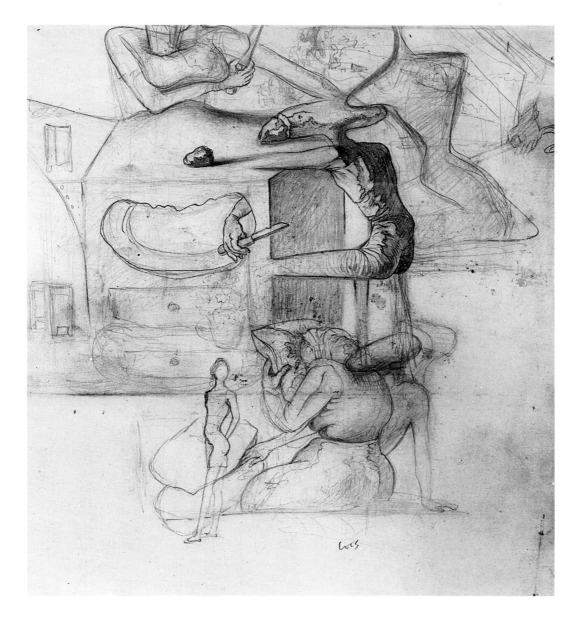

105. Studies for *Weaning of Furniture-Nutrition, Cannibalism of Autumn,* and *The Grasshopper Child* (1932–33)

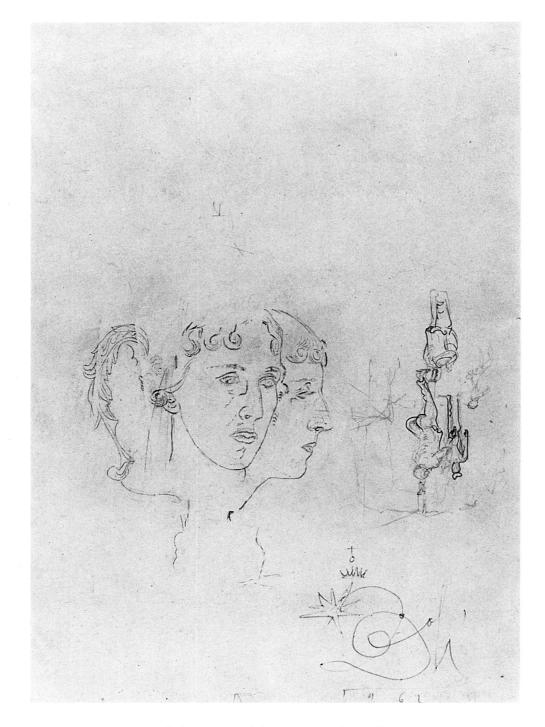

106. Study for *Portrait of the Vicomtesse de Noailles* (1933)

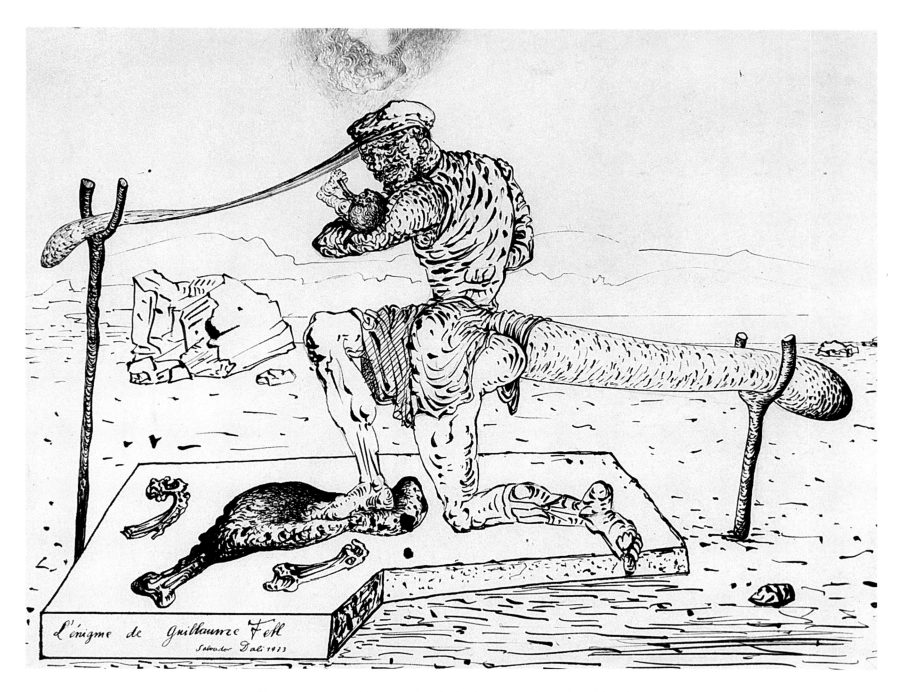

L'énigme de Guillaume Tell
Salvador Dali 1933

107. *The Enigma of William Tell with the Apparition of a Celestial Gala* (1933)

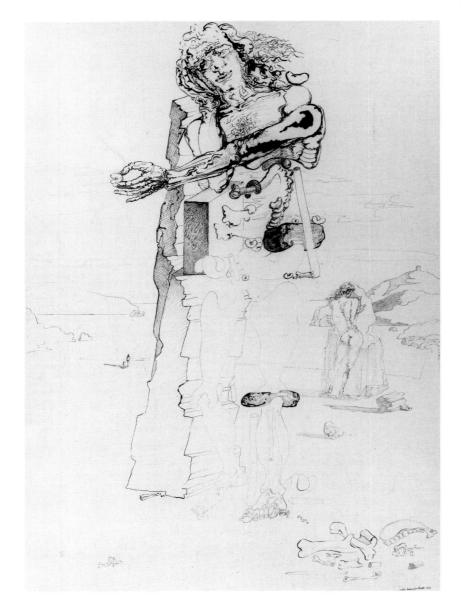

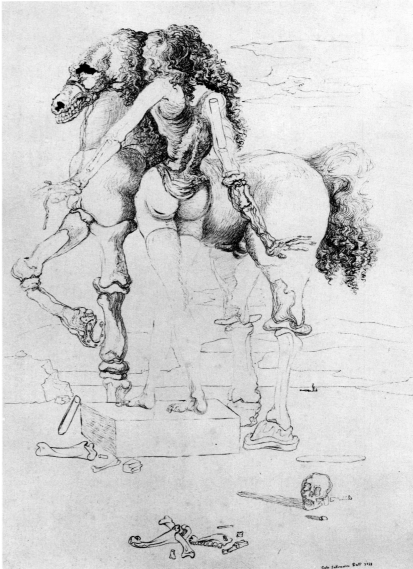

108. *Surrealist Figure in Landscape of Port Lligat* (1933) 109. *Femme-Cheval* (1933)

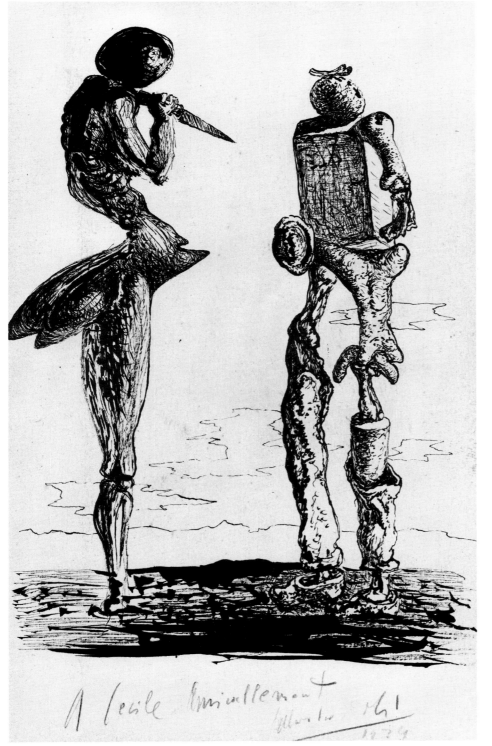

110. *Homage to the Angelus of Millet* (1934)

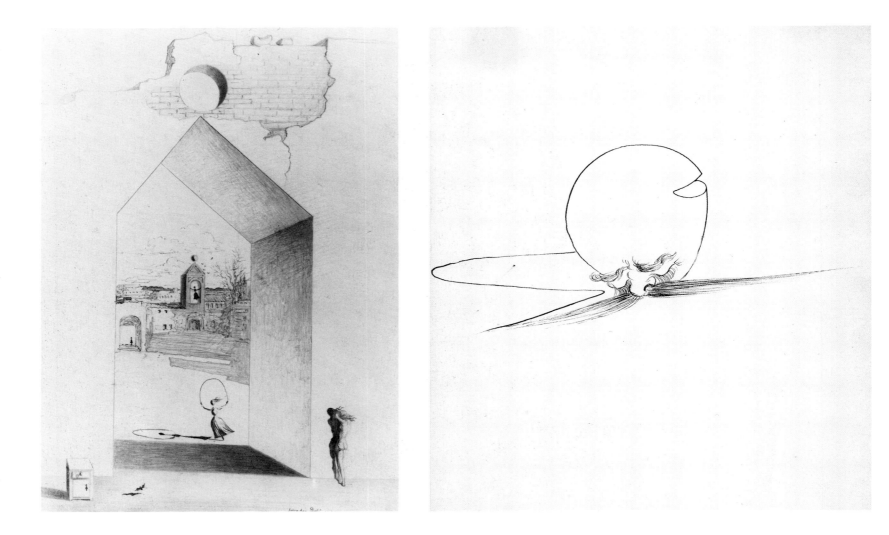

111. *The Nostalgic Echo* (Frontispiece of *Nuits Partagées* by Paul Eluard) (1935)

112. *Conic Anamorphosis* (1934)

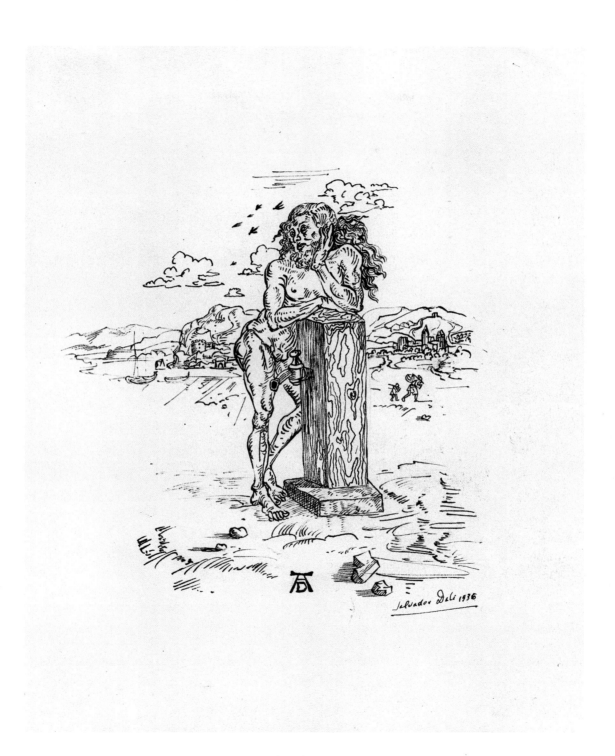

113. *Pastiche (after Dürer)* (1936)

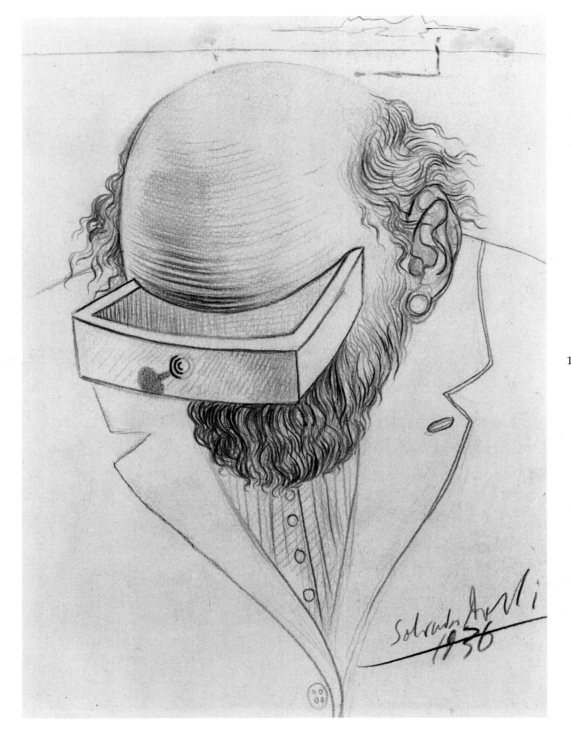

114. *Freudian Portrait of a Bureaucrat* (1936)

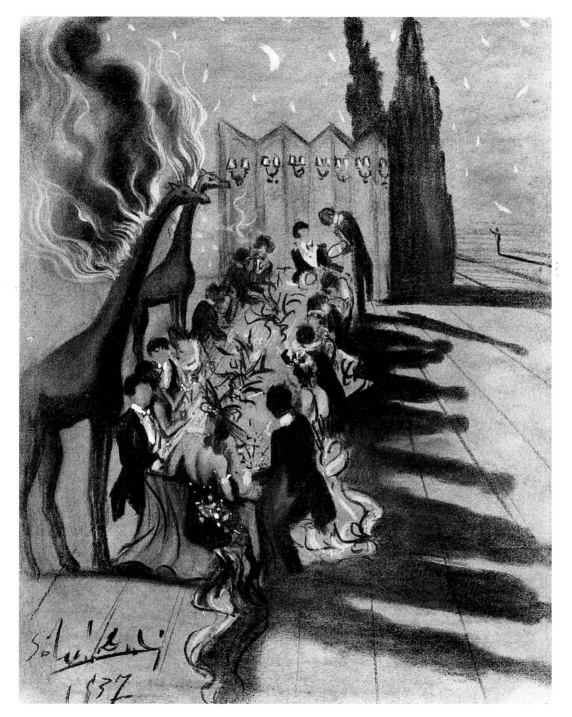

115. *Dîner dans le désert éclairé par les girafes en feu* (1937)

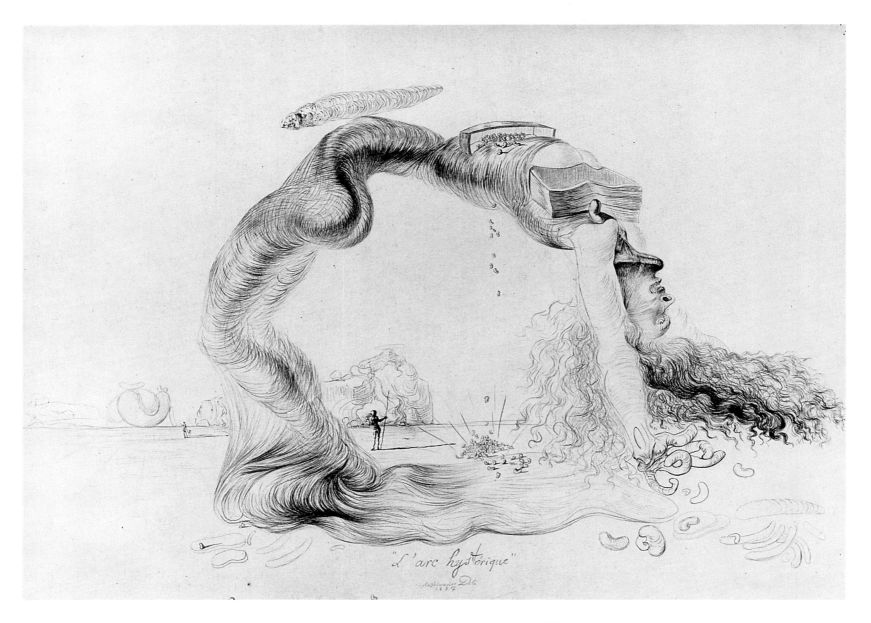

"L'arc hystérique"

116. *L'Arc Hystérique (The Hysterical Arch)* (1937)

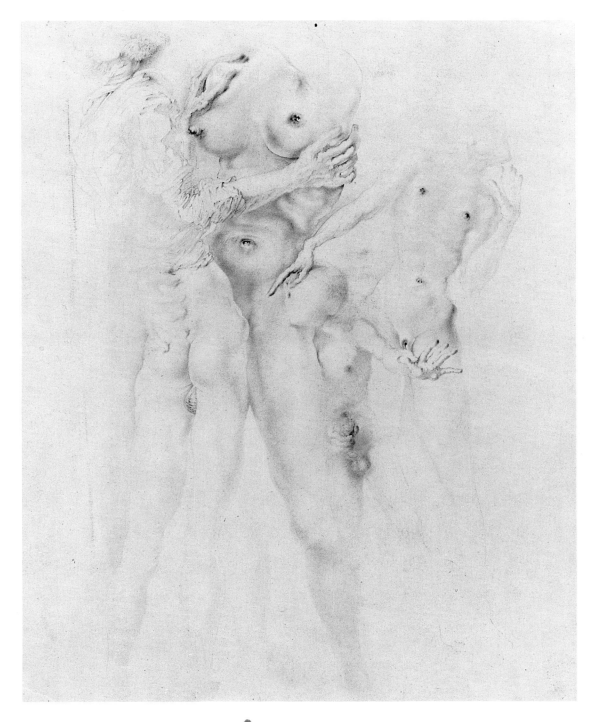

117. *William Tell Group* (1942–43)

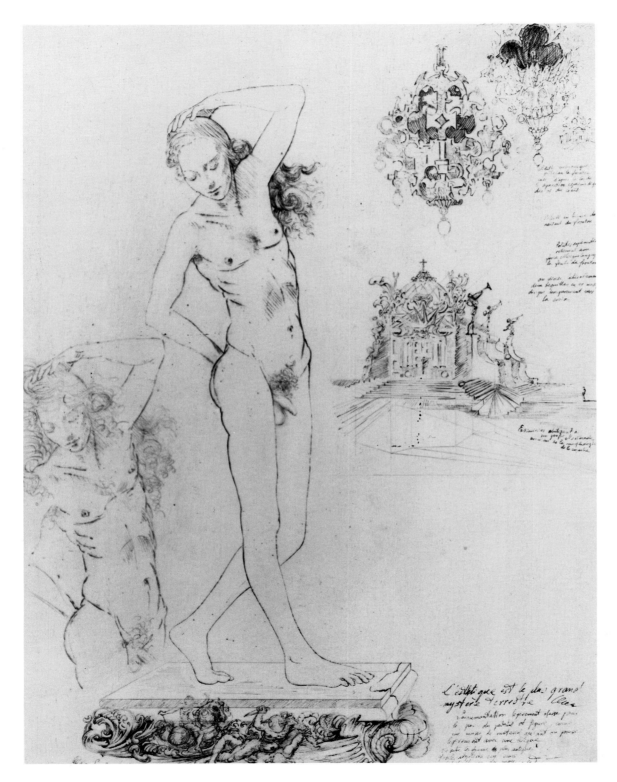

118. *The Esthetic Is the Greatest of Earthly Enigmas* (1943)

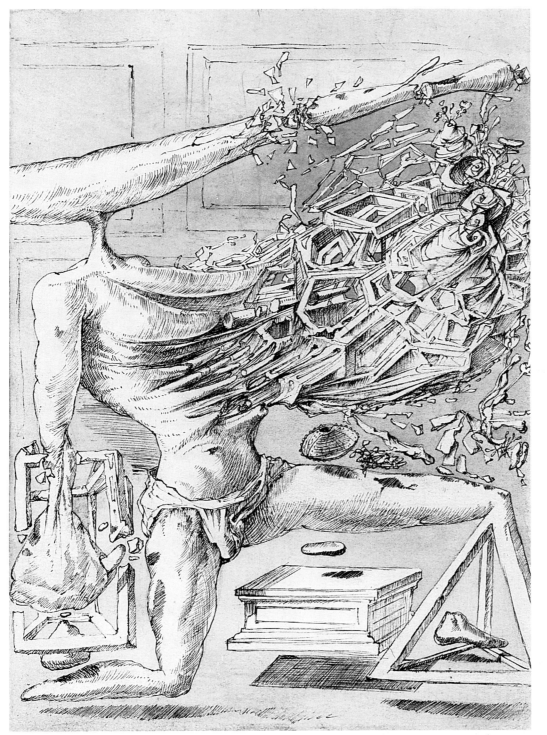

119. *Kneeling Figure in Decomposition* (1950–51)

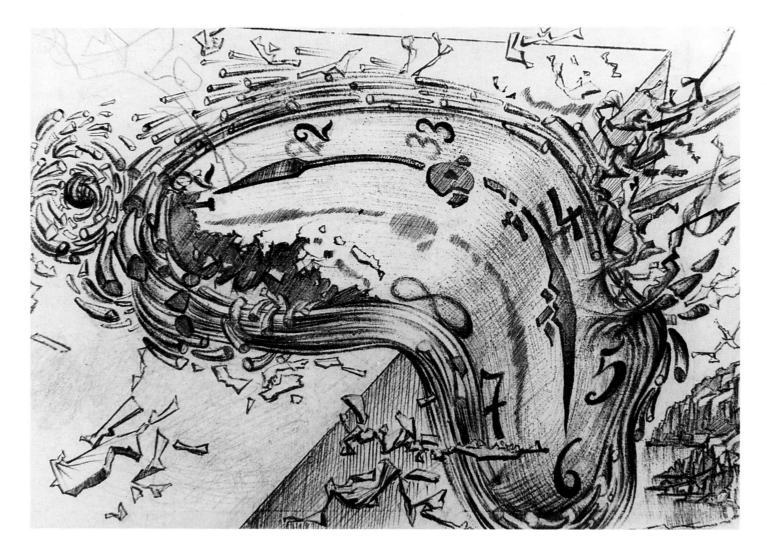

120. *Soft Watch Exploding* (1954)

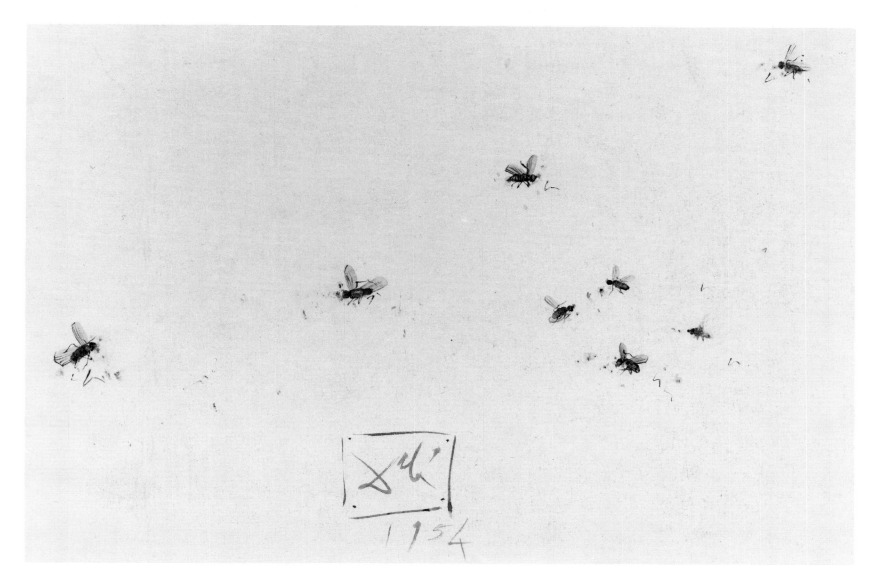

121. *Seven Flies (and a Model)* (1954)

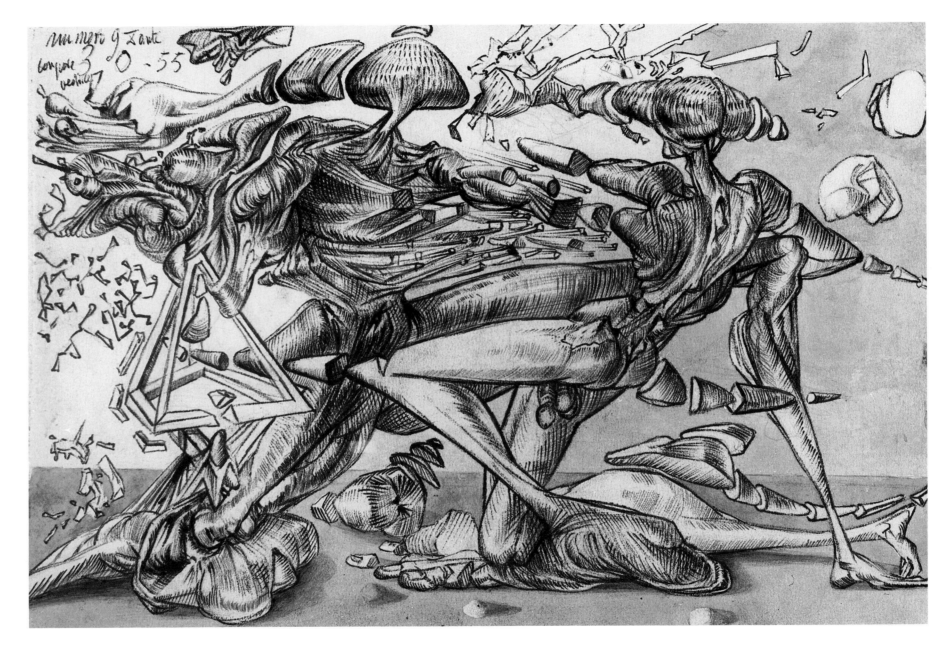

122. *Combat* (1955)

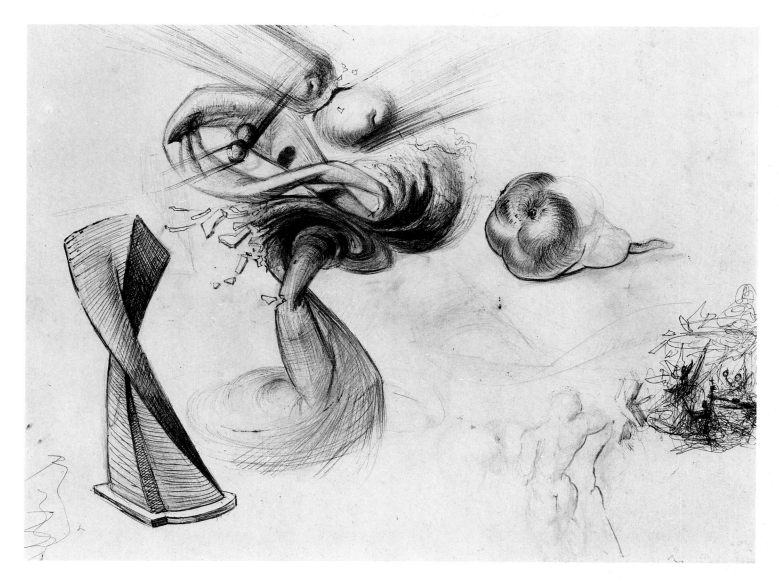

123. *Compotier et Fruits* (Study for *Nature Morte Vivante*) (1956)

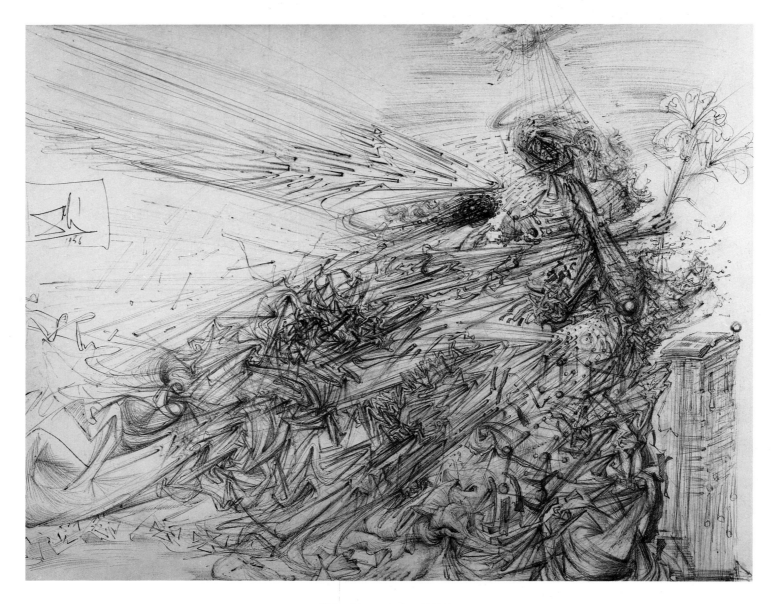

124. *Annunciation* (1956)

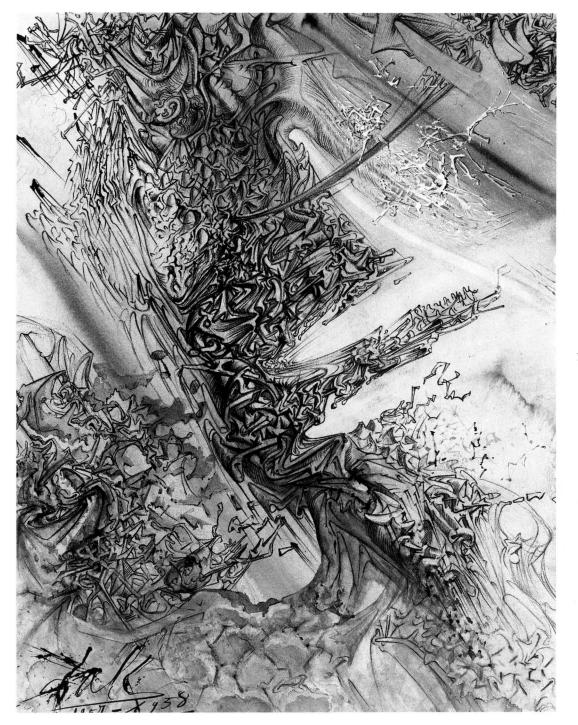

125. *Ange Pi-mesonic (Pi-mesonic Angel)* (1958)

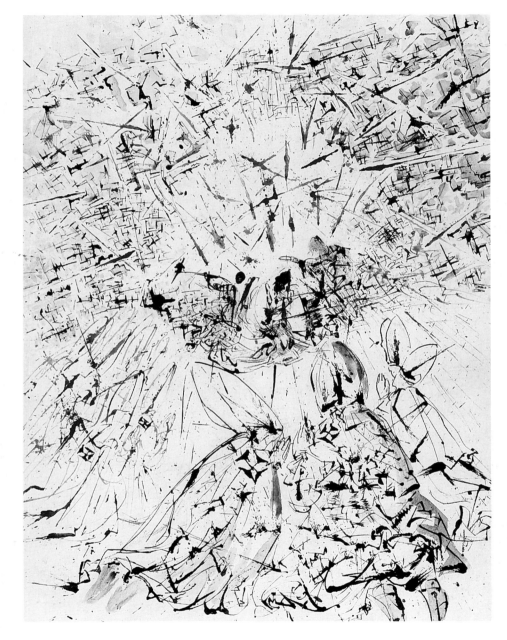

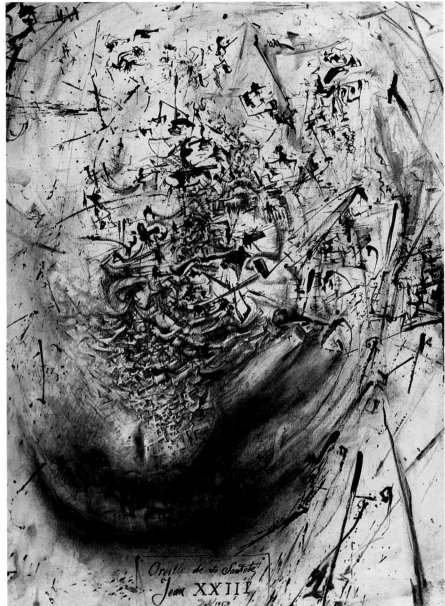

126. *Coronation of Pope John 23rd* (1958)

127. *Oreille de Sainteté Jean XXIII (The Ear of His Holiness Pope John 23rd)* (1959)

Para el circulo artistico de Sant Lluc
¡ viva Fortuny !

19 59

128. *St. Luke* (1959)

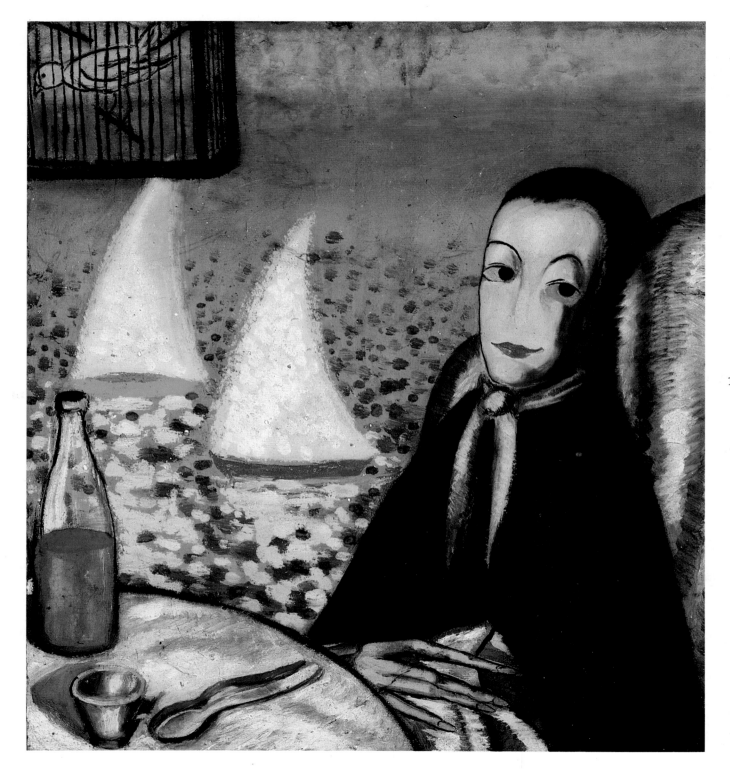

129. *The Sick Child* (1914–15)

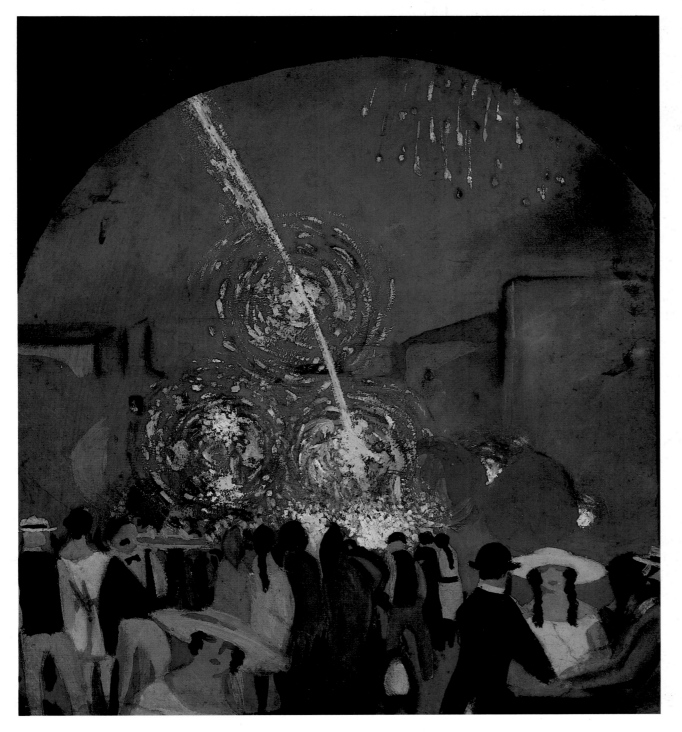

130. *Fiesta in Figueres* (1914–16)

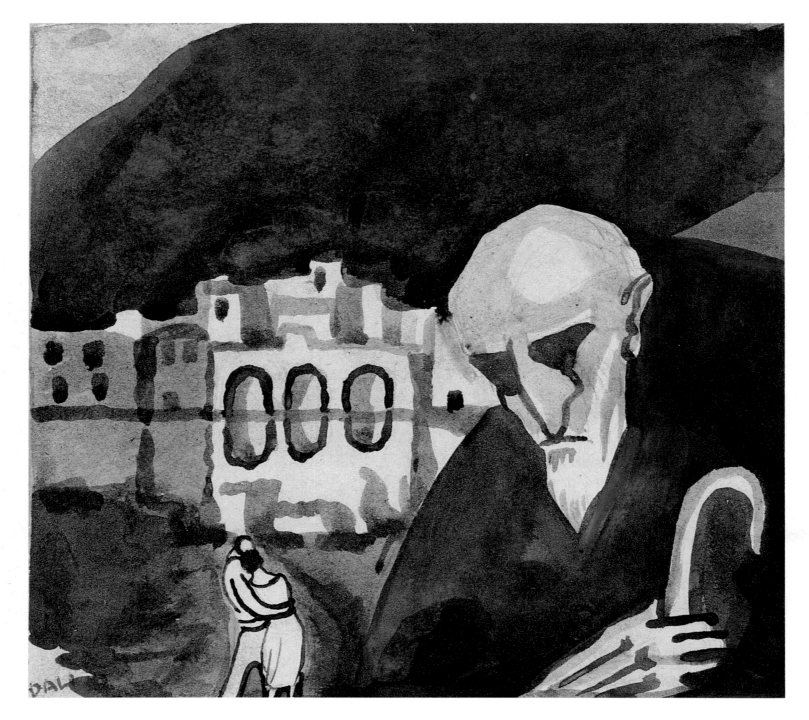

131. *Old Man of Portdogué* (1919–20)

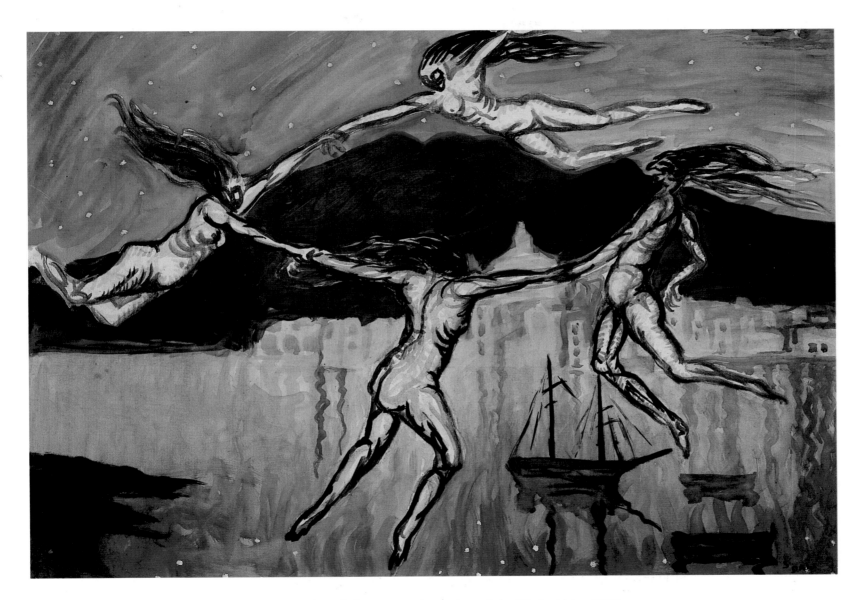

132. *La Sardana de las Brujas (The Sardana of the Witches)* (circa 1920)

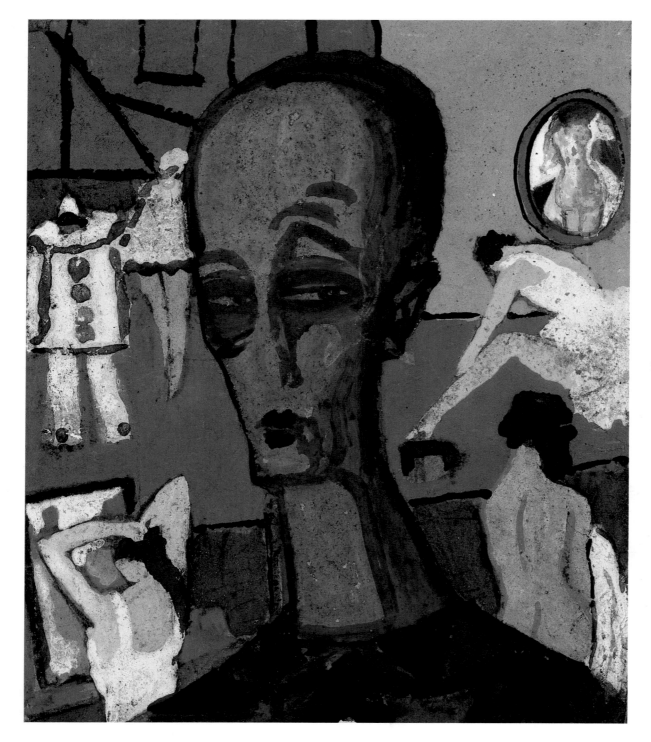

133. *Saltimbanques* (1920–21)

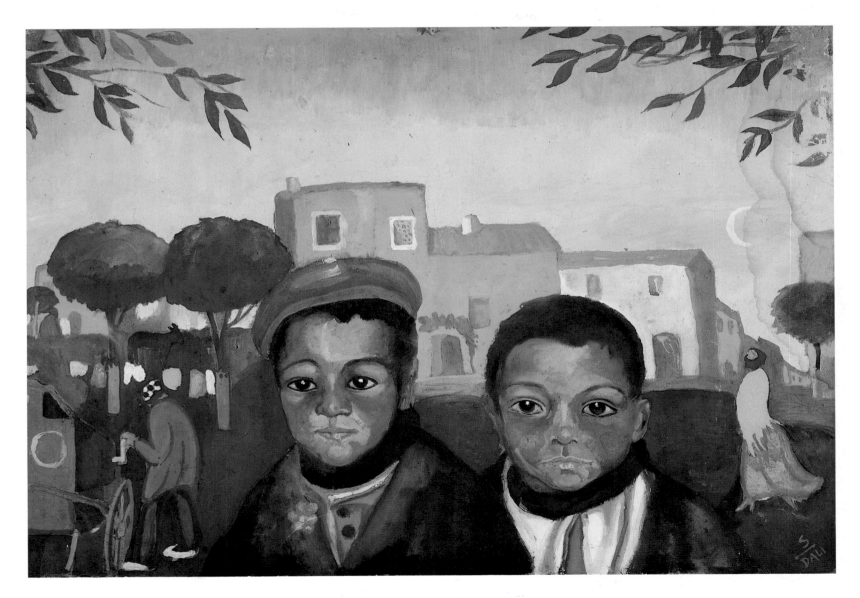

134. *Two Gypsy Lads* (1920–21)

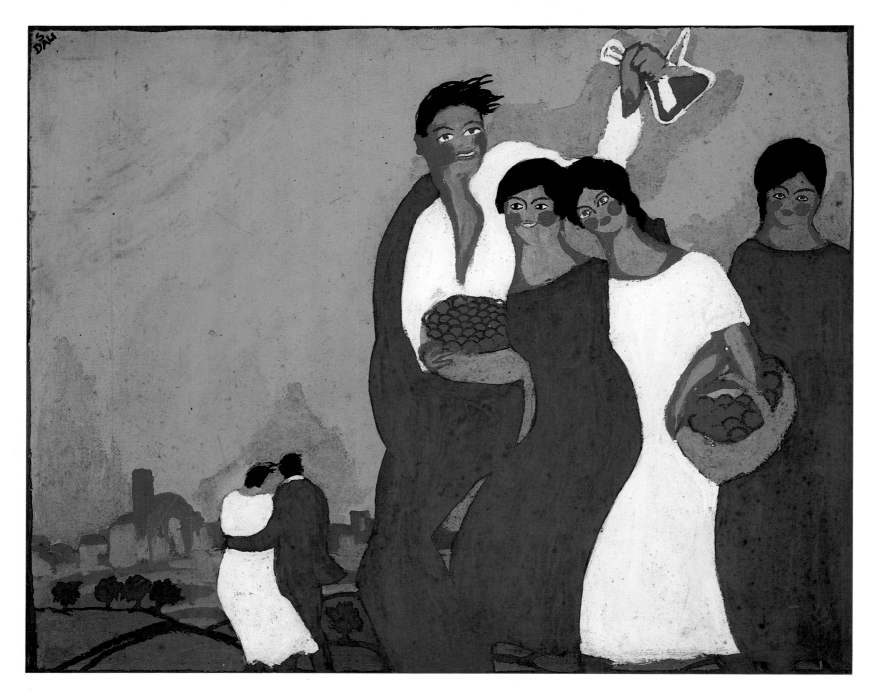

135. *Poster: Fieres i Festes de la Santa Creu* (1921)

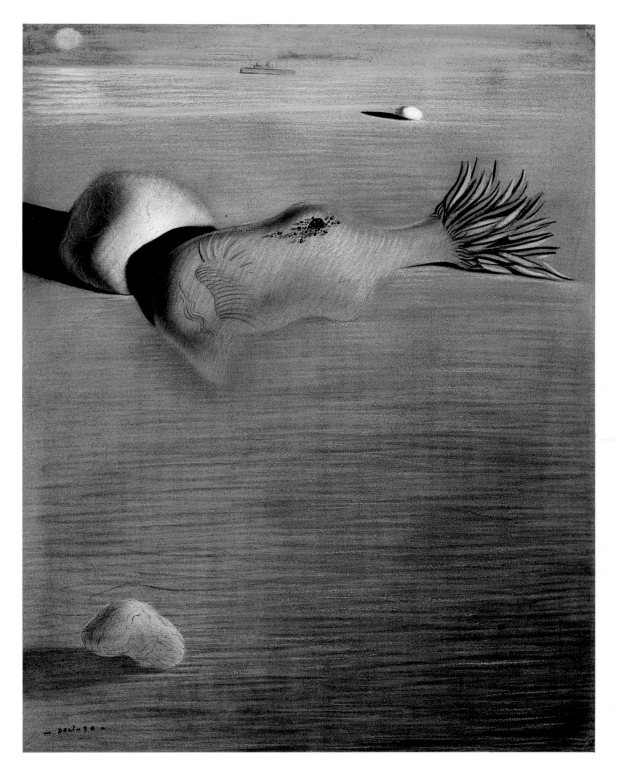

136. *El Gran Masturbateur* (1930)

137. *Decalcomania* (1936)

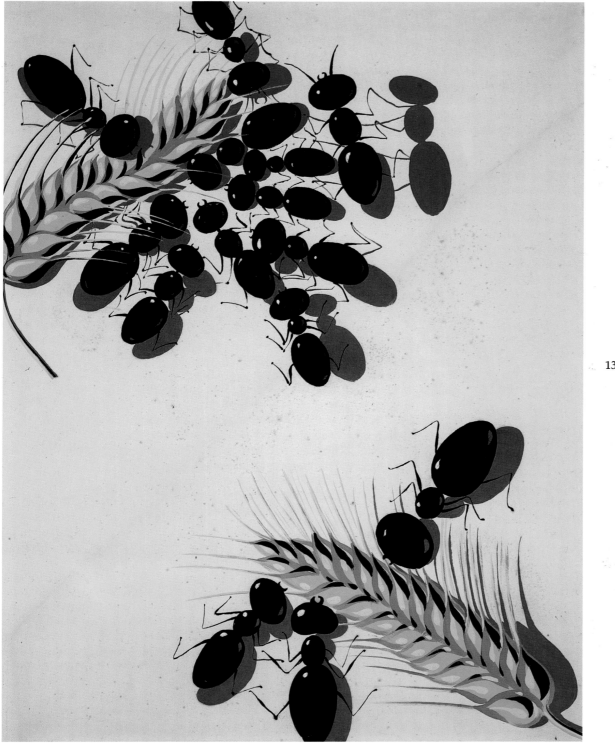

138. *Les Fourmis* (1936–37)

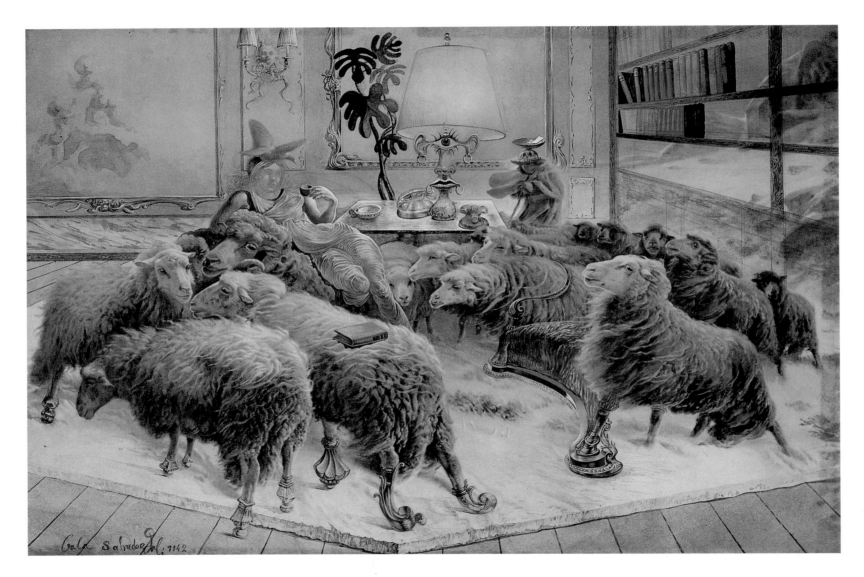

139. *The Sheep* (1942)

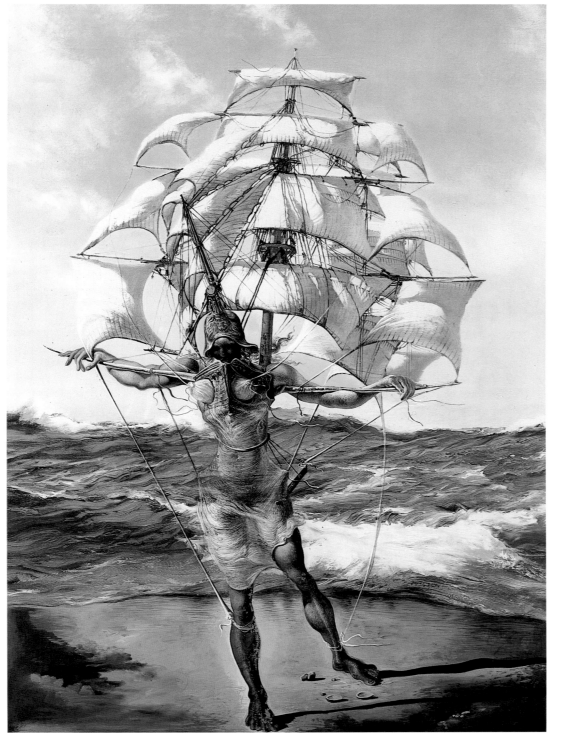

140. *The Ship* (1942–43)

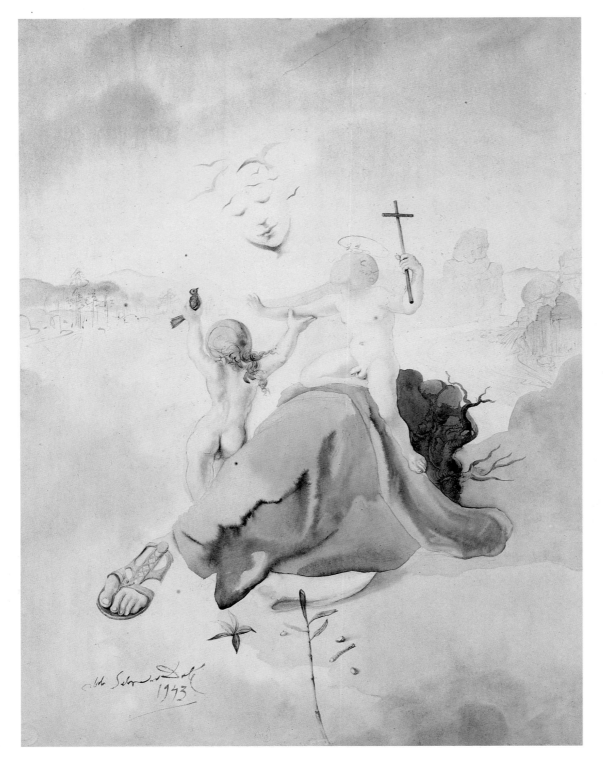

141. *The Madonna of the Birds* (1943)

142. *Future Martyr of Supersonic Waves* (1949–50)

143. *Study for Head of the Madonna of Port Lligat* (1950)

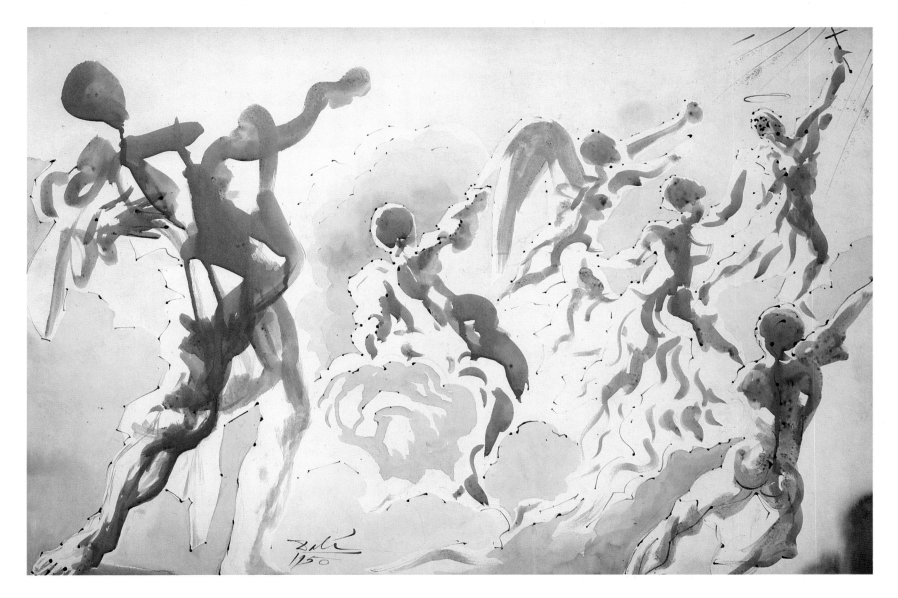

144. *Ascent into the Sky* (1950)

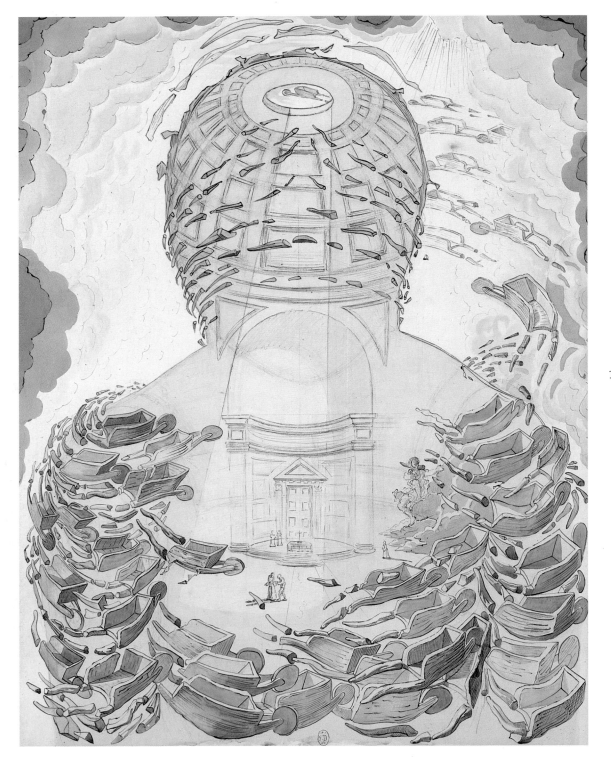

145. *Les Brouettes* (1951)

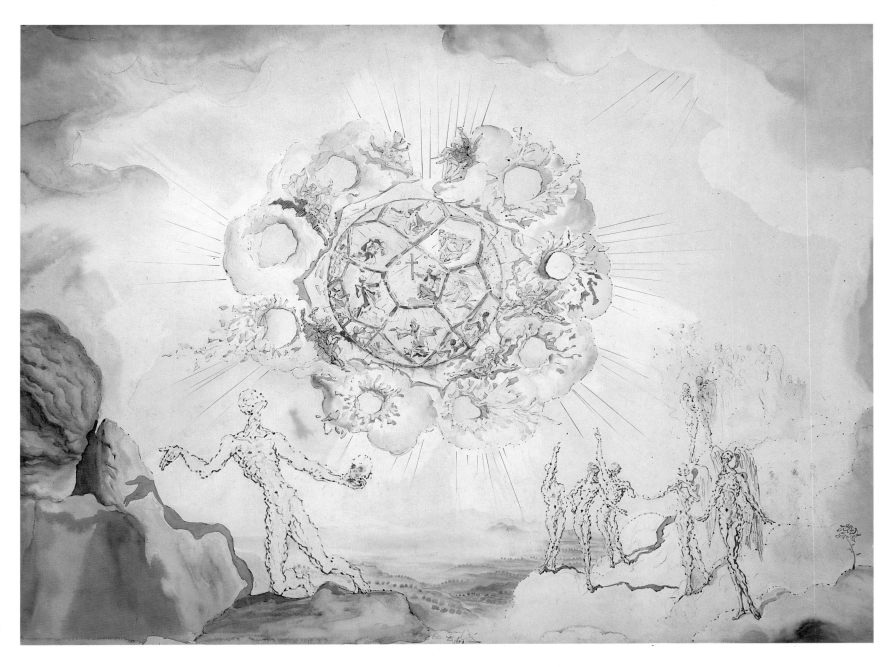

146. *Cosmic Contemplation* (1951)

147. *Opposition* (1952)

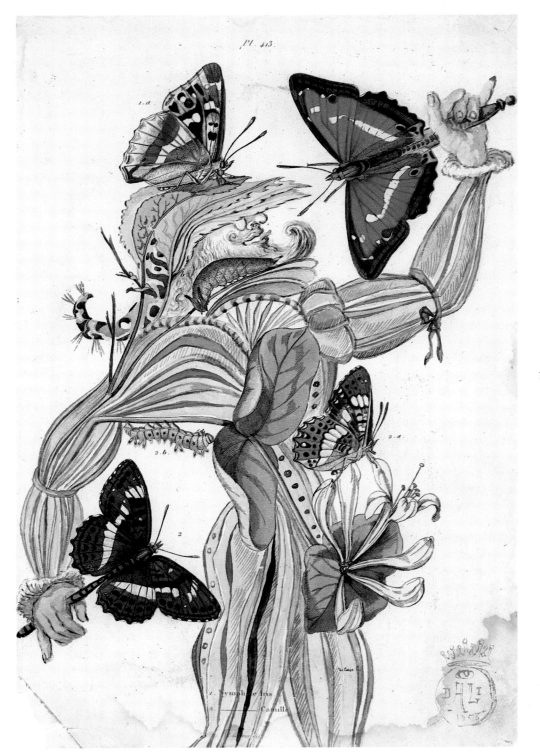

148. Illustration for *Tres Picos* (1955)

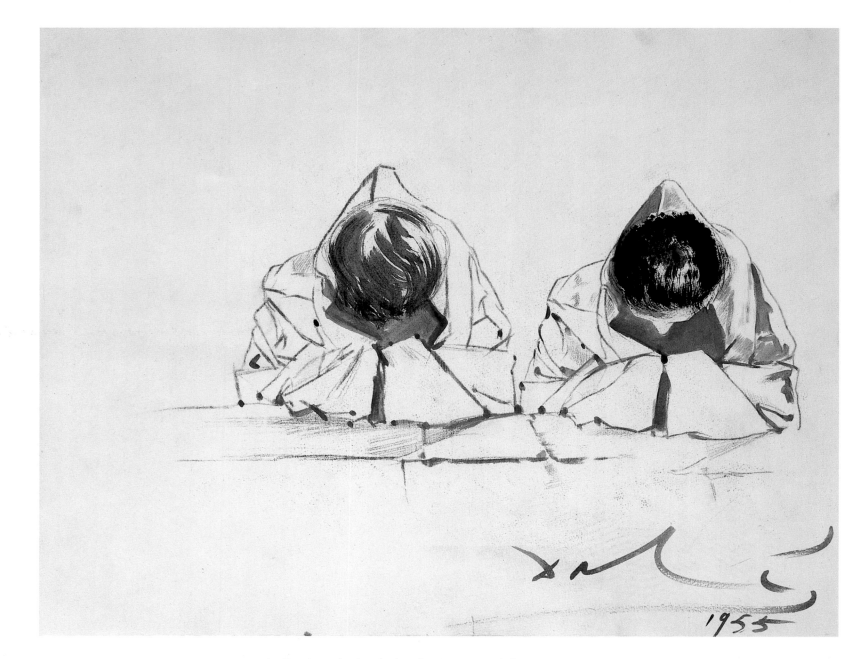

149. *Two Disciples* (Study for *The Sacrament of the Last Supper*) (1955)

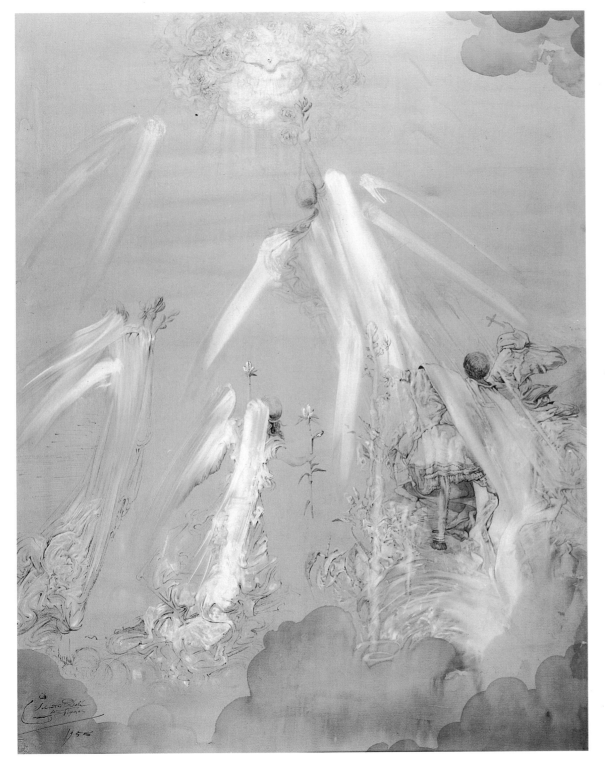

150. *Allegorical Saint and Angels in Adoration of the Holy Spirit* (1958)

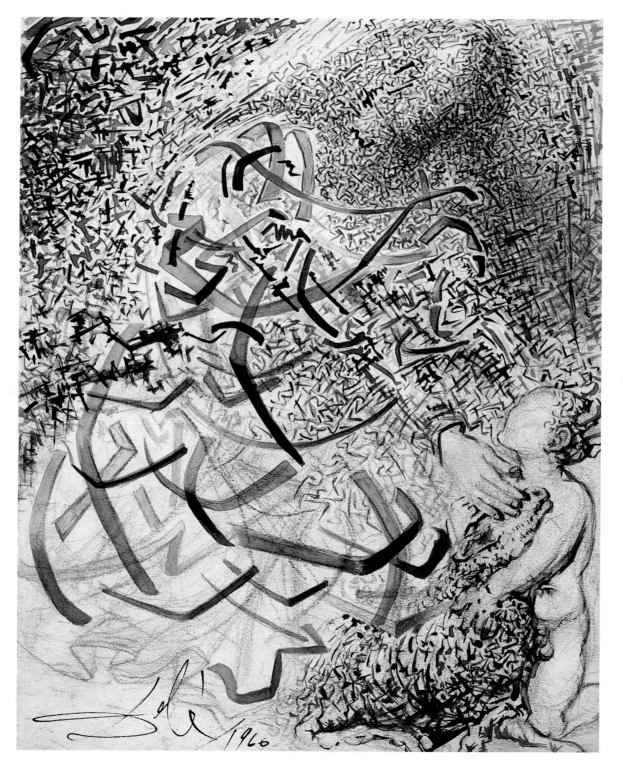

151. *Saint Anne and the Infant* (1960)

152. *The Battle of Tetuan* (1960)

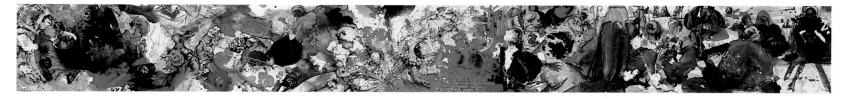

153. *After the Battle* (1960)

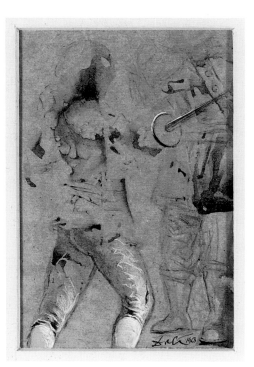
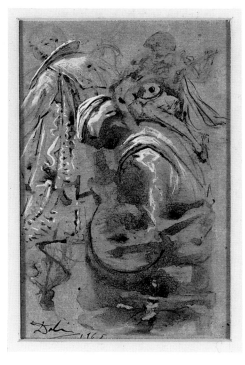
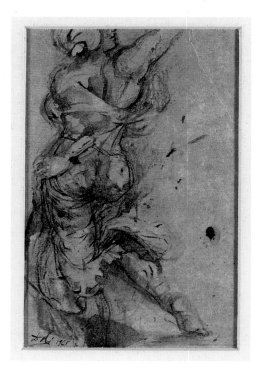

154. *D'Artagnan, Jouene de Luth, Crieuse de Poissons* (1963)

155. *La Soif (Thirst)* (1965)

156. *La Leçon d'Anatomie (The Anatomy Lesson)* (1965)

157. *Hannibal Crossing the Alps* (1970)

158. *Hitler Masturbating* (1973)

159. *Transformation of Antiques magazine cover into the Apparition of a Face (1974)*

List of Illustrations

Paintings

1. *View of Cadaques with Shadow of Mount Pani*
 (1917)
 Oil on canvas
 15½ × 19 inches

2. *Punta es Baluard from Riba d'en Pitxot, Cadaques*
 (1918–19)
 Oil on canvas
 8 × 11 inches

3. *Hort del Llane, Cadaques* (1918–19)
 Oil on canvas
 7⅞ × 10⅞ inches

4. *Port of Cadaques (Night)* (1918–19)
 Oil on canvas
 7⅜ × 9½ inches

5. *Playa Port Alguer from Riba d'en Pitxot* (1918–19)
 Oil on canvas
 8 × 9½ inches

6. *Portdogué, Cadaques* (1918–19)
 Oil on canvas
 8⅜ × 11 inches

7. *View of Portdogué (Port Alguer), Cadaques* (1920)
 Oil on canvas
 17¾ × 20 inches

8. *Self-portrait* (1918–19)
 Oil on canvas
 10½ × 8¼ inches

9. *Self-portrait (Figueres)* (1921)
 Oil on canvas
 14½ × 16½ inches

10. *View of Cadaques from Playa Poal* (1920)
 Oil on canvas
 11½ × 19 inches

11. *Portdogué and Mount Pani from Ayuntamiento*
 (1922)
 Oil on canvas
 17 × 21 inches

12. *Still Life: Pulpo y Scorpa* (1922)
 Oil on canvas
 21⅜ × 22½ inches

13. *Still Life: Fish with Red Bowl* (1923–24)
 Oil on canvas
 19¾ × 21¾ inches

14. *The Lane to Port Lligat with View of Cape Creus*
 (1922–23)
 Oil on canvas
 22¾ × 26¾ inches

15. *Cadaques* (1923)
 Oil on canvas
 38 × 50 inches

16. *Bouquet (L'Important c'est la rose)* (1924)
 Oil on cardboard
 19¾ × 20½ inches

17. *Tieta, "Portrait of My Aunt," Cadaques* (1923–24)
 Oil on canvas
 20¾ × 16¼ inches

18. *Still Life: Sandia* (1924)
 Oil on canvas
 19½ × 19½ inches

19. *Seated Monk* (1925)
 Oil on canvas
 39½ × 27 inches

20. *(Double-sided Verso "Studio Scene")*
 Oil on canvas
 39½ × 27 inches

21. *Study of a Nude* (1925)
 Oil on canvas
 39 × 28 inches

22. *Girl with Curls* (1926)
 Oil on panel
 20 × 15¾ inches

23. *Portrait of My Sister* (1923)
 Oil on canvas
 41 × 29¾ inches

24. *Girl's Back* (1926)
 Oil on panel
 12½ × 10¾ inches

25. *The Basket of Bread* (1926)
 Oil on panel
 12½ × 12½ inches

26. *Femme Couchée* (1926)
 Oil on panel
 10¾ × 16 inches

27. *Apparatus and Hand* (1927)
 Oil on panel
 24½ × 18¾ inches

28. *The Bather* (1928)
 Oil on panel
 20½ × 28¼ inches

29. *Beigneuse [sic]* (1928)
 Oil on panel
 25 × 29½ inches

30. *Ocell . . . Peix* (1927–28)
 Oil on panel
 24 × 19½ inches

31. *Dit Gros etc. (Big Thumb, Beach, Moon and Decaying Bird)* (1928)
 Oil on panel
 19¾ × 24 inches

32. *Anthropomorphic Beach* (fragment) (1928)
Painted cork
19 × 11 inches

33. *The Ram (Vache Spectrale)* (1928)
Oil on panel
19¾ × 25 inches

34. *The First Days of Spring* (1929)
Oil on panel
19¾ × 25⅝ inches

35. *Profanation of the Host* (1929)
Oil on canvas
39⅜ × 28¾ inches

36. *The Font* (1930)
Oil on panel
26 × 16¼ inches

37. *La Main (Les Remords de conscience)* (1930)
Oil on canvas
16¼ × 26 inches

38. *The Average Bureaucrat* (1930)
Oil on canvas
31⅞ × 25¾ inches

39. *Shades of Night Descending* (1931)
Oil on canvas
24 × 19¾ inches

40. *Au Bord de la Mer* (1931)
Oil on canvas
13¼ × 10⅜ inches

41. *Suez* (1932)
Oil on canvas
18½ × 18½ inches

42. *Oeufs sur le Plat sans le Plat* (1932)
Oil on canvas
23¾ × 16½ inches

43. *Catalan Bread* (1932)
Oil on canvas
9⁹⁄₁₆ × 13 inches

44. *The Invisible Man* (1932)
Oil on canvas
6½ × 9⅜ inches

45. *Memory of the Child-Woman* (1932)
Oil on canvas
39 × 47¼ inches

46. *Fantasies Diurnes* (1932)
Oil on canvas
32 × 39½ inches

47. *Portrait of Gala* (1932–33)
Oil on panel
Actual size 3⁷⁄₁₆ × 2⅝

48. *Sugar Sphinx* (1933)
Oil on canvas
28⅝ × 23½ inches

49. *Untitled (Persistence of Fair Weather)* (1932–34)
Oil on canvas
26¼ × 18½ inches

50. *Average Atmospherocephalic Bureaucrat in the Act of Milking a Cranial Harp* (1933)
Oil on canvas
8¾ × 6½ inches

51. *Myself at the Age of Ten When I Was the Grasshopper Child* (1933)
Oil on panel
8⅝ × 6⅜ inches

52. *The Ghost of Vermeer of Delft Which Can Be Used as a Table* (1934)
Oil on panel
7⅛ × 5½ inches

53. *Skull with Its Lyric Appendage Leaning on a Night Table Which Should Have the Exact Temperature of a Cardinal Bird's Nest* (1934)
Oil on panel
9½ × 7½ inches

54. *Atmospheric Skull Sodomizing a Grand Piano* (1934)
Oil on panel
5½ × 7 inches

55. *Surrealist Poster* (1934)
Oil on cardboard, with key
27 × 28 inches

56. *The Weaning of Furniture-Nutrition* (1934)
Oil on panel
7 × 9½ inches

57. *Meditation on the Harp* (1932–34)
Oil on canvas
26¼ × 18½ inches

58. *Archeological Reminiscence of Millet's Angelus* (1933–35)
Oil on panel
12½ × 15½ inches

59. *The Javanese Mannequin* (1934)
Oil on canvas
25½ × 21¼ inches

60. *Puzzle of Autumn* (1935)
Oil on canvas
38½ × 38½ inches

61. *Paranonia* (1935–36)
Oil on canvas
15 × 18⅛ inches

62. *The Man with the Head of Blue Hortensias* (1936)
Oil on canvas
6⅜ × 8⅝ inches

63. *Three Young Surrealist Women Holding in Their Arms the Skins of an Orchestra* (1936)
Oil on canvas
21¼ × 25⅝ inches

64. *Morphological Echo* (1936)
Oil on panel
12 × 13 inches

65. *Morphological Echo* (1934–36)
Oil on canvas
25½ × 21¼ inches

66. *Anthropomorphic Echo* (1937)
Oil on panel
5⅝ × 20⅜ inches

67. *Enchanted Beach with Three Fluid Graces* (1938)
Oil on canvas
25⅝ × 32 inches

68. *Telephone in a Dish with Three Grilled Sardines at the End of September* (1939)
Oil on canvas
18 × 21⅝ inches

69. *Old Age, Adolescence, Infancy (The Three Ages)* (1940)
Oil on canvas
19⅝ × 25⅝ inches

70. *Daddy Longlegs of the Evening — Hope!* (1940)
Oil on canvas
10 × 20 inches

71. *Slave Market with the Disappearing Bust of Voltaire* (1940)
Oil on canvas
18¼ × 25¾ inches

72. *Disappearing Bust of Voltaire* (1941)
Oil on canvas
18¼ × 21¾ inches

73. *Tristan Fou* (1938–39)
Oil on panel
18 × 21⅝ inches

74. *Sentimental Colloquy* (1944)
Oil on canvas
10¾ × 16⅛ inches

75. *Geopoliticus Child Watching the Birth of the New Man* (1943)
Oil on canvas
18 × 20½ inches

76. *The Broken Bridge and the Dream* (1945)
Oil on canvas
26¼ × 34³⁄₁₆ inches

77. *Autumn Sonata* (1945)
Oil on canvas
6½ × 12 inches

78. *Fountain of Milk Spreading Itself Uselessly on Three Shoes* (1945)
Oil on canvas
7¼ × 8½ inches

79. *Landscape of Port Lligat* (1950)
Oil on canvas
23 × 31 inches

80. *The Angel of Port Lligat* (1952)
Oil on canvas
23 × 30¾ inches

81. *Eucharistic Still Life (Nature Morte Évangélique)* (1952)
Oil on canvas
21½ × 34¼ inches

82. *The Disintegration of the Persistence of Memory* (1952–54)
Oil on canvas
10 × 13 inches

83. *Noon (Barracks Port Lligat)* (1954)
Oil on canvas
14¾ × 16⅝ inches

84. *Two Adolescents* (1954)
Oil on canvas
22 × 25½ inches

85. *Nature Morte Vivante (Still Life — Fast Moving)* (1956)
Oil on canvas
49¼ × 63 inches

86. *Sainte Hélèna à Port Lligat* (1956)
Oil on canvas
12¼ × 16¾ inches

87. *Dionysus Spitting the Complete Image of Cadaques on the Tip of the Tongue of a Three-Storied Gaudinian Woman* (1958–60)
Oil on panel
12¼ × 9 inches

88. *Velázquez Painting the Infanta Margarita with the Lights and Shadows of His Own Glory* (1958)
Oil on canvas
60½ × 36¼ inches

89. *Beatrice* (1958–60)
Oil on canvas
15½ × 11¾ inches

90. *The Discovery of America by Christopher Columbus* (1958–59)
Oil on canvas
161½ × 122⅛ inches

91. *The Ecumenical Council* (1960)
Oil on canvas
118 × 100 inches

92. *The Hallucinogenic Toreador* (1969–70)
Oil on canvas
157 × 118 inches

Drawings and Watercolors

93. *Christ en Perspective* (1950)
Sanguine
30 × 40 inches

94. Childhood Sketch, *Witches and the Fall of Eve*
(1916–18)
Ink
8¾ × 9 inches

95. *Cadaques* (1917–18)
Charcoal
13⅝ × 9 inches

96. *Portrait of Joaquim Montaner (Alegória del
Navigante)* (1919–20)
Charcoal
23½ × 18½ inches

97. *Cubist Study of Figures on a Beach* (1923–25)
Ink
7¾ × 10 inches

98. *Figure in Flames* (1923–25)
Ink
12½ × 9½ inches

99. *Barracks — Cadaques* (1923)
Pencil
12¼ × 9 inches

100. *Femme Couchée (Nu Allongé)* (1926)
Pencil
5 × 5¾ inches

101. *Female Nude* (1926)
Pencil
9³⁄₁₆ × 8 inches

102. *The Bather* (1927)
Ink
9½ × 12½ inches

103. *Gradiva* (1930)
Ink with pencil shading
13¾ × 9¾ inches

104. *Figures after William Tell* (1932)
Red and black ink
10 × 5¾ inches

105. Studies for *Weaning of Furniture-Nutrition,
Cannibalism of Autumn,* and *The Grasshopper
Child* (1932–33)
Pencil
9 × 8 inches

106. Study for *Portrait of the Vicomtesse de Noailles*
(1933)
Pencil
9½ × 6¾ inches

107. *The Enigma of William Tell with the Apparition
of a Celestial Gala* (1933)
Ink and pencil
6¾ × 8¾ inches

108. *Surrealist Figure in Landscape of Port Lligat*
(1933)
Ink
42 × 30 inches

109. *Femme-Cheval* (1933)
Ink
20¾ × 14⅝ inches

110. *Homage to the Angelus of Millet* (1934)
Ink
7¼ × 4¼ inches

111. *The Nostalgic Echo* (Frontispiece of *Nuits
Partagées* by Paul Eluard) (1935)
Pencil
11½ × 8¼ inches

112. *Conic Anamorphosis* (1934)
Ink
11½ × 8¾ inches

113. *Pastiche (after Dürer)* (1936)
Ink
10 × 7⅝ inches

114. *Freudian Portrait of a Bureaucrat* (1936)
Pencil
10¾ × 7⅞ inches

115. *Dîner dans le désert éclairé par les girafes en feu* (1937)
Charcoal
24¼ × 18 inches

116. *L'Arc Hystérique (The Hysterical Arch)* (1937)
Ink
22 × 30 inches

117. *William Tell Group* (1942–43)
Pencil
12⅛ × 18½ inches

118. *The Esthetic Is the Greatest of Earthly Enigmas* (1943)
Red and black ink
11 × 8¼ inches

119. *Kneeling Figure in Decomposition* (1950–51)
Ink with wash
9½ × 6⅜ inches

120. *Soft Watch Exploding* (1954)
Ink
5½ × 7½ inches

121. *Seven Flies (and a Model)* (1954)
Ink
6 × 9 inches

122. *Combat* (1955)
Ink with wash
6⅜ × 9¼ inches

123. *Compotier et Fruits* (Study for *Nature Morte Vivante*) (1956)
Pencil
16¼ × 21½ inches

124. *Annunciation* (1956)
Ink
17 × 22 inches

125. *Ange Pi-mesonic (Pi-mesonic Angel)* (1958)
Ink with pencil and gouache
16 × 12 inches

126. *Coronation of Pope John 23rd* (1958)
Red, blue and black ink
21½ × 14¾ inches

127. *Oreille de Sainteté Jean XXIII (The Ear of His Holiness Pope John 23rd)* (1959)
Ink with pencil and gouache
21⅛ × 14¾ inches

128. *St. Luke* (1959)
Ink
9¾ × 11½ inches

129. *The Sick Child* (1914–15)
Gouache and oil on cardboard
22⅝ × 20¼ inches

130. *Fiesta in Figueres* (1914–16)
Gouache and oil on cardboard
22½ × 20½ inches

131. *Old Man of Portdogué* (1919–20)
Watercolor
4½ × 5 inches

132. *La Sardana de las Brujas (The Sardana of the Witches)* (circa 1920)
Watercolor
16½ × 23½ inches

133. *Saltimbanques* (1920–21)
Gouache
6¾ × 5⅜ inches

134. *Two Gypsy Lads* (1920–21)
Gouache
20½ × 29½ inches

135. *Poster: Fieres i Festes de la Santa Creu* (1921)
Gouache
16½ × 25½ inches

136. *El Gran Masturbateur* (1930)
Pastel
25½ × 19¼ inches

137. *Decalcomania* (1936)
Gouache on black paper
12 × 15 inches

138. *Les Fourmis* (1936–37)
Gouache on tinted paper
26 × 19½ inches

139. *The Sheep* (1942)
Watercolor conversion of print of painting by Schenck
9 × 13½ inches

140. *The Ship* (1942–43)
Watercolor conversion of print of painting by Montague Dawson (*Wind and Sun . . . The Lightning*)
25 × 18 inches

141. *The Madonna of the Birds* (1943)
Watercolor
24½ × 18½ inches

142. *Future Martyr of Supersonic Waves* (1949–50)
Gouache with pencil
5½ × 10¾ inches

143. *Study for Head of the Madonna of Port Lligat* (1950)
Ink with sanquine wash
19⅞ × 12⅜ inches

144. *Ascent into the Sky* (1950)
Wash
20 × 29¾ inches

145. *Les Brouettes* (1951)
Wash and pencil
40 × 30 inches

146. *Cosmic Contemplation* (1951)
Watercolor and ink
30½ × 40½ inches

147. *Opposition* (1952)
Watercolor and ink
17 × 12 inches

148. Illustration for *Tres Picos* (1955)
Watercolor and ink conversion of print
10¾ × 7¼ inches

149. *Two Disciples* (Study for *The Sacrament of the Last Supper*) (1955)
Watercolor
20 × 26 inches

150. *Allegorical Saint and Angels in Adoration of the Holy Spirit* (1958)
Watercolor
39¾ × 29½ inches

151. *Saint Anne and the Infant* (1960)
Watercolor
9½ × 7¼ inches

152. *The Battle of Tetuan* (1960)
Gouache
2⅞ × 25⅜ inches

153. *After the Battle* (1960)
Gouache
2⅞ × 25⅜ inches

154. *D'Artagnan, Jouene de Luth, Crieuse de Poissons* (1963)
Watercolor and gouache with pen and ink
Each 2¾ × 4¼ inches

155. *La Soif (Thirst)* (1965)
Ink and gouache
11½ × 18 inches

156. *La Leçon d'Anatomie (The Anatomy Lesson)* (1965)
Ink
13½ × 18¼ inches

157. *Hannibal Crossing the Alps* (1970)
Watercolor and gouache
28¾ × 39 inches

158. *Hitler Masturbating* (1973)
Paranoiac-critical conversion
6¾ × 8¾ inches

159. *Transformation of* Antiques *magazine cover into the Apparition of a Face* (1974)
Paranoiac-critical conversion
11½ × 8¾ inches

Chronology

1904 Salvador Dali born in Figueres (formerly Figueras), Spain, on May 11, in the district of Girona in Catalonia, the son of Salvador Dali y Cusi, a notary, and Felipa Domenech.

1914 Dali begins his education at a private school run by the Brothers of the Marist Order in Figueres.

1917 Studies drawing under Professor Juan Nuñez at the Municipal School of Drawing in Figueres.

Early Works, 1917–1927

1918 The city of Figueres presents two exhibits of works arranged by Dali's father in the upper foyer of the town theater, which is now converted into the Teatro Museo Dali. Dali experiments with Impressionism and Pointillism.

1919 Contributes articles and illustrations to the local review *Studium*, later published by the Institute of Figueres.

1921–22 Dali attends the San Fernando Academy of Fine Arts in Madrid, where he meets Federico García Lorca and Luis Buñuel. Exhibits paintings in a student art show at the Dalmau Gallery, Barcelona. Experiments with Cubism.

1923 Dali suspended from the San Fernando Academy of Fine Arts on the charge of inciting a student rebellion against school authorities.

1924 Dali imprisoned for thirty-five days in Girona for alleged subversion. Illustrates *Les Bruixes de Llers* by C. Fages de Climent.

1925 Dali returns to the San Fernando Academy of Fine Arts in Madrid. His first one-man show is held at the Dalmau Gallery in Barcelona. Numerous contributions to *Gaseta de les artes*. Receives considerable local notice as a leading young Catalan painter.

1926 His first trip to Paris with his aunt and his sister, Ana María, where he visits Picasso and Miró. His second one-man show held at the Dalmau Gallery in Barcelona.

Dali expelled from the San Fernando Academy for refusal to take his final examination on grounds that he knows more than the professors who will quiz him.

1927 Dali called to the Castle of San Fernando to do nine months military service. Collaborates regularly on the journal *L'Amic de les arts*, in which his first major written work, "Saint Sebastian," appears.

Transition, 1928

1928 On Dali's second visit to Paris, Miró introduces him to the Dadaists and the Surrealist group. Publishes the *Manifest Groc* in Sitges, Spain, with Lluis Montanyà and Sebastià Gasch. Participates in the Annual International Exhibition of Paintings at the Carnegie Institute in Pittsburgh, Pennsylvania, exhibiting *The Basket of Bread*.

Executes a series of gravel collages revealing the influence of Gris, Picasso, Ernst, Miró, Arp, and other contemporaries.

Surrealism, 1929–1941

1929 Dali first meets Gala Eluard when she visits Cadaques with her husband, the French poet Paul Eluard. She will become Dali's lover, his muse and inspiration.

Dali's first one-man show in Paris, at Goeman's Gallery. *Un Chien andalou*, for which Dali and Luis Buñuel wrote the scenario, is shown at Ursulines Film Studio in Paris "amid much scandal and sensation."

Contributes seven articles to *L'Amic de les arts*, including "Review of Antiartistic Tendencies," a veritable defense of *La Revue surréaliste*, in which Dali takes a strong stand against all academicism.

1930 Publishes in the magazine *Le Surréalisme au service de la révolution* a long poem-manifesto, "L'Ane pourri," in which he expounds his theory of the paranoiac process of thought. Writes and illustrates *La Femme visible* (Edition Suréalistes, Paris) dedicated to Gala. Collaborated with Buñuel on the scenario of *L'Age d'or*. This film, which caused a scandal, was shown at Studio 28 in Paris. The League of Patriots and others rioted in protest against the film, destroying many Surrealist works exhibited in the lobby.

1931 Gala and Dali settle in Port Lligat. Exhibit at the Pierre Colle Gallery in Paris.

1932 *The Persistence of Memory* is first exhibited in a Surrealist retrospective at the Julien Levy Gallery in New York. Dali writes scenario, *Babaouo*, which was never filmed. This work contains a critique on the cinema and an essay on *William Tell*. Pierre Colle Gallery presents one-man show.

1933 Collectors and friends form "The Zodiac" group, whose purpose is to subsidize the Catalan artist. Julien Levy Gallery organizes Dali's first one-man show in New York. Dali continues to collaborate with the magazines *Le Surréalisme au service de la révolution* and *Minotaure*. His first Surrealist works shown in Spain, at the Galerie Catalane in Barcelona.

1934 Gala and Dali are married in a civil ceremony on January 30. Dali's first one-man show in London is held at the Zwemmer Gallery. Dali expelled from the Surrealist movement but continues as a peripheral figure. Produces forty-two etchings to illustrate *Les Chants de Maldoror* by Comte de Lautreamont for Albert Skira. Dali and Gala make their first trip to New York, and his series of special illustrations

of the city appears in the *American Weekly* from February to July. Exhibits at Julien Levy Gallery on Madison Avenue in New York.

1935 Julien Levy publishes *The Conquest of the Irrational* in New York and Paris. This major essay expounds on his "paranoiac-critical method," a "spontaneous method of irrational knowledge based on the interpretive-critical association of delirious phenomena." Dali lectures at the Museum of Modern Art on "Surrealist Paintings and Paranoiac Images."

1936 Dali gives lecture in diving suit on the occasion of the International Surrealist Exhibition in London. Spanish Civil War forces Dali to leave Spain. Signs contract with the English collector Edward F. W. James, whose patronage will subsidize Dali's career through 1938. Dali appears on the cover of *Time* magazine in December.

1937 Dali visits Harpo Marx in Hollywood to write the scenario for "Giraffes on Horseback Salad." Writes *The Metamorphosis of Narcissus*, a "poeme paranoiaque" illustrating his double-image painting of the same name. In three visits to Italy, he studies Palladio and is increasingly influenced by the Renaissance and baroque painters. Dali designs dresses and hats for Elsa Schiaparelli.

1938 Dali introduced to Sigmund Freud by Stefan Zweig in London. Participates in the International Surrealist Exhibition in Paris, then drifts away from the Surrealist movement asserting "L'Surréalisme — C'est moi!"

1939 In New York, Dali accidentally crashes through Bonwit Teller's window to international fame while rearranging a Surrealist window display. Dali's *Declaration of Independence of the Imagination and the Rights of Man to His Own Madness* published in defense of His "Dream of Venus" exhibit for the New York World's Fair. The ballet *Bacchanale* premiers at the Metropolitan Opera House; scenario, costumes, and scenery by Dali. Dali returns to France.

1940 The Dalis flee from Arcachon, France, shortly before the Nazi invasion, taking the S.S. *Excambion* from Lisbon to the United States with passage paid by Picasso. Remain in exile in the United States until 1948, arriving first at the Hampton Manor in Virginia (the home of Dali's friend Caresse Crosby), then traveling between the Del Monte Lodge in Pebble Beach, California, and the St. Regis Hotel in New York.

1941 Dali exhibits at the Julien Levy Gallery in New York, the Art Club of Chicago, and the Dalzell Hatfield Gallery in Los Angeles. His first major retrospective exhibition held at the Museum of Modern Art, New York, in conjunction with a show of Miró. His ballet *Labyrinth* opens in New York. The Museum of Modern Art show travels to Cleveland, Detroit, and Chicago in 1941–42.

Classic Era, 1943 to Present

1943 The Morses (donors of the St. Petersburg Museum collection) purchase their first Dali painting, *Daddy Longlegs of the Evening — Hope!* Dali's autobiography, *The Secret Life of Salvador Dali*, published by Dial Press, New York. Dali creates the first series of jewels for the Duke de Verdura.

Dali exhibits portraits of American personalities at the Knoedler Gallery in New York. The Morses attend the show and meet Dali and Gala. Completes studies for three murals for New York apartment of Helena Rubenstein.

1944 Dali designs costumes and sets for three ballets: *Sentimental Colloquy, Mad Tristan,* and *El Café de Chinitas.* His novel *Hidden Faces* published by Dial Press. Commissioned by Billy Rose to do seven paintings to illustrate the "seven lively arts" for the lobby of the Ziegfeld Theater. Creates a second series of jewels for Carlos Alemany.

1945 *Dali News* published for his exhibition at the Bignou Gallery in New York. Illustrates *The Maze* by Maurice Sandoz and the dust jacket for an anthology on demonology entitled *Speak of the Devil.*

1946 Dali works with Walt Disney on a film called *Destino*, which was never made, and designs dream sequences for Alfred Hitchcock's movie *Spellbound.* Illustrates *Macbeth* and *Don Quixote.*

1947 Cleveland Museum of Art organizes Dali retrospective in which eleven paintings from the Morse Collection are exhibited.

1948 Illustrates *Fifty Secrets of Magic Craftsmanship.* Dali returns to Spain. Designs sets and costumes for *As You Like It* by Shakespeare at the Eliseo Theater in Rome.

1949 The artist produces his first large-sized canvas, *Madonna of Port Lligat*, measuring twelve by eight feet, for a new series of "classical and religious" artworks.

1950 Exhibits *The Temptation of Saint Anthony* at the Carnegie Institute in Pittsburgh.

1951 Writes *Manifeste Mystique* to explain his nuclear mysticism. Paints *Christ of St. John of the Cross.*

1952 Dali and Gala, accompanied by the Morses, travel to Iowa, Missouri, Texas, and Florida, where Dali gives a series of lectures on nuclear mysticism in his art. Exhibits *Assumpta Corpuscularia Lapislazulina* at the Julien Levy Gallery in New York.

1953 Writes a scenario for *The Flesh Wheelbarrow* at the Del Monte Lodge in California. The film was never made.

1954 Dali works with Robert Descharnes on a still-unfinished film entitled *The Prodigious Story of the Lacemaker and the Rhinoceros.* Holds exhibits in Rome, Venice, and Milan, where he shows, among other works, 102 watercolors illustrating the *Divine Comedy* by Dante. Publishes *Dali's Moustache* with photographer Philippe Halsman.

1955 Dali gives lecture at the Sorbonne in Paris, "The Phenomenological Aspects of the Paranoiac-Critical Method."

1956 *The Sacrament of the Last Supper* is exhibited at the National Gallery in Washington on loan from the Chester Dale Collection. Large retrospective exhibition opens at Knokke-le-Zoute, Belgium. Dali writes treatise *Dali on Modern Art.*

1957 Commissioned by French publisher Joseph Foret to produce fifteen lithographs to illustrate *Don Quixote.*

1958 Dali and Gala married in religious ceremony at la Capella de la Mare de Deu dels Angels in Girona, Spain.

The New York Graphic Society publishes the first monograph on Dali's art, written by Mr. A. Reynolds Morse.

1959 Finishes painting *The Discovery of America by Christopher Columbus,* the first in a series of monumental canvases depicting historical and Spanish myths.

1960 *Ecumenical Council* exhibited at Carstairs Gallery in New York.

1961 Dali writes story and designs sets and costumes for *Ballet de Gala,* premiered at the Teatro Fenice in Venice. Dali gives first lecture at the École Polytechnique on the myth of Castor and Pollux.

1962 Exhibits *The Battle of Tetuan* beside the canvas on the same subject by Fortuny in the Palacio Tinell in Barcelona.

1963 Knoedler Gallery in New York exhibits Dali's work featuring *Galacidalacidesoxiribunucleic-acid.* Dali publishes *The Tragic Myth of Millet's Angelus,* a manuscript in French that had been lost for twenty-two years. *Dali de Gala* is published by Robert Descharnes.

1964 Dali awarded one of Spain's highest decorations, the Grand Cross of Isabella the Catholic. Publishes a sequel to his autobiography, *The Diary of a Genius.* Important retrospective show opens in Tokyo, Japan.

1965 The Gallery of Modern Art at Columbus Circle in New York holds a major retrospective exhibition of 370 works, which includes the entire Morse Collection. Dali publishes *Open Letter to Salvador Dali.* Produces a series of illustrations for a new edition of the Bible. Creates first important sculpture, the *Bust of Dante.*

1966 Designs First Day Cover for the twenty-year anniversary of the World Federation of United Nations Association.

1967 Completes *Tuna Fishing* for presentation at the Hotel Meurice in Paris. Rizzoli publishes *The Dali Bible.* Jean-Christophe Averty makes film with Dali called *A Soft Self-Portrait.*

1968 Dali writes tract entitled *My Cultural Revolution,* which is distributed to the rioting students at the Sorbonne in Paris while Dali flees to Port Lligat.

1969 Starts painting *The Hallucinogenic Toreador.*

1970 Dali finishes *The Hallucinogenic Toreador.* An important European retrospective opens at the Boymans-van Beuningen Museum in Rotterdam.

1971 Mr. and Mrs. A. Reynolds Morse open their Dali collection to the public in a wing of their office building. Dali comes to Cleveland for the official opening on March 7, 1971.

1972 Knoedler Gallery in New York exhibits Dali holograms.

1973 British Broadcasting Company films documentary, *Hello Dali,* in Port Lligat.

1974 Teatro Museo Dali is inaugurated in Figueres, Spain.

1975 The film made by Dali on tape, *Impressions from Upper Mongolia (Homage to Raymond Roussel),* is produced by German television.

1978 Exhibits first hyper-stereoscopic painting, *Dali Lifting the Skin of the Mediterranean Sea to Show Gala the Birth of Venus,* at the Solomon R. Guggenheim Museum in New York.

1979 Dali inducted into France's prestigious Académie Française des Beaux-Arts. Retrospective at the Georges Pompidou Center opens in Paris.

1980 The Tate Gallery, London, holds a slightly smaller version of the massive Pompidou retrospective.

1981 Dali's "Art in Jewels" (the Catherwood and Cheatham collections) sold to Japanese investors for $3.9 million.

1982 Salvador Dali Museum opens in St. Petersburg, Florida, exhibiting works from the collection of Mr. and Mrs. A. Reynolds Morse.

Gala dies in Pubol, Spain, on June 10.

King Juan Carlos confers the title of Marquis of Dali of Pubol on Salvador Dali for the artist's exceptional contribution to Spanish culture.

1983 The first major Spanish exhibition "Four Hundred Works of Salvador Dali, 1914–1983" is shown in Madrid and Barcelona, Spain.

1984 The Gala-Salvador Dali Foundation is established in Figueres, Spain.

Dali suffers severe burns in a bedroom fire at his castle in Pubol, Spain, for which he undergoes surgery. Afterward, goes into total seclusion in an apartment in the Torre Galatea adjacent to his museum in Figueres.

1985 After five years of silence and seclusion, Dali protests against his exploiters.

Dali joins campaign to make Barcelona the site of the 1992 Olympic Games. He gives reproduction rights of *The Cosmic Athlete* for use on a promotional poster. Dali is said to deny rumors of his being held captive in the Torre Galatea.

Dali appears on television for the first time in six years to announce recent donation of works to the Teatro Museo Dali in Figueres, Spain.

Madrid official announces that Dali has agreed to design a plaza for the city, costing $1.5 million, which will include a huge dolmen.

1986 The Salvador Dali Museum, St. Petersburg, Florida exhibits the first public showing of Dali's forty-eight sculptures donated to the Museum by Isidro Clot.

New York Grand Jury indicts seven people for misrepresentation of reproductions as Dali "lithographs."

Dali receives pacemaker after suffering heart failure.

Madrid unveils the square designed by Dali consisting of his sculpture *Homage to Newton*. Weighing one ton, it is a salute to gravity. Facing it is a dolmen of granite propped up on three cement legs.

Shelby Fine Arts Gallery owners in Albuquerque, New Mexico, indicted on fourteen counts alleging fraud, criminal conspiracy, and criminal solicitation in regard to the sale of Dali's graphics.

Dali allows photographer Helmut Newton from *Vanity Fair* magazine to photograph him in a satin gown. He wears the Grand Cross of Isabella the Catholic and displays the tube in

his nose through which he has been fed for over four years due to a psychological problem with swallowing.

1987 Dali in extreme depression.

Manhattan couple convicted in state supreme court on charges of selling spurious Dali lithographs as "art investments."

A Japanese group representing a Tokyo museum purchases *Lincoln in Dalivision* for $2.3 million. The work is loaned for two years to the Salvador Dali Museum in Florida. Dali's former secretary, Captain Peter Moore, announces the donation of three hundred paintings to Spain.

Shelby Fine Arts Gallery owners are convicted after pleading guilty in art-fraud case concerning Dali graphics.

Battle of Tetuan brings $2.4 million at auction. Sold to Japanese investors.

1988 Dali donates the painting *The Birth of a Goddess* to Jordi Pujol, President of the Catalan government. The first Soviet exhibit of Dali's work opens in Moscow at the Pushkin Museum of Art, featuring two hundred graphic works from the French collector and publisher Pierre Argillet.

1989 Dali dies on January 23 in Figueres and is buried in the Teatro Museo.

Dali's sister, Ana María, dies in Cadaques on May 17.

Major retrospective of 350 Dali works exhibited in Stuttgart, Zurich, and Humlebaek (Denmark).

1990 The Dali estate ($130 million) is willed to the state of Spain, with the works to be divided between Madrid and Figueres. Fifty-six paintings will be housed in the Teatro-Museo Dali, Figueres, Spain, and possibly also in Barcelona, and 130 paintings will be exhibited in an undecided location in Catalonia.

Continuing the 1989 show, an exhibition of

over one hundred Dali works opens at the Montreal Museum of Fine Arts.

Dali exploiters William Mett and Marvin Wiseman of the Center Art Gallery of Honolulu are found guilty in federal court of misrepresentation of Dali prints and art fraud. The world's largest art-scam trial runs for five months before the three defendants are found guilty on seventy-three of seventy-nine charges.

A prominent Japanese art collector, Masao Nangaku, owner of several of Dali's large masterworks, plans a Dali Museum in his Minami Tower Hotel in Las Vegas.

1991 "The Dali Adventure," featuring recollections by Dali collectors A. Reynolds and Eleanor Morse, is released.

Dali Museum in St. Petersburg acquires *Galacidalacidesoxiribunucleicacid* for $1 million.

The Teatro Museo Dali acquires *Apotheosis of the Dollar*.

1992 Mrs. Edwin Bergman donates collection of seventy-seven Surrealist paintings to the Art Institute of Chicago, featuring three Dali works.

Dali Museum celebrates tenth anniversary in St. Petersburg.

Barcelona's Summer Olympics renew interest in Dali's Catalonia.

Meredith Etherington-Smith publishes biography of Dali in London.

Lee Catterall publishes *The Great Dali Art Fraud*, detailing the history of the fraudulent Dali graphic market.

1993 Dali's 1951 painting *Christ of St. John of the Cross* is moved from Glasgow Museum of Art to be the centerpiece in Glasgow's newly opened St. Mungo Museum of Religious Life and Art.

"Dali's Dalis," an exhibition of works by Dali from his own collection, opens in Seville.